Dead History, Live Art?
Spectacle, Subjectivity and
Subversion in Visual Culture
since the 1960s

Tate Liverpool Critical Forum, Volume 9

Dead History, Live Art?
Spectacle, Subjectivity and Subversion in Visual Culture since the 1960s

EDITED BY JONATHAN HARRIS

First published 2007 by
Liverpool University Press
4 Cambridge Street
Liverpool L69 7ZU

British Library Cataloguing-in-Publication data
A British Library CIP record is available

ISBN 978-0-85323-189-9 cased
 978-0-85323-438-8 limp

Typeset by www.axisgraphicdesign.co.uk
Printed and bound in the European Union
by Hartley Reproductions Ltd.

Contents

Acknowledgements

This volume in the Critical Forum series, like all of its predecessors, is the product of a sustained collaborative effort by staff at Liverpool University Press, Tate Liverpool, and the Centre for Architecture and the Visual Arts at the University of Liverpool. As series editor I would like to thank, in particular, Andrew Kirk from the Press, Lindsey Fryer and Laura Britton from Tate, and Anne MacPhee at the University. In addition, and on behalf of the Critical Forum editorial board, I would like to thank all the authors whose contributions make up this book. In what has been a very busy year for Liverpool University Press I would like to pay tribute to the hard work and good humour of everyone involved in any way with the production of this book, the sourcing of its illustrations, and the related research events at Tate Liverpool in the last two years that have helped to shape, and considerably focus, the concerns of this collection.

Jonathan Harris
Series Editor, *Critical Forum*

1

Introduction:
Performance, Critiques, Ideology
Contemporary Art and Art History in an Age of Visual Culture

JONATHAN HARRIS

> Till the eyes tire, millions of us watch the shadows and find them substance;
> watch scenes, situations, actions, exchanges, crises. The slice of life, once a
> project of naturalist drama, is now a voluntary, habitual, internal rhythm;
> the flow of action and acting, of representation and performance, raised to
> a new convention, that of a basic need.
>
> <div align="right">Raymond Williams[1]</div>

Act One[2]

[brightly!]

Thank you for inviting me here today to your world-class university!

I hope my talk this morning will strike you as... well, worldly, and pretty
classy. In preparing myself for this event I realized I needed first of all
to get myself... a world.

[brings a small plastic globe out of a box and places it on the table]

... and, of course, some class!

[rummages around and brings a small sculpture of a dinosaur out of the box; holds it up]

This *is* pretty classy, I'd say. It's one I made earlier... *Much* earlier, actually, when I was thirteen (thirty-two years ago) and at school, in Adelaide, in South Australia.

Diplodocus.

(What kind of secret history, I wonder, might these objects have? Secret even from me?...)

It struck me that, when considering the orthodox costume usually regarded as *de rigueur* for this kind of event today [interview for a job teaching performance art at a university], I would look a bit like a television newsreader: bland tie and jacket, sitting behind a desk – basically a stiff reading from some sheets of paper. Here I am then.

So: I will read the news of the world to you for a bit.

[brings out a wig from the box and places it roughly on bald head]

Well – you never see bald newsreaders these days, do you?! The days of Reginald Bosanquet and Robert Dougall [English TV newsreaders from the 1970s] are long gone. Actually Bosanquet wore a wig as well. And bald newsreaders in the US were probably banned by those wise founding fathers.

[brightly!]

It's good finally to be able to rejoin the polity of the hirsute!

[brings gong out of box and hits it once]

OK.

[in a hammed-up American accent]

'This is a World News Alert!!!

'I'm Jonathan Harris and I'll be your newscaster today.
Dateline June 27 2005

'The stories at the top of the news this bright and breezy morning:

BONG!!!

[brings first sign out of box and holds it up to audience]

 'The Proudest Daddy David. First Pictures of baby Cruz as the
 Beckhams brave taking all their boys to a restaurant.

 'Can you see that from where YOU are?

BONG!!!

[brings second sign out of box and holds it up to audience]

 'World Weeps for the Pope. Full reports and pictures, pages 1, 2, 3, 4,
 5, 6, 7, 8, 9 and opinion page 12.

 'Can you see that from where YOU are?

BONG!!!

[brings third sign out of box and holds it up to audience]

 'Michael Jackson "tried to be left Home Alone with Macaulay Culkin"

 'Can you see that from where YOU are?

BONG!!!

[brings fourth sign out of box and holds it up to audience]

'Drama isn't hot unless it has a baby-swap plot – curriculum innovators take note!

'Can you see that from where YOU are?

BONG!!!

[brings fifth sign out of box and holds it up to audience]

'Maggie's anguish as U.S. bans Mark Thatcher

'Can you see that from where YOU are?

BONG!!!

[brings sixth sign out of box and holds it up to audience]

'This News Alert has been brought to you by Mars bars – the milk chocolate bar with soft nougat and caramel centre...

'Now can you see that from where YOU are?

[waits 15 seconds or so depending on reaction from audience]...

' – well, when did the TV news actually ever really *explain* anything to you?'

[takes wig off, puts globe, dinosaur, gong, and signs back in the box]

OK. Well. That's the end of one of my performances today. Its cues and clues were made explicit – it had a beginning and an end, and a set of

rather tired and evident conventions.

It was also a record, as it happens, of another event.

On Monday 4 April 2005 I had to go to Sheffield to review an exhibition at the Graves Gallery for *Art Monthly*. I went into a store there to buy a newspaper and was advised that, if I bought a copy of the *Daily Express*, I would receive a free Mars bar or Snickers bar. I went for the Mars bar, as you saw, and sat down to glance at the headlines while I ate it. They became more bizarre as I turned the pages – dead pope-mania, tales of Michael Jackson and – as we know now – his entirely innocent 'home-alone' friends, and Margaret Thatcher's son banned from the US effectively for being a terrorist.

I wondered whether the preservatives and e-numbers in the Mars Bar had gone to my head!

These headlines, in their teeming graphic and semantic fusions and confusions, seemed somehow anarchically amoral for the *Daily Express*. Almost a kind of Situationist self-parody played out by one of the most atavistic, xenophobic and generally unpleasant newspapers in Britain.

So.

My little performance stands, apart from anything else, as a modest record and representation of a day out when ideologies of various kinds – relating to faith, identity, consumption, history, culture and 'the presentation of self in everyday life' (to use Erving Goffman's famous phrase)[3] – became briefly *dramatized* for me, at any rate, as the oddities they truly are. What kind of society do we live in? Brecht called this kind of *theatricalization* (making the familiar strange and therefore coming to see it afresh) the 'alienation effect'.[4]

I began as I did in order to indicate that the kinds of 'performances' that particularly interest me are those that have entered, inhabit and,

1 Joseph Harris

arguably, come virtually to define public social and political life in the contemporary era. Of course, these include all the 'manifest' or 'declared' performances in film and TV and 'live art', as well as in conventional drama in theatres.[5] But what might be called *dramatized public life performance* goes infinitely far beyond that now into social life understood as forms of both self- and unselfconscious representation. Assumptions of, and values to do with, truth and fictiveness, identity and narrative meaning are bound up importantly, and sometimes painfully, with these public performances in their myriad individual and collective instances and expressions.

I have an old passport here that belonged to my dead father. It shows him in his *wig*, looking out anxiously at the viewer.

[holds it out at the audience]

 'Can you see that from where YOU are?'

My dad, presumably experiencing a midlife crisis of one kind or another, had tried experimenting with the wig when in his late 30s and early 40s (about my age) – wanting the new image to *be* him, but, in the passport photograph, it's clear *he's* not sure he's pulled it off. Look at the expression on his face. There is a miserable gap, that is, between *his* sense of himself (including what he *thinks* he *should* look like) and the way he actually looks in the photograph, to do with the way *he thinks he really looks* in the photograph. As someone, that is, who is really only impersonating someone else, the 'someone else' he really wanted to *be* at the time: a man with a full head of hair. So this photograph, when I look at it, tells a painful truth to me about what my father thought of as a fictive representation – one made even more unsettling, to him, because he was contriving to appear to be like that, *or rather, to be that person*, within a legal document, with the beady eye of the state upon him.[6] His image, a consciously refashioned self-representation, is a kind of forgery, then, as far as he himself is concerned.

I have another sad old passport –

[holds it out at the audience]

– of *me* when I was about 20 when I had *real* hair but which now *looks* to me like a wig.

"Can you see that from where YOU are? (I don't really want you to, you know: they're just too personal and painful!)"

2 Jonathan Harris

Act Two

This collection of essays, along with the transcript of an extensive interview with Amelia Jones, partly derives from a conference held at Tate Liverpool on the occasion of its survey exhibition 'Art, Lies and Videotape: Exposing Performance' (November 2003–January 2004). Together, these contributions examine aspects of the history, current meanings and likely future of art centred on performance and the use of the human body.[7] But all these essays begin with the recognition that 'performance' and 'performance art' are problematic, if productive, categories, meaningful and functional within various overlapping institutional and discursive contexts – the art gallery, the university seminar, the archive, the book and the wider situation of everyday life and popular culture. All the authors included in *Dead History, Live Art?* interrogate the significance of these meanings for performance and performance art, suggesting ways in which to think beyond their usual references and implications, while, at the same time, acknowledging the substantial work carried out by artists, historians, critics and theorists who fashioned these meanings, references and implications in the decades between, roughly, the end of the Second World War and the present. There is no *single* history to performance art, as, for instance, Joshua Sofaer, Richard Layzell and Amelia Jones indicate in their contributions here, but together these discursive fields cultivated in museum and gallery curatorship, art history and the library/archive have constructed an entity which may *appear* homogeneous and unified. In this appearance – a consummate performance in itself –

Performance Art becomes as real and as unchallengeably *factual* as other twentieth-century art-historical shibboleths such as Abstract Expressionism and Cubism: the mere data of experience.[8] The principal purpose of *Dead History, Live Art?*, however, is radically to counter this appearance, and to show the fractured and stratified elements and layers, the discontinuities and heterogeneities that constitute this marketable art world entity.

Terms forming the subtitle indicate the three chief aspects of this counter-history and counter-performance. First of all, a concern to place performance and performance art within a wider history and theoretical account of *spectacle* in contemporary capitalist society. Secondly, a critical focus on subjectivity and its discourses in recent art and aesthetic theory, aiming to show the complex relations between performance art and its various progenitors, peers and competitors, such as Minimalist and 'Do-It-Yourself' art of the 1960s – the particular concerns here, respectively, of Frazer Ward and Anna Dezeuze. Thirdly, the beginnings of a critique of the objectivizing ideologies of 'subversion' and 'critical practice' in avant-garde art associated with a number of highly influential critics and theorists including Peter Bürger, Rosalind Krauss, Hal Foster and Benjamin H. D. Buchloh (the latter three all members of *October* magazine's editorial board since the 1980s, responsible for performing, as it were, the 'Duchamp effect' that fetishized the readymade as Ur-avant-garde artefact).[9] Several themes and sets of questions predominate in this book, woven in and out of these three key areas of interrogation and dispute. These concern:

· the construction and contestation of social (ethnic, class, gender, sexual, colonial and other) meanings and identities through dramatized public life performance, including its nineteenth-century ethnographic forms of exploitative display, and in 'performance art' (Robert Summers, Jane Chin Davidson);

· the distinctions and relations between *private* ('internal') and *public* ('external') notions and experiences of self and subjectivity produced

within performances of all kinds (August Jordan Davis, Frazer Ward, Anna Dezeuze);

· the complex and dynamic interactions between 'live' performance art and the processes and forms of its 'documentation' (Joshua Sofaer, Richard Layzell);

· the impact on the experience and meaning of performances of all kinds wrought by mediating techniques and technologies of mechanical, electronic, digital and Internet reproduction (Beryl Graham, Amelia Jones);

· the significance and implications of 'interactivity' and 'collaboration' within performance art, in a long historical process dating from 1960s utopian 'Do-It-Yourself' art, through 'classic' 1970s and 1980s body art, to, for example, contemporary 'disembodied' Internet performance practices (Anna Dezeuze, August Jordan Davis, Beryl Graham);

· the relations between 'performance art' narrowly conceived and the spectacular 'theatricalization' of public events in contemporary society – particularly the role of broadcast TV in the construction of major international public events, such as the invasion and subsequent occupation of Iraq by US, British and other military forces in 2003 (Amelia Jones, August Jordan Davis).

· the impact of both performance art and dramatized public life performance upon the discipline of art history, and its evolving relationship with novel inter- or trans-disciplinary fields such as 'visual culture' and 'visual studies' (Amelia Jones, Robert Summers).

Sophisticated inquiry into what I have called dramatized public life performance requires a convergence of concepts, methods, arguments and values from a wide range of orthodox academic disciplinary arenas: across, that is, drama studies and art history, but also social

and cultural history, literary studies, communications and cultural studies. Beyond these relatively conventional arts and humanities specialisms, however, this analytic convergence must extend to, and include, critical or interpretative sociology (for example, drawing on 'symbolic-interactionism' and its related developments since the 1960s), philosophy (particularly phenomenology and its focus on embodied experience), social psychology and politics. All of these fields have much to contribute to an understanding of public performance in the broader senses I have outlined: from the TV and newspaper 'set piece' mediation of international events such as wars and occupations, to the construction and narration of ongoing national and regional social and political life (e.g. representations of the work of politicians and democratic institutions; celebrity culture; sports and entertainment spectacles), to the performances that constitute the 'micro-events' of individual life and small group contact (e.g. self-presentation at work, in social and sexual relationships, and sub-cultural activities that reinforce identity and senses of community).

However, I prefer to think of this work and process of intellectual convergence in terms of clearly defineable *problems requiring solutions*, rather than in terms of institutionalized disciplines, or inter-disciplinary activities, setting out a nascent field of regularized and reproducible academic procedures. Though the critical study of dramatized public life performance could develop within universities, and therefore may be understood essentially as a matter of academic interests either clashing or meshing, the impetus for the inquiry remains, in one important sense, institutionally homeless. Since the 1970s, in Britain at any rate, only the Birmingham Centre for Contemporary Cultural Studies, under the initial direction of Stuart Hall (trained as both a literature specialist and a sociologist), was able to organize and sustain this kind of radical convergence, directly linked as it was then to a political and social radicalism based on the New Left, feminism and the rise of new social movements concerned with ethnicity and sexuality.[10] The Centre, as Hall points out, identified a set of problems to try to answer: How might sub-cultural language-use contribute to classed and gendered identity? What role does popular

culture play in undermining the Protestant work ethic in capitalist societies? Why did conventional British socialist politics in the 1970s make marginal the interests of the black working class?

Three principal historical and theoretical problems or conceptual 'problematics' (that is, sets of concepts and questions) are central to the study of dramatized public life performance. (1) The sphere of *hegemony*, or how social and political order in societies is created and maintained; (2) the sphere of *culture*, or how representations of all kinds create a sense of a world, and a world of shared, though disputed, meanings and values; and (3) the sphere of the *political state* and its forms, powers and limits in historical and contemporary societies. A variety of definitions of 'theatre' and 'performance' relevant to the study of dramatized public life exist, with links both to the conventional historical study of the arts and to the understanding of contemporary forms of spectacle and the theatricalization of everyday life. These forms all become intelligible (and begin to make sense as an intelligible *pattern* of events, processes and meanings) within an integrated analysis of the development and operation of hegemony, culture and the political state. For example – and specifically pertinent to Ward's consideration here of the relations between Minimalism and performance art – Michael Fried's highly derogatory notions of 'theatre', 'theatricality' and 'literalism', developed within his hostile criticism of the artefacts created and exhibited by Donald Judd, Robert Morris and others in the mid-1960s, was partly elaborated in complex relation to his sympathy with Denis Diderot's attack on pre-revolutionary theatre, painting, morality and politics in eighteenth-century France. 'Spectacularization' in culture, a process and development that jointly alienates both the objects represented and those subjects held in the act of 'beholding', brings about what Fried called 'dislocation and estrangement', echoing Diderot's own claim that a *de-theatricalization* of beholding and visual representation was necessary in order to once again make both looking and visual representation 'a mode of access to truth and conviction'.[11]

However much the situations in eighteenth-century France and US society in the 1960s differed, there is clearly a significant overlap

between what Fried dismisses as the corruption of 'theatricality' in Minimalism and Guy Debord's now well-known concept of 'the spectacle' – a Marxian concept with a lot more theorizing and politics behind it, though the idea remains equally troublesome in some respects, particularly when it comes to questions of cultural value, contemporary society and what might be called critical aesthetic practice.[12] The spectacle developed, according to Debord, at a certain point in the accumulation of capital and the development of commodification in capitalist societies. Though the 'society of the spectacle' has often been interpreted to mean simply the dominance of the mass media, for Debord, TV, for instance, was only what he called 'its most stultifying superficial manifestation'. Spectacle in fact had two bases: 'incessant technological renewal' and the 'integration of State and economy'. The spectacle harnessed sight, Debord claims, as it was 'the most abstract of the senses, and the most easily deceived'.[13] But Debord's 'spectacle' seems theoretically monolithic and, in one sense, ahistorical: when can it said to have *started*? What, if anything, escapes it? What might ever escape it in the future? Can artists or others (filmmakers, performers of any kind) ever really subvert spectacle? Debord's own pronouncements tended to suggest not.[14]

This dilemma is a central problem for the study of performance art and dramatized public life performance. Marxian critiques going back to Debord, Herbert Marcuse, Theodor Adorno and further all attacked spectacle, though gave it other names too, such as 'mass culture'.[15] In this tradition of what might be called 'high art' Marxism the vast bulk of twentieth-century industrially produced culture – setting aside the fringes of both folk and elite forms – simply has no positive content. Now, whatever else the study of performance in its broadest senses – dramatized public life, TV, film, Internet, the traditional dramatic and performance arts – involves, this question and problem of values and evaluative process remains absolutely central. For most people, including scholars and students, born after 1945 such a *tout court* rejection of mass and popular media as 'spectacle' implies a denial of part of their formative experience, however critical such people may also be of the development of industrial culture in the capitalist

societies of the West, or of the fate of the post-Soviet bloc societies that embraced capitalism and the 'free market' after 1991. The 'society of the spectacle' thesis, that is, though very valuable as a radical critique of 'advanced' or 'consumer' capitalist development, must be subject to historicization: an equally radical analysis of its historical *evolution and mutation* over the decades of the twentieth century and of the relation between this complex history and the earlier commercial and industrial phases of capitalism in the late eighteenth and nineteenth centuries.

The integrated problematics of hegemony, culture and the political state find particular form in any actual historical moment. 'Performance', understood as a stratified range of practices, values and experiences, is also, always, historically specific. For example, Tate Liverpool's 2005 exhibition *Summer of Love: Art of the Psychedelic Era*, and its two related publications, focus on performance and spectacle in a range of visual arts, and in visual culture broadly.[16] The exhibition and books attempt to make sense of psychedelic art, film, rock concerts, light shows, happenings, drug culture, fashion, dance and design in terms of what the 1960s has come to represent in social and political terms. In attempting to show something of the true diversity of practices that constituted that mid-1960s conjunctural 'moment', performance is argued to be radically heterogeneous; *not* reducible to an essence (such as the experience of taking LSD), or seen fundamentally as an expression or symptom of something else. This methodological pluralism is a recurring theme in *Dead History, Live Art?* evident in, for example Jane Chin Davidson's historical account of racist, exploitative 'ethnographic performance' in the nineteenth century in Britain and the USA (which she links to contemporary performers interested in the history of colonialism and its impact on contemporary US society, such as Guillermo Gomez-Peña and James Luna). To take another example, Robert Summers's essay examines Los Angeles-based transsexual/stand-up comic/performance artist Vaginal Davis whose action at the Getty Institute in 1999 set out to subvert the meaning of the art library archive and its support for orthodox accounts of twentieth-century artists such as Andy Warhol and Frida Kahlo. These essays aim to show, that is,

both the complex historical relations *between* very different forms of performance practice, and the relations between these forms and specific, yet dynamic, social *formations*.

Such comparative analyses put under stress, inevitably and intentionally, the received definitions of 'performance' within the visual arts and visual arts history and theory. They also interrogate transformations in the meanings and practices of contemporary art in the light of the rise of now orthodox kinds of curator-based notions of 'performance art' since the 1960s. Richard Layzell's 'multiple persona' text and August Jordan Davis's essay on Martha Rosler's restaging of her *Semiotics of the Kitchen* piece both demonstrate how some artists *themselves* have critically reviewed and revised their own status as performers, along with their practices, products and values. Beyond these relatively conventional examples, however, several contributors here begin a discussion of dramatized public life performance, a chief example being the 'televization' and 'tele*visualization*' of the war in Iraq in 2003 and the subsequent occupation, along with the forms of protest this drew from various anti-war groups in Britain and the USA. This latter term, 'televisualization', is intended to refer to the much more consciously contrived process of creating an image and narrative of the meaning of the invasion and occupation from the US state's current 'neo-con' perspective – a process that enlisted, and continues to enlist, such US-based organizations as Fox TV news, CIA public relations staff, many 'neo-con' pro-Israeli lobby groups, the usual White House fixers, et al. (Some of this analytic work is close to the interests of the Glasgow University Media Group, active in the 1970s and 1980s, and their studies *Bad News, More Bad News*, and *Very Bad News*.)[17]

Dead History, Live Art? is also meant, both polemically and analytically, to signal frustration with the limits of orthodox art history understood as a set of operative concepts and methods. In some important ways, that is, art history (and conventional drama/screen studies) has been outstripped not only by forms of analysis growing between, or outside, established academic disciplines, but also by *contemporary cultural practice itself* – by new forms of visual-cultural production, much of it Internet-based, that have helped to make the

concerns and objects of orthodox art history (great artists, canons, authentic expressive authorial intentionality) seem quaint and old-fashioned. Beryl Graham's essay here provides many useful examples of new work utilizing, for instance, digital, robotic and Internet technology. However, this is not a call to focus exclusively on contemporary or twentieth-century society and culture: on the contrary, we need much better historical study of all kinds of visual culture before western modernity. It is to say, though, that art history's core concerns and ideological values remain far too important and strategic to be left in the hands of conventional art historians!

'Visual culture', however, is a term with its own serious problems of definition and usage. Is it the name, for instance, of an analytic method or a range of objects of study, or both? Whatever these problems, its coinage, along with others, such as 'visual studies', indicates that for some time now a sense of movement beyond 'art history' has been felt to be absolutely necessary and *named as such*.[18] This is not to say for a minute, though, that a nascent academic discipline called 'visual culture' or anything else should exclude from its analytic gaze the intellectual terrain of art history: to the contrary, as both subject and object, visual culture should include a sharp focus specifically on the history and concerns of art history as a disciplinary field with its strengths and weaknesses. Any 'visual culture' or 'visual studies' analysis *not* grounded in heuristic, evidence-based, historical inquiry, in a particular concern with the relations between 'aesthetic form' and 'social formation' (however problematic all these terms may be), with theories and debates about creativity and meaning informed by developments in art history and philosophical aesthetics, will be impoverished and remain only weakly explanatory. Amelia Jones discusses in her interview the problems in defining, practising and teaching such a new analytic field. If contemporary visual culture has in some ways outstripped art history, then it has also outstripped the institutional-pedagogic base for the subject in universities, still centred in many of its sites on the use of the dual slide projector format and adherence to a study of art regarded as safely 'historical' rather than recent, never mind contemporary. If performance and body art in many

of its forms since the 1950s has been inter-disciplinary and mixed-media based, then its adequate study requires an innovative pedagogic practice, utilizing novel technologies of reproduction and interactivity. In another, related, direction, Anna Dezeuze examines in her essay how 'interactivity' and 'collaboration' between performers and audience characterized the 'Do-It-Yourself' art of Yoko Ono, Lygia Clark and the members of Fluxus – works conceived, that is, as part of the 1960s utopian political moment, fetishizing neither the isolated performer nor his or her body.

For most scholars now in their thirties, forties or fifties trying to theorize the intellectual terrain of visual culture the likely origins of their work and careers in art history means that, arguably, they will find themselves somewhere *in between* art history and this new projected synthesis of concerns. They are caught, that is, between a more or less orthodox art-historical practice (including its 'new art history' variants) and the arguments, concepts, values and analytic procedures that might begin to constitute an alternative paradigm of cultural analysis.[19] These scholars, then, are lodged somewhere between the task and risk of *reproducing* disciplinary and pedagogic terrain, on the one hand, and trying to *produce* another, alternative – and sometimes directly oppositional – terrain on the other.[20] This dilemma of 'production' versus 'reproduction' (accompanied by its own, rather mundane, dramatic performances, played out within academia's social relations) will inevitably follow the enactment of the kinds of radical critique which 'visual culture' potentially stands for – threatening, for example, traditional academic art-historical research interests, fated to run up against the inertia of existing pedagogic programmes and conventional academic assessment habits, and likely (at least initially), given its unfamiliar intellectual complexity, to baffle potential 'student-consumers' and their parents seeking vocational return on their investment. 'Media studies' it ain't, though the seductions of that term and the promise of a job in TV or publishing will probably end up characterizing its marketing by the universities.

Act Three

To sum up. *Dead History, Live Art? Spectacle, Subjectivity and Subversion in Visual Culture since the 1960s* proposes the radical critique of performance and 'performance art' discourses. This critique is now a central part of any adequate analysis of contemporary visual art. The study of performance in terms of dramatized public life requires an intellectual convergence based in *problem-solving*, using the existing disciplinary apparatus, but clearly moving well beyond that, and beyond even orthodox academic notions of inter-disciplinarity. This means a focus on *new creative and critical production* as well as on *academic reproduction* – the latter an inevitable and necessary feature of education, in universities as anywhere else in the socio-institutional fabric. Young people (and those older, of course) immersed in the 'society of the spectacle' need to be given the tools to make sense of it, and to be able to evaluate its content and impact on their lives. Universities continue to offer one of the few places where this kind of critical work, in teaching and research, can still take place.

The study of public life performance and display in visual culture and society broadly is linked to the visual arts, theatre, screen drama, mass and popular culture studies, but moves clearly far beyond those areas and the disciplinary techniques that have grown up to make sense of them. The development of this new convergence of interests is partly dependent upon embedding theoretical clarification into the heart of teaching and research practices in the universities. It is the intellectual equivalent in the broad field of 'visual cultures' of replacing what used to be called 'English Literature' with what Raymond Williams settled on calling 'writing in society'.[21]

Many of the concepts and methods of analysis needed probably haven't even been invented yet. But *writing* remains at the heart of what I propose: the 'theatre' of writing – the writing of students and scholars – and its barrage of effects and conventions, means and modes, idioms and dispositions needs fundamental reconsideration (Joshua Sofaer's essay in this volume touches on this issue at several points). It seems to me that in teaching we rarely, if at all, focus on writing productively or creatively. I don't mean getting students to

write grammatically or intelligibly, though that is, of course, part of it. Some would say it's all we can do! Rather I mean getting students to think through the dramas of their own forms of subjective 'composition and self-composition', to paraphrase Kant.[22] And, of course, this *is* partly utopian! Keele University's department of visual arts, incidentally, had tried seriously to do this, in the years between 1994–99. *All* students were engaged then both in making art and making forms of analytic critique – the then-emergent digital technologies were central to students' projects when they were being both 'artists' *and* 'critics' or 'theorists'.[23] Keele's ethos saw students as *productive* as well as reproductive, as *makers* as well as interpreters. Common to all the essays included in *Dead History, Live Art?* is a sense that the best contemporary practitioners are also their own theorists, and see a dynamic, dialectical relationship between their performances as artists and their performances as critical thinkers.

In broader social and political terms, the study of both contemporary art narrowly defined and dramatized public life performance forms part of an ambitious project designed fundamentally to interrogate and extend the 'social inclusion' and 'cultural democracy' policy directives that now powerfully influence state funding of the arts in Britain (and which finds echoes in the policies and rhetoric of other societies such as the USA, Germany and Poland). Let's take *these* terms and their rhetoric *very seriously*, I'm arguing – meaning that they should be understood *critically* and *creatively* too: made the stuff of analysis and new cultural production, and pursued also through a range of developments involving collaboration with commercial and other non-state organizations in the business of electronic, digital communication media. This is a theme pursued, for example, in the British and Irish Cultural Policy Collective's 2003 pamphlet *Beyond Social Inclusion: Towards Cultural Democracy.*

Finally, some areas for new work building on the essays in this collection include the following:

Study of the relations between cultural critique and cultural production. There are sustained negative pressures, for example, from many

institutions and media organizations effectively working against the development of inter-disciplinary or 'problem-solution'-based inquiry. These include the still highly conservative policies and practices of museum exhibition, curation and archiving; the profit-motivated agendas of most publishing companies which reproduce ideologies of individual authorial expression; conventional broadcast radio and TV treatments of the arts, drama, public life and culture still overwhelmingly focused on 'great men' themes. On the other hand, positive pressures can occur too. Sometimes contemporary cultural production appears to outmode thinking within academic discourse. For instance, one of the most compelling critiques of 'reality TV' I've seen occurred recently in an episode of the BBC science-fictional/ fantasy drama series *Dr Who*.

Study of public life performance and display in contemporary society. This is an area closely related to the existing fields of visual anthropology and the study of documentary culture. Two problems interest me particularly: the reconstitution of 'public'/'private' realms of representation, experience and ideology in contemporary society and the dramatization of politics as a form of visual narrative. (A founding text in this latter analysis would be Raymond Williams's 1974 essay 'Drama in a Dramatized Society', in which he talks of the spread of dramatic representation in British society as a whole in the 1960s and 1970s. One key development in this process was the decision taken by the government to allow the routine televizing of the workings of the British Parliament at Westminster in 1974.)[24]

The creation and study of contemporary cultural democracy. This multi- and inter-disciplinary project would produce new forms of research, teaching, information and entertainment manifest in continuous broadcast forms – via, for example, public radio, Internet and broadcast television sources. This would be an international as well as national development, tapping into the veins of creative independent public broadcast media that exists in the USA, Europe and Asia. The impetus and impulse for this project is, in one sense, an absolute rejection of the

pessimism that underpins most readings of the 'society of the spectacle' thesis. In another sense, however, it is also a means through which to begin to understand 'spectacle' and 'theatricality' *precisely as historical processes of hegemony, culture and the political state*, and able, therefore, to be challenged and potentially replaced. The inspiration for these kinds of studies is clearly present in all the essays included in *Dead History, Live Art?* which together represent the beginnings of an inquiry into the future of art and culture, its complex historical inheritances and now global critical contemporary context.

NOTES

1 Epigraph to *Raymond Williams on Television: Selected Writings*, ed. Alan O'Connor (London and New York: Routledge, 1989).

2 This first section draws almost verbatim on a lecture/performance I gave at the University of Manchester on 27 June 2005 to an audience from the School of Arts, Cultures and Histories.

3 Erving Goffman, *The Presentation of Self in Everyday Life* (Harmondsworth: Penguin, 1959).

4 See John Willett (trans. and ed.), *Brecht on Theatre: The Development of an Aesthetic* (London: Methuen, 2001 [1964]), and 'Against Georg Lukacs', trans. S. Hood, in R. Taylor (ed.), *Aesthetics and Politics* (London: New Left Books, 1977), pp. 79–85.

5 On what Raymond Williams called 'manifest' and 'diluted' signs/meanings, see *Culture* (Glasgow: Fontana, 1981), especially pp. 207–14.

6 See John Tagg, *The Burden of Representation: Essays on Photographs and Histories* (London: Macmillan, 1988).

7 See Adrian George (ed.), *Art, Lies and Videotape: Exposing Performance* (London: Tate Publishing, 2003), and Adrian Heathfield (ed.), *Live Art and Performance* (London: Tate Publishing, 2004).

8 On the category of 'experience' and its ideological uses specifically within modernist criticism and theory, see Jonathan Harris, *Writing Back to Modern Art: After Greenberg, Fried, and Clark* (London and New York: Routledge, 2005), especially pp. 29–34.

9 See also Peter Bürger, *Theory of the Avant-garde* (Minneapolis, MN: University of Minnesota Press, 1984).

10 See, for example, Stuart Hall, Dorothy Hobson, Andrew Lowe and Paul Willis (eds), *Culture, Media, Language* (London: Hutchinson and the Birmingham Centre for Contemporary Cultural Studies, 1981).

11 Michael Fried, *Absorption and Theatricality: Painting and Beholder in the Age of Diderot* (Berkeley, CA, and London: University of California Press, 1980), p. 104.

12 See Guy Debord, *The Society of the Spectacle*, trans. Donald Nicholson-Smith (New York: Zone Books, 1994 [1967]), and Anselm Jappe, *Guy Debord* (Berkeley, CA, and London: University of California Press, 1999). On 'critical aesthetic practice', see Catherine Belsey, Critical Practice (London and New York: Methuen, 1980).

13 *The Society of the Spectacle*, sections 24 (*Comments on the Society of the Spectacle* [Debord, trans. Malcolm Imrie, London: Verso, 1990]), 7, 18.

14 See Debord's *Comments on the Society of the Spectacle* and, for instance, Jappe's own analysis.

15 See, for example, Herbert Marcuse, *The Aesthetic Dimension* (London: Macmillan, 1978), and Theodor Adorno, *The Culture Industry: Selected Essays on Mass Culture*, ed. J. M. Bernstein (London: Routledge, 1991). For a critique of 'mass culture' theory, see Raymond Williams, 'Culture and Technology', in *The Year 2000* (New York: Pantheon Books, 1983).

16 See Christoph Grunenberg (ed.), *Summer of Love: Art of the Psychedelic Era* (London: Tate Publishing, 2005) and Christoph Grunenberg and Jonathan Harris (eds), *Summer of Love: Psychedelic Art, Social Crisis and Counterculture in the 1960s* (Liverpool: Liverpool University Press and Tate Liverpool, 2005).

17 See, for example, Glasgow University Media Group, *Bad News* (London: Routledge and Kegan Paul, 1976).

18 See Jonathan Harris, 'Putting the "Culture" into Visual Culture: the Legacy and Challenge of Raymond Williams', *Visual Culture in Britain*, vol. 5, no. 2 (2004), pp. 63–75.

19 See Jonathan Harris, *The New Art History: A Critical Introduction* (London and New York: Routledge, 2001).

20 On the meanings of 'alternative' and 'oppositional', see Raymond Williams, 'The Bloomsbury Fraction', in *Problems in Materialism and Culture* (London: New Left Books, 1980), and Culture, pp. 70–81.

21 See Raymond Williams, *Writing in Society* (London: Verso, 1984).

22 See Michael Podro's discussion of this notion in *The Critical Historians of Art* (New Haven, CT, and London: Yale University Press, 1982), pp. 6–7.

23 See Jonathan Harris, 'Art Education and Cyber-Ideology: Beyond Individualism and Technological Determinism', *Art Journal*, vol. 56, no. 3 (Fall 1997), pp. 39–45.

24 See Raymond Williams, 'Drama in a Dramatized Society', in *Writing in Society*, pp. 11–21 and, for example, 'The Question of Ulster', in O'Connor (ed.), *Raymond Williams on Television*, pp. 163–67.

2

Namesake
Who's Performing Whom?

JOSHUA SOFAER

[T]he proper name is only ever supposed to refer and not to mean.

Julian Wolfreys[1]

When I first got your email I thought: hey, that's me!

Joshua Sofaer, New York

One cannot help having a slightly disagreeable feeling when one comes across one's own name in a stranger. Recently I was very sharply aware of it when a *Herr S. Freud* presented himself to me in my consulting hour.

Sigmund Freud[2]

Travelling up the Finchley Road in North London, soon after I had arrived in the capital in the early nineties, my eye stopped on a shop front which read: Jews for Jesus. It is possible that I had heard of the organization before, but the fact that here there was a concrete registration of this seeming contradiction struck me. I crossed the road and gazed into the window. There were a few ceremonial objects used in the Jewish household – I seem to remember a Hanukkiah, the eight-branched candelabra used during the festival of Hanukkah – and a Seder plate, used at the Passover meal. There was also a selection of books, often with a graphic incorporating both a star of David and a crucifix. I was a bit perplexed. I wrote down the telephone contact number clearly printed on the window and went on my way.

A couple of days later I phoned up the number and asked the person at the other end, 'What is Jews for Jesus?' After a lucid but almost blunt reply ('We are Jews who believe that Jesus was the Messiah') I could practically hear the pen poised over the paper ready to take down my contact details in preparation for my indoctrination. When I announced (and spelt) my name – Joshua Sofaer – S-O-F-A-E-R – Sierra, Oscar, Foxtrot, Alpha, Echo, Romeo – there was an awkward silence. It was the kind of silence that comes when someone thinks that they misheard, or that you are taking them for a ride, but then realise that no, you really are telling the truth. 'Oh,' came the eventual reply, 'you know there is another Joshua Sofaer in New York who is very involved with Jews for Jesus.'

The call finishes and I am left feeling uneasy. There is another me (at least one other). But not only that, he is an active member of what I take to be a weird Messianic cult. Oh dear.

In May 2002 I went to visit Joshua Sofaer USA, the New York based evangelist in his early thirties, a full-time proselytising 'Jewish believer' who preaches for the acceptance of Jesus, as a member of the Messianic Judeo-Christian organization Jews for Jesus.[3]

By spending time with another Joshua Sofaer and recording our conversations, I hoped to better understand how names function. My hunch was that in our lives we live our names, that our names act as scripts given to us at birth which we then go on to perform. Observing the similarities and differences in our attitudes and understanding of what it meant to be in the world as 'Joshua Sofaer', how we lived our names – both exactly the same and completely different – a wider picture evolved.

In May 2004, two years after my initial visit to Joshua Sofaer,[4] *I presented 'Namesake: The Story of a Name', a live performance with soundscape in collaboration with the composer Jonathan Cooper at three venues in London. They were The Jewish Museum (the London Museum of Jewish Life), Home (an art gallery and performance space based inside a family house in Camberwell and noted for its commitment to live art practices), and The Swiss Church in London (which has a growing programme of cross-cultural and intercultural arts activities). Each of these three venues and their audiences (the Jewish venue and audience,*

the Art venue and audience, and the Christian venue and audience)
contributed to the resonances of the piece and underlined the need for
tolerance through religious and national exchange in the current climate
of tense international relations. These concerns were filtered through the
telling of the story of my meeting with my namesake, and our
understanding of the meanings of our name.

The personal proper name designates its referent. We hail another with
his or her name and we respond to our own name being called. But even
the fact of this trip alone, that it was made at all, forces the conclusion that
names are not simply designators but activators which affect, alter,
produce and even dictate life narratives. The personal proper name
offers a proliferation of significations outside and beyond its referent.

The problem of the name is one that has long been acknowledged.
Plato's 'Cratylus' is a Socratic dialogue dedicated entirely to the subject
and concludes with a provocation to Western socio-linguistic and
philosophical thought: 'it's one thing to be a name and another to be the
thing it names'.[5] As early as the fourth century BCE the designator and the
referent were being separated.

I rehearse below some of the implications of the performing of a
namesake. Here performance research and the creation of the
performance piece 'Namesake: The Story of a Name', leave the stage and
enter the academy. The research for both outcomes – performance and
critical writing – find themselves reliant on each other; the writing quotes
the performance and the performance quotes the writing.

It can be bad luck to have a namesake. It can be a matter of life and
death. For Deepak Patel it was fatal. Admitted to Northwick Park
Hospital in London on 24 April 2001 and diagnosed with
meningococcal septicaemia, his life-saving medicine was given to
somebody else with the same name.[6] He died.

Deepak was neglected for a namesake; he was passed over in favour
of a non-identical identical. This is the nightmarish stuff of Kafka made
real; the horror of mistaken identity; deselected or selected by accident.

The fear of being falsely accused, being the right actor in the wrong part, is something we all live with. One of the strongest arguments against the death penalty is that the wrong person might be convicted. This fear is not restricted to the weight of the law. As Benzion Kaganoff discovered:

> It was a widespread folk belief among Jews during the Middle Ages that, confronted with two individuals of the same name, the ministering angels were as likely as not to choose the wrong one. Therefore, some maintained that several families with a common name should not reside in one dwelling. People went so far as to avoid entering the home of a sick person who bore their name, lest the Angel of Death arrive during the visit and take the wrong soul.[7]

This 'folk belief' is a superstitious recontextualization of the fear of false accusation, manifest in a conception of the administrative order of heaven. However far from other belief systems it may be, this kind of conviction identifies the threat to one's 'individuality' that is made by the presence of a namesake.

The misrecognition that takes place in the encounter with a namesake is not quite the same as that which takes place with the double, the false twin, or the doppelganger: the mistaken identities which span cultural narratives from Esau and his twin brother Jacob, to Alfred Hitchcock's *The Wrong Man*. The difference is that whereas the misrecognition by Isaac of one son for another, or the witnesses and law enforcement officers of Christopher Emmanuel Balestrero for the real culprit 'Daniell', are based on false assumptions, the encounter with the namesake is based on a truth: two players have identical nomenclature.

In Michael Waldron's nineteenth-century farce *A Slight Mistake or Mistaken Identity*, the action (and consequently the rather outmoded humour) arises from a newly employed servant's confusion between the master she has not yet met and an unemployed valet who is looking for work, both of whom happen to have the same name. In a narrative world where names *mean* (the servant in question is called Belinda *Cookwell*, the police-officer Constable *Catchem*) it is no surprise that the namesakes are both called Thomas Thompson,

'Thomas' from the Hebrew word meaning 'twin' (Didymus being the Greek version which means 'double-minded'). Thomas Thompson, Thomas son of Tom, a twin name, doubled, then doubled again by the namesake; eight names in one. The semantic properties of this name would not have been lost on the Sunday School educated Victorian audience.

While Waldron's comedy may be slight and pivot on a reductive and essentialist class-based politics which we now regard as unacceptable upper-class privilege (servant treated as master, master denied 'proper' respect), the encounter of the namesake is one with which we keenly identify. Two people, the same yet different, who swap places momentarily, and offer us an insight of what might have been, throwing back the questions: *who are you and what legitimates you?*

Edgar Allan Poe's short story *William Wilson* is the tale of the title character's conflict with his namesake. Ostensibly *William Wilson* is Wilson's deathbed confession of his lifelong struggle against the dogged interference of his namesake – William Wilson – who follows him from preparatory school to Eton to Oxford and beyond, mimicking him, bringing him down and exposing him. The story ends with Wilson's account of the 'last eventful scene of the drama' in which he finally challenges his namesake to a duel and murders him.[8]

But right from the epigraph, Poe indicates that Wilson's namesake is parabolic. Underneath the title, the caption reads:

> What say of it? what say of CONSCIENCE grim,
> That spectre in my path?[9]

Wilson's namesake is his own conscience, which plagues him throughout the narrative of the story, and throughout his life; he makes his appearances conveniently just at the moments when Wilson is in the process of committing a crime against *his own* moral code. The epigraph makes it clear enough that the namesake is a metaphor, but there are repeated clues within the text:

> I might, to-day, have been a better, and thus a happier man, had I less frequently rejected the counsels embodied in those meaning whispers which I then but too cordially hated and too bitterly despised.[10]

William Wilson's namesake is his better self, his conscience, which doggedly follows him around, checking and commenting on his actions: a conscience which he finally destroys.

In *William Wilson*, Poe employs the use of a literary namesake. It would be easy, then, to understand *William Wilson* as simply a parable: the namesake as a literary conceit. Even within the narrative world of the story, however, both name and namesake are presented as an invention, as being self-willed.

> Let me call myself, for the present, William Wilson. The fair page now lying before me need not be sullied with my real appellation.[11]

and again later:

> In this narrative I have therefore designated myself as William Wilson, – a fictitious title not very dissimilar to the real.[12]

As Daniel Hoffman points out:

> The chosen disguise reveals that its bearer is, in his own view, self-begotten: he is William Wilson, William son of his own *Will*. He has, that is, willed himself into being – willed the self we meet, the one that survives its murder of its double.[13]

The name is, like Thomas Thompson, in and of itself a namesake, doubled and then quadrupled. *William Wilson* and his namesake *William Wilson* – the four wills, the force of will. The namesake is acknowledged as a fake, as the creator of its own fiction. This fabrication forces the question of the identity of William Wilson. Who, in fact, is he?

Poe tempts us to a conclusion with the inclusion of several autobiographical references. For a start, Wilson shares a birthdate not only with his namesake, but also with his author. Poe was born on 19 January 1813; so was Wilson.[14] Poe went to preparatory school at Dr Bransby's; so did Wilson. Poe had to leave the University of West Virginia because of misadventures in gambling; Wilson must leave Oxford for the same reason.[15] William Wilson thus becomes a literary namesake for his author Edgar Allan Poe. A namesake in all but name. That 'William Wilson' is not the 'real' name of the

character, even within the narrative, is made possible by the text itself and allows for our indulgence that *William Wilson* is an autobiography of its author – or at least an autobiography of the author's struggle with his conscience.

In this context *William Wilson* is less a literary conceit than the struggle to represent self in writing; an acknowledgement of the self that is other – existing solely as a namesake – in the published name of the author. Jorge Luis Borges acknowledges the fictive autobiographical doppelganger of the writer in 'Borges and I':

> The other one, the one called Borges, is the one things happen to. I walk through the streets of Buenos Aires and stop for a moment, perhaps mechanically now, to look at the arch of an entrance hall and the grillwork on the gate; I know of Borges from the mail and see his name on a list of professors or in a biographical dictionary. I like hourglasses, maps, eighteenth-century typography, the taste of coffee and the prose of Stevenson; he shares these preferences, but in a vain way that turns them into the attributes of an actor. It would be an exaggeration to say that ours is a hostile relationship; I live, let myself go on living, so that Borges may contrive his literature, and this literature justifies me.[16]

Borges separates himself out from his published namesake, who *plays* at being Borges. The namesake is an actor, which is to say he pretends to be something which he is not. In this context, Poe's story of a namesake (one which is eerily contemporary in its formulation and the complexity with which it approaches the relationship of an author's life to that of his fiction) usefully articulates the struggle of self-judgement and the gap between the internal self and that self's public performance.

Poe's short story *William Wilson* is his progeny, verified by the published attribution '*by Edgar Allan Poe*'. This mechanical reproduction of his name – his printed namesake – articulates his life (his life's work, his work as his life).

To read about oneself, to write about oneself, to see one's name printed and reprinted, to hear one's name in conversation, is often to read or write or hear as if it was the name of another. In this context – the context of the post-industrial revolution – our personal proper name becomes our namesake in written and spoken language.

Mechanical reproduction – printing, photography, film – offers us the same kind of estrangement that we feel when we look in a mirror: it is both us and not us.

The mechanical reproduction of our name (a kind of printed namesake) validates us as subjects. Just as the verbal appellation hails us into the social space, even if (as Judith Butler has observed[17]) that appellation is based in hate speech, so too *seeing one's name in print*, be it praise or slander, accords us the status of social subject. For the narrator of *A la recherche du temps perdu* the publication of his article in *Le Figaro* newspaper allows him to perform within a social context wider than his immediate self or surroundings. His understanding of this operation rotates specifically around the reproduction of his name in print:

> I saw at the same hour my thought – or at least, failing my thought for those who were incapable of understanding it, the repetition of my name and as it were an embellished evocation of my person – shine on countless people, colour their own thoughts in an auroral light which filled me with more strength and triumphant joy than the multiple dawn which at that moment was blushing at every window.[18]

The narrator is caught up not with the success (or more pertinently for this particular narrator, the failure) of his writing, but rather the literal fact of its multiplication:

> I made up my mind to send Françoise out to buy more copies – in order to give them to my friends, I would tell her, but in reality to feel at first hand the miracle of the multiplication of my thought and to read, as though I were another person who had just opened the *Figaro*, the same sentences in another copy.[19]

The narrator's desire to read 'as though I were another person' his own article – his own name – is his desire to witness firsthand his existence in social space. Again the analogy of the mirror is useful: we look in the mirror to check that we look OK, but also to check that we still exist.

The narrator of *A la recherche du temps perdu* separates himself from his printed namesake, a namesake whose printed presence then validates his own existence. But while there are two namesakes in this model – the name of the narrator and the printed name – there is only one corporeal

body. The self-validation offered by the name in print is problematized as soon as the uniqueness of the name is lost. The acknowledgement of a namesake – a corporeal other with identical nomenclature – invalidates, or at least destabilizes, the referential function of the personal proper name through the multiplication of the referent. Put simply: it is no longer necessarily clear to whom the name refers.

It becomes apparent that Joshua Sofaer really is well in there with Jews for Jesus. The promotional literature of the organization, entitled 'Not Ashamed', describes him as 'one of the next generation' who 'has a key role in charting the future of the movement'.

So there is this guy who stands over there looking back at me with my name. He has me intrigued and he leaves me feeling a bit uneasy. I send him a long rambling email, arrange a time to visit, and fly out to New York to meet him.

I hadn't really a clue what we were going to talk about (despite the fact that I had sent him an eight-page document of questions which covered everything from nicknames he was given as a schoolboy to what his career goals were). When I get out the family tree, pretty soon we realize that we are related. We share a great-great-grandfather in mid-nineteenth-century Baghdad. Our great-grandfathers worked together in the Sofaer grocery store in Rangoon.

We are family!

There are (at least) two ways in which we might live our names. The first is in terms of the etymology of our names – what our names literally mean – the second is the intersubjective meaning, which is to say the assumptions or understandings we make when a name is introduced to us. 'Joshua' and 'Sofaer' both have their etymological roots in Hebrew. Joshua means salvation – literally 'salvation from God'. It has the same root as Jesus. Sofaer is the Hebrew for scribe. The Sofaer is the person who writes and repairs the Torah, teffilin and mezuzah, the holy texts of Judaism.

For Joshua Sofaer there is a dynamic conflict in the etymology of his name, which encompasses his whole cultural identity as a self-identified Jew

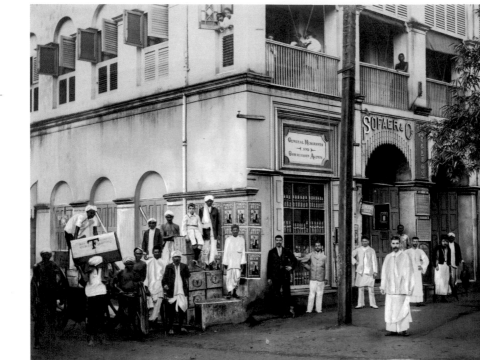

Sofaer General Merchants
& Commission Agents,
Rangoon, Burma c.1908

who believes in Jesus. On the one hand 'salvation' from 'Joshua' corresponds to his work as a missionary, and on the other he has the original order of ancient Judaism in the role of the 'Sofaer', the vocation of his forefathers. He lives in two cultural worlds and, by his own reckoning, doesn't really fit in either of them. He is living his name. Everything he stands for is embodied by 'Joshua' and 'Sofaer'; not only that, he thinks so too.

The way that 'Joshua' has meant something to me was by its difference. I was so conscious that my name announced my Jewishness when I was growing up that I took it for granted that the same thing would be true for my elder sister Joanna. It was only years into this belief that I came to understand that there is no Joanna in the Old Testament at all. The way in which I live 'scribe' is through the putting of words on a page. Writing, among other things, is what I do.

So there you have it. After our first face-to-face encounter it seemed like both Joshua Sofaers were performing their names differently and, yet, the same.

Comedian Dave Gorman and filmmaker Alan Berliner have both made works about their namesakes: *Are You Dave Gorman?* and *The Sweetest Sound* respectively. Both Gorman and Berliner go about collecting as many namesakes as they possibly can, using all the contemporary technical search resources open to them (the internet, email, postal directories etc.).

For Gorman, the task of collecting Dave Gormans originates in a bet with his friend and eventual collaborator Danny Wallace. Danny drunkenly bets his mate that he will never meet another Dave Gorman and that there probably aren't many more in the world anyway. Dave sets about proving him wrong. What starts at first as a laddish jaunt turns into an obsession, becomes a performance routine, a television series on BBC2 and eventually a book.[20] Fifty-four Dave Gormans later, Wallace agrees that his mate has won the bet.

The script of the performance and the book are littered with references to the accumulative nature of the project. Gorman is only interested in racking up the Dave Gormans to prove a point. The imperative rotates around a notion of 'pride'; he must win the bet.

> How was Dave treating it now? Self-discovery? A search for identity?
> To feel he wasn't alone in the world? That there were others out there with something fundamental in common with him?
> Bollocks.
> He was doing it to prove me wrong.[21]

There is a wilful rejection of any attempt to understand what might be at stake in the project beyond the bet:

> Although they offered us exceptional hospitality, we were men on a mission, and we couldn't stop for long. We had more Dave Gormans to find today, and a very tight schedule to keep.[22]

But what starts as a project pursued for its absurdly obsessive comic value ends up problematizing the easy correspondence between a signifier and its identity that Gorman had once felt:

> Before all this started I was Dave Gorman. Now, I was only *a* Dave Gorman. Those two words that had once defined me now merely defined a subset to which I belonged. I was one of many. [...] What did Dave Gorman do?

Anything. Who was Dave Gorman? Anyone. Where did Dave Gorman live? Anywhere. My name meant everything and nothing.[23]

The journey which Gorman undertakes to assert his will and power – that he was right – ends up (albeit within the comic narrative) by robbing him of the unique performative power of his name and thus his self-assurance of who he is.

Berliner starts at the conceptual point where Gorman concludes. His imperative is one of existential questioning: 'What can they be doing with *my* name? Are they better Alan Berliners than I am?', will 'the other Alan Berliners look more like Alan Berliner than I do?', 'Who knows if my life would have been different if I'd had another name'.[24]

Berliner's film is autobiography, psycho-philosophy, social history, and investigates the relationship between authorship, performance and the personal proper name. He allows his personal quest to open up a discourse on the ontology of personal proper names and investigates the form and context of names within North American culture. The film revolves around a dinner party he holds for the twelve other Alan Berliners that he has contacted (or Allan, Allen or Alain Berliners). He asks them questions about their likes and dislikes, habits and activities in a comedic, pseudo-scientific (perhaps disingenuous) attempt to find commonalities relating to 'Alan Berliner'. But whereas Gorman starts with a banality – a bet – and ends up questioning the currency of his personal nomenclature, Berliner, having started with such questions, concludes with the disappointment of the banal:

So if you're feeling a little let down because you expected some big revelation from my dinner party, imagine how I feel. All that preparation and anticipation... and for what? I still have to share my name with them. I'm probably still going to be mistaken for them. And it seems I'm destined to be the real Alan Berliner in my mind only. But please, don't think of my experiment as a total failure.

Berliner hopes for an epiphany in understanding the condition of the namesake but the actuality falls short of his expectations.

Although he never overtly states his imperative in such terms, Berliner hints at the initial source of his enquiry being rooted in a direct confusion between himself and one in particular of his namesakes;

what he describes as the 'ultimate embarrassment': the confusion between himself and another Alan Berliner, another filmmaker.

> A few years ago someone with my name made a film called *Ma Vie en Rose*. The critics loved it. I loved it too. That's when everyone hailed my debut as a feature film director. No one ever did bother to ask why I would suddenly start making films in French. There might even be a few people watching right now who think this is one of his films, or that I'm him or that he's me.

Later on in the film he alludes in the voiceover, with some irony, to that particular Alan Berliner in shot:

> That's the other filmmaker, the one in black. He even looks more like a filmmaker than I do.

Perhaps the search and research for all the other Alan Berliners in the world ('I can't stop thinking of them as the competition') is less about trying to establish his own identity and more about trying to dilute the cultural power and recognition of his most famous namesake: the other filmmaker, the Alan Berliner who has been critically acclaimed for his larger scale, bigger budget feature.[25] By authoring a film about the name 'Alan Berliner', by employing the other Alan Berliners as actors in his narrative, Berliner asks his namesakes to perform *him*. Their doubling, which would ostensibly negate the possibility of any authentic original 'Alan Berliner', paradoxically enforces his role as auteur and assures the authorship of his filmic performance as *his*.

For Gorman and Berliner, both of who are making their respective works at the *fin de siècle* – a time of massive public interest in personal history and family heritage – the acknowledgement of the multiple existence of their name problematizes what is for all of us, the contested and fractured space of identity recognition. The familiar becomes unfamiliar; the unfamiliar becomes familiar. As Hillel Schwartz comments in his extended study of 'copies', *The Culture of the Copy*:

> Powerful stuff, these namesakes, despite our insistence that individuals make their own waves in the world. Given a culture that reveres originals yet trusts that copies will more than do them justice, the blessing of a name is inadequate to its burden.[26]

The multiplication of the personal proper name forces us to question those attributes contemporary Western society holds close: individuality, self-determinism and difference.

In his much-quoted essay 'The Work of Art in the Age of Mechanical Reproduction', an essay which continues to provoke a discourse on the relationship between the object and its double, Walter Benjamin argues that the reproduction of the artwork radically affects its aura.[27] Benjamin defines aura as the 'historical testimony', the 'authority', something tied to 'presence' and yet also with a 'unique phenomenon of a distance, however close it may be'. For Benjamin, mechanical reproduction marks the destruction of the aura of an artwork but he also sees this destruction as 'a symptomatic process whose significance points beyond the realm of art'. Aura, as Benjamin sees it, cannot be reproduced. Andy Warhol might ultimately agree with Benjamin that aura is present in the historical testimony of the object, but for Warhol, mechanical reproduction is crucial to the cultural comprehension of aura, insomuch as it is mechanical reproduction (print, photography, television, film) which goes to hype the 'authentic original'. This is true not only for artworks but for people as well.

> Some company recently was interested in buying my 'aura'. They didn't want my product. They kept saying, 'We want your aura'. I never figured out what they wanted. But they were willing to pay a lot for it. So then I thought that if somebody was willing to pay that much for it, I should try to figure out what it is.
>
> I think 'aura' is something that only somebody else can see, and they only see as much of it as they want to. It's all in the other person's eyes. You can only see an aura on people you don't know very well or don't know at all. I was having dinner the other night with everybody from my office. The kids at the office treat me like dirt, because they know me and they see me every day. But then there was this nice friend that somebody had brought along who had never met me, and this kid could hardly believe that he was having dinner with me! Everybody else was seeing me, but he was seeing my 'aura'.[28]

Warhol separates seeing and knowing (that is, being familiar) through time as the key factors that affect aura. To know someone (well) is to negate the possibility of seeing their aura. Aura for Warhol is eradicated through familiarity.[29] What goes to create aura, however, is not so much

the not seeing, as the seeing but not knowing. And this kind of seeing without knowing, without one-to-one familiarity, is what mechanical reproduction through mass media offers. This is, after all, how celebrity is created.

What happens to aura and the authentication of the original when there is a namesake; not a reproduced copy, but another authentic original? Benjamin says that there is no point in asking for the authentication of the original of an artwork that is designed for reproduction:

> From a photographic negative, for example, one can make any number of prints; to ask for the 'authentic' print makes no sense. But the instant the criterion of authenticity ceases to be applicable to artistic production, the total function of art is reversed. Instead of being based on ritual, it begins to be based on another practice – politics.[30]

Following this argument through, it makes no sense to ask who is the authentic Dave Gorman, Alan Berliner or Joshua Sofaer. All subjects with the same name have equal authority to authentication and it is perhaps this that is the most destabilizing aspect of the namesake in a culture which places such importance on 'individuality'.

And yet there are desperate attempts within the artworld to authenticate the original, often for reasons of commerce. To continue with Benjamin's example of the photograph: particular photographic prints *are* accorded the status of authentic orginal. Sherrie Levine's photographic practice of directly appropriating existing images – literally photographing a photograph without any transformations or additions – not only questions the authorship of the image, but also further complicates Benjamin's statement that there is no authentic print.[31] Through limited editions, the inclusion of the artist's signature, the quality of the paper, there is a hierarchy which is often couched in terms of the original and its copy.

This hierarchy is also manifest in the deployment of personal proper names. Celebrity culture might tell us something about the way in which the contemporary West views the interchange of naming and mechanical reproduction. This takes us to Benjamin's second proposition: that when authenticity ceases to be applicable, the function

of art is reversed from ritual to politics. It is the de-politicization of mass media and what Jacqueline Rose calls the 'murderous'[32] culture of celebrity that has re-reversed the equation and brought ritual into the culture of reproduction. Fans who chant 'there's only one David Beckham' to José Fernandez Diaz's *Guantanamera* are not trying to claim that there is only one person in the world who has, or has the right to, that personal proper name, but rather they are making a desperate attempt to authenticate the particular David Beckham that they revere. The phrase 'there is only one David Beckham' de-authenticates other people with that name. Ironically it is the reproductive industry – mass media – that gives Beckham his status as authentic original. As Ellis Cashmore points out:

> the national media ensured that the name 'Beckham' made its impress on the public consciousness. Widespread interest in, and consumption of what many took to be, a 'wonder goal' guaranteed Beckham an audience.[33]

The link here between mass media – the reproductive machinery – and the aura of the authentic original David Beckham is one of cause and effect. No media, no aura. Indeed Cashmore takes this one step further by asking us to consider that the forms of reproduction are in fact the only David Beckham that there is:

> is there actually anything apart from the Beckham served up on our TV screens and in print?[34]

The religious attention of the 'fans' who devote themselves to the Beckham cult worship the aura which emanates from the icon. It is no surprise that this is the word we use to describe those players who have reached the zenith of celebrity – icon – a word that is both authentic embodiment (the one and only David Beckham) and reproduction (the printed and televised image) simultaneously.

Celebrity is a useful tool for gauging what is at stake in the namesake because of its preoccupation with singularity and uniqueness. The ultimate in celebrity recognition is that of single name signification.

> Single name fame is probably the zenith of global celebrity. Elvis, Marilyn, Pelé, Jesus: they exist at a level somewhere above the usual layer of celebs where the mention of one word provokes instant recognition.[35]

Single-name fame is the zenith of global celebrity – the thing contemporary Western society rates so highly – because it is a sign of recognition and success. Part of the cachet of single-name fame is the risk it takes in reproduction. There are many fewer Marilyn Monroes than there are Marilyns. By existing as a single-name celebrity you raise the stakes by asking people to identify the signifier 'Marilyn' with the particular Marilyn: a film actress Marilyn Monroe whose major output was in Hollywood comedy in the 1950s etc., etc. If the single-name celebrity can survive the namesake test then they are perceived as having 'made it'.

Having a namesake then, is a threat, because it forces the question: *do we know to whom you are referring?*

Perhaps the metaphorical model that Poe articulates in *William Wilson* is actually the most adequate to describe the literal namesake too. The namesake becomes our social conscience, always there to remind us that our 'individuality' is a fragile construct ready to shatter at the calling of another who shares our name.

Joshua asks me if I would like to accompany him the following Sunday on a deputation to a church in the Bronx. A deputation is when a member of Jews for Jesus goes out, most frequently to other evangelical churches and organizations, to drum up support; that is, financial as well as spiritual support. I stood on the step to Joshua's apartment on Sunday morning feeling much less nervous than I had at our first meeting.

'How do we get there?' I asked.

'We're gonna drive,' he said, pointing to a slightly battered jeep with a massive logo emblazoned on the side which read JEWS FOR JESUS.

Why is it that getting in that jeep was so uncomfortable?

We drove due north of Manhattan for some time, me sitting next to my namesake in the Jews for Jesus jeep, nervous again, as Joshua recounted stories of how people have tried to veer him off the road in response to the logo on the side, and I get thinking about the possibility of being mistaken for him by the angels of death if there was to be an accident, and then I

decide that actually they are just as likely to come for me as for him and that the confusion could work to my advantage, when finally we end up outside a small brick and wood Baptist Evangelical Church in the Bronx.

After some singing and shaking of hands I glance down at the order of service and in an instant of horror and excitement see that I am due on stage after the next hymn. 'Sermon – Joshua Sofaer'. The horror and excitement quickly dissipates. My namesake gets up and talks about the Jewish origins of the feast of Pentecost. He was a good performer, a confident speaker; we certainly both crave an audience. But what struck me more than anything in witnessing my namesake witnessing to this Baptist congregation was how 'Jewishy' he was. It was kind of like watching Woody Allen in a nativity play. And I realized that regardless of his belief, Joshua Sofaer really was performing in two different worlds.

In the jeep on the journey back to Manhattan we start to talk in more depth about his beliefs. Without the theological knowledge as ammunition it becomes difficult to challenge him on his own terms. I am frustrated that he remains so assuredly unmoved by my arguments. What also becomes clear is that as far as he is concerned it is not necessary that I agree with him. How could it not be imperative for him to need me to agree with him? I really didn't understand because I did need him to agree with me. It wasn't enough for me to simply lay out my views on a market stall in case of any takers. And I suddenly realized, and I told him, that maybe, after all, it was me that felt the need to convince, that contrary to the assumption, it was me that was the proselytiser. And I began to wonder: who's performing whom?

NOTES

1 Julian Wolfreys, *The Derrida Reader: Writing Performances* (Edinburgh: Edinburgh University Press, 1998), p. 17.

2 Sigmund Freud, *The Psychopathology of Everyday Life*, Standard Edition Vol. 6 (London: Vantage, 2001), p. 25.

3 Jews for Jesus rose out of the ABMJ (American Board of Missions to the Jews) and was formed in 1973 by Moishe Rosen in the San Francisco Bay area of the USA. Its stated focus is to proclaim Jesus of Nazareth as Messiah to the Jewish people. They do this through on-street evangelism, advertising campaigns and educational programmes. It is not a church. They have no religious leader. By 1996 they had an annual budget of over 13 million US dollars, 80 per cent of which came from individual donations. The existence of Jews for Jesus has led to counter-missionary organizations such as Jews for Judaism, which oppose Jewish evangelism. Jewish evangelism is also officially opposed by most mainstream Christian Churches including Lutheran, Methodist and Episcopalian branches of the Church, the Church of England and the Catholic Church. Jewish evangelism is widely supported by Baptist Churches.

4 I went to see him a second time and to record further interviews in January 2004.

5 Plato, *Cratylus*, trans. C. D. C. Reeve (Indianapolis: Hackett Publishing, 1998), p. 78.

6 Sharon van Guens, 'Patient died after drugs were given to namesake', *The Evening Standard*, 1 November 2001, p. 9.

7 Benzion C. Kaganoff, *A Dictionary of Jewish Names and their History* (London: Routledge and Kegan Paul, 1978), p. 112.

8 Edgar Allan Poe, *Visions of Poe*, ed. Simon Marsden (Exeter: Webb & Bower), p. 34.

9 Attributed to Chamberlain's *Pharronida*. [This is disputed. See Daniel Hoffman, *Poe Poe Poe Poe Poe Poe Poe* (Louisiana: Louisiana State University Press, 1998) p. 212]. Poe, *Visions*, p. 24.

10 Poe, *Visions*, p. 28.

11 Poe, *Visions*, p. 24.

12 Poe, *Visions*, p. 25.

13 Hoffman, *Poe*, p. 209.

14 Or at any rate in its first printing in 1839. 'Poe kept moving his birthdate forward, in successive magazine biographies, in order to seem younger than he was. So, it appears did William Wilson.' Hoffman, *Poe*, p. 210. The fact that Poe went to the trouble of altering his character's birthdate alongside his own stresses the importance of the autobiographical reference.

15 Even the briefest biography of Poe will give these details. See for instance Hoffman, *Poe*, p. 210.

16 Jorge Luis Borges, 'Borges and I', in *Authorship: From Plato to the Postmodern, A Reader*, ed. Seán Burke (Edinburgh: Edinburgh University Press, 1995), p. 339.

17 See Judith Butler, *Excitable Speech: A Politics of the Performative* (London: Routledge, 1997).

18 Marcel Proust, *In Search of Lost Time*, Vols 1–6, trans. C. K. Scott Moncrieff and Terence Kilmartin, rev. D. J. Enright (London: Vintage, 1996), Vol. 5, p. 652.

19 Proust, *In Search of Lost Time*, p. 653.

20 All quotations are taken from the book, which to a large extent repeats the television script.

21 *Are You Dave Gorman?* is co-written by Dave Gorman and his friend and collaborator Danny Wallace. This quote is from Danny Wallace. Dave Gorman and Danny Wallace, *Are You Dave Gorman?* (London: Ebury Press, 2001), p. 126.

22 Danny Wallace. Gorman and Wallace, *Are You Dave Gorman?*, p. 222.

23 Dave Gorman. Gorman and Wallace, *Are You Dave Gorman?*, p. 304.

24 All quotes transcribed from the film *The Sweetest Sound*, dir. Alan Berliner, Cine-Matrix, 2001.

25 Perhaps after all, just as the name speaks more of the namer than the named, I betray more about myself than Alan Berliner by this comment.

26 Hillel Schwartz, *The Culture of the Copy: Striking Likenesses, Unreasonable Facsimiles* (New York: Zone Books, 1996), p. 338.

27 Walter Benjamin, 'The Work of Art in the Age of Mechanical Reproduction', in *Illuminations*, ed. Hannah Arendt, trans. Harry Zorn (London: Pimlico, 1999), pp. 211–44.

28 Andy Warhol, *The Philosophy of Andy Warhol* (Orlando, FL: Harvest, 1975) p. 77.

29 Familiarity is not the same as exposure. Familiarity depreciates aura but exposure through reproduction is the food of celebrity. Familiarity enables a knowledge not acquired through exposure.

30 Benjamin, 'The Work of Art', p. 218.

31 For a discussion of Sherrie Levine's practice see Douglas Crimp, *On the Museum's Ruins* (Cambridge, MA: MIT Press, 1993), especially pp. 126–48, 'Appropriating Appropriation'.

32 Jacqueline Rose in conversation with Marina Warner, South Bank Talks, The Purcell Room, 28 January 2003. Rose described the culture of celebrity as "murderous" because it sets up celebrities only in order that they should later be shot down.

33 Ellis Cashmore, *Beckham* (Cambridge: Polity Press, 2002), p. 20.

34 Cashmore, *Beckham*, p. 44.

35 Cashmore, *Beckham*, p. 43.

3

A Great Technician
Document, Process and Persona in Performance and the Everyday

RICHARD LAYZELL

A conversation between (in order of appearance) Richard Layzell, Ivan Curtin, Bailey Savage, Yves Klein, Harry Shunk, Shelley Sacks, Joseph Beuys and Tania Koswycz

In the course of developing a process-based installation for Firstsite[1] in 2002, I invented four artists, their studios and subsequently their artwork. While constructing the assemblages of one of these imaginary artists, Tania Koswycz, I discovered an ease of invention that was unnerving. Her work was actually more straightforward to make than my own. The adoption of this device – stepping outside to look askance – marked the beginning of an ongoing relationship. After the exhibition opened I intermittently continued to produce her work. Subsequently she has become a friend, critic and collaborator, although I've not had the desire to personify or perform her. She is not a persona to occupy, like Bailey Savage[2] or Max Hombre.[3] Our conversations are occasionally made public[4] and her presence continues to evolve. What initially appeared to be a diversion has become central to my recent practice.

Talking to Tania is a process of negotiation and enquiry. I've adopted the dialogue as a form or framework, which can unpick, deviate and stimulate. For this conversation I've invented Ivan Curtin. Ivan is the performer who is myself in the global site-specific work *International Cleaning*. By separating out the performer's experience from the artist's, issues of temporality, documentation and the position of live practice

emerge. And others may want to join in. This also reflects Bakhtin's view of the dialogic imagination and the heteroglot novel. His definition of dialogue is that 'there is no existence, no meaning or thought that does not enter into dialogue or "dialogic" ("dialogichekeli") relations with the other, that does not exhibit intertextuality in both time and space relations.'

RL I'm ready, are you?

IC Can we talk about this?

RL I thought we had. The camera angle is good now. The tripod is discreet. We've been through your actions and where the lens frame ends. So you know the physical boundaries. If people start to notice us talking they'll realize something's going on.

IC It's all camera, camera, camera with you this morning. For me the gloves are an important issue.

RL The gloves?

IC Yes. I haven't worn gloves before for *International Cleaning.* I look like a doorman, a commissionaire. Do we know if they have commissionaires in Prague? And these are more like workman's gloves, confused messages here.

RL It's not that important, Ivan. People watching the video will know about commissionaires, they'll make the references. You look smart. You're wearing white gloves, locally purchased. You'll be brushing an area of the square in front of a building that could be a hotel. That's enough.

IC It's important to me, Richard. This action is about to happen on a weekday morning in the centre of Prague and I'll be experiencing it

1 *International Cleaning*
Prague 2001, video stills

2 *International Cleaning*
Prague 2001, video stills

with the passing audience who witness it or take it in unconsciously. Do you want your precious art audience back in Western Europe or on the worldwide web to think this was staged?

RL How it appears now doesn't matter so much. The documentation becomes the work with longevity.

IC I can't accept this. It goes against all that we've talked about in the past. Aren't you getting seduced by dissemination? Or do you just want to get on with it and are trying to shut me up?

RL I thought we were ready to go. I guess I am in directorial mode a bit. Fair enough. Mind if I have a cigarette?

IC You don't smoke.

RL Metaphorical. I'll cover up the camera. The moment's passed. There'll be another one. It's important you feel comfortable with this. I'm relying on you.

IC So?

RL So both the dimensions of this very simple event are equally important.

IC Then why do I feel marginalized?

RL But you're absolutely central, Ivan.

IC That's not how it feels at the moment. I'm focusing on the actions that we discussed, on getting in a physical and mental state to carry out the 'cleaning' as an act of not-performance that will resonate around this environment and its occupants. Why not leave the camera out of it now and again? It seems to be in control of everything, more than you and me.

RL Well, then there'd be no record of your actions, the action, the event.

IC And what difference would that make?

RL It's all relative, Ivan. I guess the global nature of *International Cleaning* is central to the concept for me. The more locations the bigger the impact.

IC On whom?

RL On the audience, on the overall concept.

IC Which audience are we talking about? The one I'm dealing with in the here and now, or the one looking at the website or the edited video?

RL The latter, I guess.

IC Exactly. Look at it from my point of view. I'm a performer. I take it seriously. I do research. I try to get inside your head. I think we are collaborating on this. At least that's what you lead me to believe. You're the artist. You make these constant references to 'documentation', which I struggle with. The issues that interested me in exploring this project with you were: the subliminal nature of these actions in public places; the areas between performing and not-performing or 'working'; the invisibility of these actions; the status of the cleaner in global society; your broader ideas about 'changing the world in small ways'. I can relate to these. But here we seem to be endlessly talking about the camera.

RL We're in the pressures of the moment, Ivan, trying to make it happen while the opportunity is there. All those references and intentions are still present. But I need to have an eye on the bigger picture as well.

IC Is this about money?

RL How do you mean?

IC This fixation on documentation, the evidence. So one day these remote scrappy images might be marketable? Performers don't have this obsession with evidence. The event is enough. Or is this how you justify it as 'art'? There has to be some kind of visual statement or accompaniment. Is it a way of clinging on to a visual language when in fact these actions are just that, no more no less?

RL Have I upset you?

IC No. I'm just trying to get to the bottom of it. I usually find you quite evasive about this. Maybe I should have mentioned it before. I'm frustrated.

RL I suppose it's always been there for me, as an issue. But it's not about posterity or the art market. It's a problem to resolve. And I'm continually trying to find a solution.

IC Are you any closer?

RL I think so. It began early on, after my first installation, when Malcolm Hughes[5] talked to me about the need to make sense of it, and the only way to do this was to examine documentation. In response I produced a carefully crafted book, with working notes, reflective text and photographs. And spent far longer on this than on the work itself. A later breakthrough came in writing and compiling *Enhanced Performance*[6] and working with Deborah Levy as an editor and mentor. For the first meeting at her house in Holloway I nervously handed over a pile of black and white photographs and a few tight-lipped typed pages. She suggested I go away and write freely, as much as I could. I felt like a first year creative writing student.

IC And did you?

RL At the next meeting I had something like a hundred pages of text. The photographs weren't so significant by then.

IC So is *Enhanced Performance* about documentation or story telling?

RL They amounted to the same thing in the end.

IC And was this a relationship to documentation?

RL Absolutely.

IC Through text?

RL Text and image. Deborah's interventions were simple but incisive. She encouraged me to list the materials used in each work, as if they were gallery pieces. She also suggested I choose six or eight significant photographic images and write in detail about each one.

IC This wasn't obvious to me, from reading through it.

RL It didn't need to be. The important thing was that it stimulated a sense of reflective detail, to glean as many grams of stuff from one image, one moment, in effect.

IC Can you point one of these out? Do you always carry a copy around with you, by the way?

RL Usually. You never know. OK, here's one: it's a colour photograph printed from a transparency of Bailey Savage in his boat, taken by the sculptor Jo Stockham. Here's what I wrote about this image nine years later:

As Bailey Savage in London, several weeks after the Cambridge campaign, he is in another place, over the edge, no longer any pretence of normality. He walks around the private view of 3D '89 at Watermans Arts Centre

inside his boat, still talking about revolution and ma (Margaret T.), announcing the imminent launch of the boat he wears, named in his honour, 'The Bailey Savage'. Trapped inside this wooden construction there was no pretence or assumption of real power as there had been in Cambridge where truth and fiction were at times uncomfortably indivisible. Here I was visually a victim of my own folly, a man in a boat that won't float. Or will she. 'I know what you're all wondering ladies and gentlemen, will she float?' I walk down from the Arts Centre terrace onto the muddy banks of this Thames tributary, still muttering my slogans, his slogans, green rubber fishing waders knocking together, 'Wee aaar in ay revoloooshun heeyaaarr in Britt'n and izn't it marvellous, will she float?'

I start to feel alone, remote from the crowd watching, wondering if I have the nerve to do this. The painful side is the implicit ridicule of manhood contained within this political pillorying. I feel like a complete jerk. But I'm doing it for art and for the collective release of the desperation withheld in this current political climate where there's so little questioning, keep your

3 Bailey Savage

head down and sell, sell, sell. The straps holding the boat are pulling on my shoulders, I wish they'd been the same colour as the suit but the construction itself is a practical success, I can walk. The water is so shallow I'll have to go further out. In reality I'm looking for a large puddle deep enough to sit in. Will I be able to manipulate my legs inside the thing and actually sit down? Here goes. 'Yes, she floats!'

The look of triumph in the photograph belies how I was feeling. This image succeeds so well for me because it demonstrates what I wanted the performance to achieve and didn't feel – being within it – that it had. The surrounding landscape puts him in perspective, overtakes him, dilutes the monster down, 'Shut up, Bailey Savage.'[7]

IC There's something missing. You talk about what was happening more than the image itself. Here, this morning, you're fixated on the image and don't seem so interested in the intricacies of the action, on my performance.

RL That's not true, but there is something missing, you're right. Something about the nature of the technology, or the image, or the transaction. That kind of 35mm photograph was the common currency then. The quality of colour, the grain, the composition...

IC So you'd write differently about it now.

RL Inevitably. Reflection is a historical moment in time as well. You might just as well wonder what he'd say now?

BS I went a bit off the rails there. It was over-work. I took a holiday. I'm pleased to be appearing in a new TV series that puts young business minds through their paces. The world is changing. Business is back. It never actually went away. Nor did I. I still have a keen interest in the arts. I'm pleased to say that some of my recommendations have been translated into current Arts Council policy. I've become quite pally with Ken Livingstone. We chat about London Underground and the PPI. I see the alliance as a potential power base. Not political but strategic. I've put a bit of cash into

the Olympic bid, although my name counts for more than the money. Delighted by the success of YBAs, although they're not really my thing. Got a couple of Peter Howson's and a John Bellany. Still have an office in Edinburgh. I remain an icon of good sense and great taste. I've joined the Board of Tottenham Hotspur. Focus on my mouth and you'll prosper. Stick with my conviction and you'll like it. Just look at me. I'm gorgeous.

IC Right.

BS Did I give you my card?

IC No. Is it as easy for you to see his perspective as Tania's?

RL Probably.

IC Can we go back to the photo.

RL Which one?

IC That one of him sitting in the river. It's slightly out of focus.

RL It was taken on the hoof. I just handed my camera to Jo and asked if she could take a few shots. It wasn't planned.

IC And now you have this much reproduced and projected photograph. Did you choose to write about this particular one because it originated spontaneously, and was taken by a fellow artist?

RL I try to aim for a random quality in documentation that reflects the process of the action. Although I've been talking about the camera a lot here in Prague, once your action begins I'll walk away and leave it running. I don't want to be seen peering through the lens, although the advantage of using a small digital camera like this is that I could easily pass as a tourist. Then there's how the technology has moved on. Still images from this movie can be extracted as jpegs and posted

on the web or animated. And the video itself can be copied endlessly, without quality loss. This is all relatively new. So the relationship to the document changes as technology evolves.

IC Have you ever actively collaborated with a photographer, or an artist/photographer, as Yves Klein did with Harry Shunk? Impressed?

RL Very. Yes, with Edward Woodman a couple of times and Gary Kirkham. I wrote a commentary on different categories of relationships between photographer and artist called 'Photography of the Moment'.[8] I unearthed six different relationships. This one, working with an artist/photographer, was the second in the series. It's a very particular and dynamic experience. I feel I'm manipulating the situation, making works for the camera and also with the photographer. Yves Klein went further. He was also creating his image I think.

YK Of course I was creating image and also myth. My art is divine, superhuman, sublime. The photograph was one of my tools to achieve this. Harry was a great technician. And it was his choice to work with artists. He pursued us. He attached himself to a number of galleries and later worked with Christo.

HS And Jean Tinguely. I was even part of the Tinguely set for a while. It just happened. Very exciting. Later I worked with Vito Acconci and some of the New York conceptualists. My mentor, the Austrian photographer Dora Kallmus, encouraged me to go in this direction. I was only 15 when I became her assistant. She was 86. So I listened. She said if I made mistakes with artists they'd probably find the results interesting.

YK Not in my case. I wanted perfection, and levitation, which we achieved. It looked effortless. I was elevated. Harry was stretched. Did you imagine your photographs would become such universal currency?

HS It just happened. I went along with it. It was a technical challenge that came from you. I knew they were good pictures. That was enough

for me. Some people refuse to believe that 'Leap into The Void'[9] was a photomontage. That says something about technology and myth. The images live on.

YK It was always partially about immortality, beyond levitation. The perfect blue was the perfect glue to bind the publicity to myself and my image. My name itself conjures up images in your mind. Is there a French artist to follow me who captures your visual memory in the same way? I doubt it. In my case the photographic record is stronger than my extant works, as I intended. The photographer unknown. The artist unforgettable. The blues run all over me.

RL Some of the images of Joseph Beuys are equally iconic: the fur coat, the hat, holding a dead hare.

IC Emblematic? Or great PR?

RL Shelley[10] would have an opinion on this. She worked with him for over a decade.

SS Beuys' clothing was used neither to create an image nor a persona, in the sense that those terms are currently used. It was part of his work, his art. He was as aware of the media as anything else. He believed in using everything. It was all functional. If it's there, use it, he would say. Everything was practical: the hat, the clean white shirt to appear smart in, the denim, the boots. Each item worked for him. He started wearing a hat to protect the opening in his head from a war wound. He never took it off in public. He also liked the Homburg and its relation to gangster movies. His jacket was his cupboard, with all the pockets where he kept his knives and pencils. The first social sculpture is yourself. The goal is to make yourself into a free human being. Everything is consciously chosen, without habit, free conscious action...

JB I consider my physical appearance as one of my most carefully crafted artworks. I am responsible for my bone structure, my profile

and my clothing. We are all responsible for each detail. But I've been accused of creating a mystique about my personal history that has fed into my status as an artist. This is a misunderstanding. My personal and cultural histories are interwoven. I'm sometimes identified with what has been projected onto me by others. This often has little relation to who I am. They may use the word 'image'. For me the trickster archetype is more accurate.

RL Your image was and is so powerful. If you'd worn suits and not made 'actions' it may have been a different story. I experienced what you've described at secondhand. I remember it vividly.

JB Yes?

RL Does the name Ted Johnson ring any bells, early 1970s? He was fixated on you.

JB Possibly, I'd need to see the face. But the story has begun.

RL Ted was from Liverpool. I knew his art school friends, Terry and Ken. Ted's artwork, such as it was, repeated his name endlessly – Ted Johnson, Ted Johnson, TED JOHNSON, along with passport photos of himself and some printed stars ★★★★★. His name was his art. His photo was the art. He was the art. He was aiming at an art star before we knew they were there. He made sure his name spread around the art world. He mailed out his pages everywhere. You probably received a bucket-load.

JB Maybe. But why did he choose me?

RL You were the artist of the day with the big persona, so naturally he wanted to learn from you, to find out how you did it. Somehow he would get to Düsseldorf and study with you at the Academy, or find a way of being around you. He started language classes and moved to Germany with his wife and stepdaughter. It was a serious project. I heard about

what happened from Terry. He went out to visit Ted with Ken, who was making films by then. They took a 16mm camera and a tripod with them. Maybe everyone would get to be famous by being around you, by brushing off of you. But it needed a bit more and would you agree to being in the film they had in mind? You must have agreed to something because I remember seeing the footage. The 'bit more' turned out to be a revolver. You were invited into a room where the camera was set up. You sat down. Ted was already there, and then Ken brought out the revolver. I remember the look on your face on film. Or maybe I imagined it. Was this harmless boys' stuff or a disturbing and abusive power game?

JB When you sign your name it's an artwork. He was right. But this action with the revolver was an encroachment. It was the price I sometimes paid. I did not ask for this. I did not look for fame or success, only conscious action. The power in the work and in the person is the secret. In the universities an enchanter has to appear. The mysteries take place in the main station. Do you know what became of him?

RL I think he's an architect now.

JB Famous?

RL No.

JB Ah.

IC Are you saying that the image is incidental but the document is central?

JB I'm saying the power in the work is the secret. Was the power in his work? It's movement that's key, arousal, heat processes, a sense of activation.

IC If movement is key, why are the photographs of your 'actions' so important?

JB They are no more important than anything else. By its nature the photograph creates stillness out of movement. It becomes another kind of work. I worked closely with certain photographers because the opportunity was there. I was conscious of these decisions, but I wasn't manipulating the media more than any other aspect of the work. There are actions of mine with no photographic record, or only Richard Demarco's[11] snapshots. Does this make them less significant?

IC That's the question. This is where we started. This is my point. Yves Klein implies that the document can elevate the work.

SS That's a position.

IC And the clothing? Am I wearing a suit today as a political comment or an art comment?

RL I see it as both. But the clothing is a vehicle rather than a core element. Tania often uses clothing as her starting point, her source material. Another approach. We've talked about this. My position is that clothing is a visual material and trigger within the greater whole. Hers is that clothing is the source of identity.

SS So why did you invent Tania Koswycz? Are people interested in her, or in her and you, your relationship?

RL I'm still finding out, Shelley. Last week I gave some talks about my work in Scotland. I'm reluctant to mention Bailey Savage, because usually all the questions are about him. This time they were about Tania.

SS Have you created a presence that's almost independent of you, your own leap into the void?

TK I'm more than a presence. I'm as integrated as Joseph's jacket. I know my mind. I'm not trying to read Richard's. That's Ivan's

thing. We have a different kind of collaboration. If he tries to get in directorial mode with me it doesn't work. I'm an artist in my own right. And I don't have Ivan's issues about the camera. Ted had the right idea, but he didn't have the staying power. Fiction is reality. The media are there to be worked over. Tracey knows the score. Jake and Dinos had Gilbert and George as their mentors. You see how it works. I'm using Richard to further my career. He's using me to further his, although you won't get him to admit it.

RL Nice to see you, Tania.

TK Thought about growing a beard, a goatee, shaving your head?

RL All those, but they don't work for me. For some reason I'm more of an invisible presence, a Mr Normal who fits in.

TK Is that where I come in?

6 *Lighten Up*, Tania
Koswycz, 2002

RL It's where performance has come in. The psychic space of other selves. The personality of the indefinable, unmarketable, political...

TK Calm down.

RL But these are my roots, the platform that launched me into my practice, the challenge to the art market. That quote from Brian O'Docherty sums it up:

> The economic model in place for a hundred years in Europe and the Americas is product, filtered through galleries, offered to collectors and public institutions, written about in magazines partially supported by the galleries, and drifting towards the academic apparatus that stabilises 'history' – certifying, much as banks do, the holding of its major repository, the museum. History in art is, ultimately, worth money. Thus do we get not the art we deserve but the art we pay for. This comfortable system went virtually unquestioned by the key figure it is based upon: the artist.[12]

And some artists choose to challenge this by making unmarketable works.

TK That's old-fashioned thinking. You can't escape the market, and why try?

IC I can't quite see how all this fits into *International Cleaning*.

RL Some of it?

IC But Tania's the antithesis of me.

RL Can you live with that?

IC Can you pay me more?

RL Is this about money?

IC It's about value.

NOTES

1 A publicly funded contemporary art gallery in Colchester, UK.

2 Bailey Savage, successful businessman and entrepreneur, created for 'The Revolution – You're in it!', Kettles Yard, Cambridge, 1989.

3 Max Hombre, 'Le Arie del Tempo', Genoa, Italy, 1998

4 An ongoing series of global dialogues between myself and Tania are intermittently published on www.rescen.net and as a chapter in *Navigating the Unknown* (Manchester University Press, 2006)

5 A British constructivist artist and teacher who set up the Experimental Course at the Slade School of Art in London in the 1970s.

6 *Enhanced Performance* (Firstsite, 1998).

7 *Enhanced Performance*, pp. 63-64.

8 *Enhanced Performance*, p. 82.

9 'Leap into The Void', photographed by Harry Shunk, October 1960.

10 Shelley Sacks worked with Joseph Beuys over a thirteen-year period until he died. She is head of the Social Sculpture Research Unit at Oxford Brookes University

11 Renowned for always carrying a low-tech camera with him, Richard Demarco photographed Joseph Beuys' works, which he commissioned for the Edinburgh Festival, in 1969.

12 Brian O'Docherty, *Inside the White Cube* (Artforum, 1976; Lapis Press, 1986).

4

Vaginal Davis *Does* Art History

ROBERT SUMMERS

Subject: Re: A Letter to My Woman of the Night, Doing Art History
Date: October 08, 2004 11:59PM Fr: Robtsum To: VAGDAVIS

Dear Ms Davis:

I hope that this e-mail finds you well, and I hope that you are having a good day. First of all, I wanted to thank you for dining with me at the Pacific Dining Car the other day. I love how dark and cozy it is in there – just the right atmosphere for chat and gossip.

During our dinner date, we briefly discussed your installation at the Eighteenth Street Art Center, and you said that you showed an 'absurd archive – since all archives are absurd'. I didn't get your comment at first. But now, thinking about it further, I agree that archives are absurd – their truth is nothing more than a fiction (which doesn't mean it doesn't have real consequences) that is passed off as a fact and an objective and accurate record. Thinking about this, I recall the performance you did at the Getty in '99 – where you performed yourself as an absurd sort of archivist. In the Getty's photography gallery, you presented an alternative archive, a verbal one, a temporary one, and you performed a different history that was culled from the objects in the museum. Your performance there could easily be construed as absurd and nonsensical by many traditionalists. But, nonetheless, you did – by your very *doing* of a different art history and a different type of curatorial work – re-order the archive, the museum exhibition, and the history that was presented by your reading of a letter, a scrap of paper, to the audience – as well as the photographs on the Getty's walls. Oh, Ms Davis, I love how you rearrange things in such a way so that the obvious no longer seems obvious and the obscure, or absurd, makes complete sense.

Vaginal Davis, styling
by 'I Love Ricky', make-
up by Glen Meadmore,
photograph © Beulah Love

On a similar note, aren't archivists who *refuse and
resist* to place texts and objects in a teleological order
that will show a proper history performing an act of
absurdity – as you yourself performed one during
your act at the Getty – at least to the protectors of
official museum and archives? But that isn't all that
you meant, is it? No, I think you also meant that all
archives, depending on where you stand (in the
archive, in the world), are always already open to
various and competing readings and histories, and
they are absurd, in a queer way. But, enough of this
for now...

Also, as we discussed the other day, I said that I have
always been troubled by art history – especially the
way it is performed by major museums, 'traditional'
art-historical texts and monographs, and
undergraduate courses. In both the courses that I
teach and the research and writing that I do, I find
myself talking and writing about people, places, and
objects that are never in 'traditional' art history
books, journals, and classrooms, but I guess that is
why I started *doing* art history in the first place – it
needs to dramatically change or be eradicated since
its *modus operandi* is completely outdated, out-of-
touch, and (dare I say) fascist from the perspective of
the 'numerical majority': women, people of colour, immigrants, queers, and
the working class and working poor, which are all those people that go to your
performances, exhibitions, and performative lectures. Just thought I'd share
this (again) ... what's your take?

As ever, Robert

Walking the Museum/Archive[1] – Going to a Performance
When walking a museum or an archive, or, better yet, a museum/archive
– given that both are intertwined: the museum is the three-dimensional
encyclopedia and filing system of the archive, and both are the place of,
the official repository of, the Nation, the Culture, the Society, the People
– I wonder how they can be productively disrupted and re-imagined
through tactics, practices. And this disruption is needed, I believe,

because as it stands now, the museum/archive's scripting and staging of art history and the people of history has fallen short and is no longer acceptable in this era of blatantly intersectional identities, multiple subjectivities and the realization that the subject, Man, has drifted away, as Michel Foucault predicted in *The Archeology of Knowledge*.[2] Indeed, the place of the museum/archive must be productively re-worked as a space of multiple possibilities – all of them competing and shifting, none of then fixed or stable.[3]

Also, drawing on the theoretical work of Michel de Certeau, who has argued that 'place' is a sort of locatedness, which is fixed and controlled, and on the other hand, 'space' is a 'practiced place', which is used by the subjects crossing, occupying and re-using it, I would like to speculate on how the place of the museum/archive can be practised *otherwise* – against the grain – which, even though this has been argued before, seems to have fallen on deaf ears when it comes to the museum/archive and much of art history.

In its relation to place, de Certeau argues, space is like a word spoken 'that is, when it is caught in the ambiguity of an actualization, transformed into a term dependent upon many different conventions' – and so, too, spaces are 'determined' both culturally and historically by subjects, by users. 'Thus', de Certeau argues, 'the street geometrically defined by urban planning is transformed into space by walkers'.[4] Similarly, walkers (and we can say performance artists are walkers) can transform museums/archives.[5] I would like to continue on the thoughts raised by de Certeau, and flesh out how tactics, practices, can aid in the re-thinking and re-imagining of the museum/archive, and thus art history – given they are all intertwined.

For de Certeau, there is a difference between 'strategies' and 'tactics'.[6] 'Strategies' require an institution, an organization, a city and/or a museum/archive that is separated from an environment. Strategies also require a 'proper place' (i.e., a regularized and/or institutionalized location, place). Strategies, then, lie behind political and economic rationales, and institutions chronically and consistently use strategies. On the other hand, 'tactics' have no proper localization, place, and they are not separated from the place in which they are practised. Indeed,

tactics can only be enacted within the territory of a place. As opposed to strategies, tactics are opportunistic, always 'on the watch', always variable, and always involve combining disparate elements to gain a momentary advantage and/or change – which, in the end, may only last but a moment.

Performance art – given that it unsettles the museum/archive, being non-reproductive/reproducible and always already vanishing, even as it is becoming, as Amelia Jones, José Muñoz, Peggy Phelan and others have argued[7] – is an act, a tactic, in a place that a queer can practise in order to disrupt the order of the museum/archive. In the place of the museum/archive, I wonder how the past and present – which is where these sites ostensibly start from and point towards in a linear fashion, being grounded in historicism as they are – can be performed in ways that run counter to the trajectory and *modus operandi* of traditional art history?[8] What tactics can be deployed? And when practised, what new knowledge productions, alternative epistemologies and counter-histories emerge from a performance in the museum/archive? As opposed to the conventional archival reliance on factual, verifiable evidence and historical relevance, how does ephemera, say, for example performance and a scrap of paper, and even anecdote and gossip, complicate the archons' – as Jacques Derrida calls the 'protectors of the archive' – claim of absolute and correct forms of knowledge and history?[9] Thinking about these questions, I will explore a performance piece entitled 'My Favorite Dead Artist' by Ms Vaginal Davis, a Los Angeles-based, working-poor, Mexican-African-American performance artist. This performative tactic was done at the Getty Center in 1999. I read Davis's piece as a powerfully productive performance, an enactment of a queer tactic, that points to other ways of performing, *doing*, art history and the museum/archive.

Who's That Girl?

Davis has been described – and performed herself – as a 'walking installation piece'.[10] Indeed, whether she is redefining the notion of an 'art-rock-concept-band' (such as her groups Black Fag, ¡Cholita!: The Female Menudo, and Pedro, Muriel & Esther [PME]) or critiquing

traditional Hollywood movies via her experimental films (for example, *Three Faces of Women* or *The White to be Angry*), she has been at the forefront of a new type of visual and performing artist who takes the Warhol adage of 'everyone will be famous for 15 minutes' one step further – her activities create new art movements and scenes every 15 minutes.

The following biographical information about Ms Davis was discovered from an unauthorized biography of the performance artist, and it supposedly contains information that Ms Davis does not want people to know about because it takes away from her working-class, punk credibility (though, ironically, you can find this on her website):

> Ms. Davis has been a subcultural figure in the seminal music and art scenes since she was a teenager from the ghettos of Watts who grifted her way into a scholarship at the exclusive Swiss boarding school Le Rosey at age 14, getting kicked out by 15 for a scandal involving Billy Idol when he was with the band Generation X. She wound up in Wallingford, Connecticut on another scholarship for underprivileged children at the prep school Choate/Rosemary. She was booted again due to some incident involving a boy committing suicide over her. She entered college early getting kicked out of Dartmouth, Harvard and Columbia and has worked full-time as a career counselor at UCLA's Placement and Career Planning Center. She was fired for beating up a colleague, ... Despite herself, Vaginal Davis received a PhD in psychology from Columbia University in New York, holds postdoctoral certification and licensing in marriage and family therapy... and she has actually taught at Loyola Marymount and Pepperdine Universities (it didn't last long).[11]

Indeed, Davis's life-story is a mixture of fact and fiction, and it doesn't matter. And it is this same tactic of 'blurring the lines' that Davis deploys in many of her performances.

The performance I discuss in this paper was performed at the Getty Center and coincided with the museum's *Nadar–Warhol: Paris–New York* photography exhibition, which attempted to make clear connections between Nadar and Warhol in terms of their practices, productions, status and fame – in a sense the Getty put these two dead artists in conversation, but the words were not from the dead but rather from the curators of the Getty Center.[12] Via the exhibition, the museum staged and scripted a history that traversed space and time, and thus connected all the points of a line together,

thereby completing the story of not only Nadar and Warhol but also of the artistic subject as such.[13] With this in mind, I read Davis's piece as a powerfully productive performance that points to other ways of staging and scripting – performing – art history and activating the museum/archive against itself.

So, conjure up an image of the Getty Center, a massive structure whose archivists order the art and art-historical literature that they possess, and now imagine Ms Davis, a 6'6', 220 lbs, Mexican-African-American, working-poor performance artist, reading aloud a letter, which is too small for the long story she will give, that tells of her encounters and escapades with Andy Warhol – as well as the punks, junkies and queers who criss-crossed both of their lives. Davis reads her memoir from a scrap of paper that contains a rich history which cannot be found within the museum/archive proper. She reads her letter before the archons who, according to Jacques Derrida, are 'first of all the document's guardians' and who are 'accorded the hermeneutic right and competence. They have the power to interpret the archives.' Furthermore, Derrida argues that the archive is

> [e]ntrusted to the archons, these documents in effect speak the law: they recall the law and call on or impose the law. To be guarded thus, in the jurisdiction of this *speaking the law*, they needed at once a guardian and a localization. Even in their guardianship or their hermeneutic tradition, the archives could do neither without substrate nor without residence.[14]

In other words, the archons, the guardians, are the only subjects deemed fit to interpret and disseminate the 'truth' of what the archive 'speaks'. Also, there needs to be a place – a literal site to cite, a location, which is fixed and controlled, to draw out the facts – where all of the material can be collected, stored, protected and presented. This relationship between archon/s and archive/s relates to the scripting and staging of the art and literature of art history by the art historian, the curator and the other related officials who objectively decide not only the correct meaning of the art and the literature but also what is deemed fit to mean anything at all within art history and the museum.[15] I argue that through performance, specifically queer performance, the claims of the archons and the order of the archive and art history is

disrupted by what is included and excluded, and via performance, such as Davis's, other genealogies, histories and lives emerge. So here I turn to Vaginal Davis, who is literally and figuratively the black bombshell in the white cube.

Performing Art History

Davis's anecdotal and gossipy story begins in the early 1980s. She states that she met Andy Warhol at a party in the Arena nightclub in Manhattan. That night's theme was 'Come As Your Favorite Dead Artist'. Davis went as Frida Kahlo – 'complete', according to Davis, 'with uni-brow and a Cabbage-Patch doll head as a stand-in for Kahlo's monkey'. Come mid-evening Davis was approached by Warhol who said that she looked exactly like Helen/Harry Morales who was, according to Davis, 'one of Warhol's "lower rung" drag queens' – and who posed before his Polaroid camera and eventually ended up as one of his models in his *Ladies and Gentlemen* series of the mid-70s.[16] Warhol, Davis states, was 'confused from the get go' by her portrayal and discussion of Kahlo, and 'I couldn't believe he didn't know who Frida Kahlo was. I mean this was before she became famous in the States – before she ended up on everyone's t-shirts, but you'd think he would know.' Davis then tells him, in a more direct fashion, that Kahlo was a famous Mexican artist who died in the late 1950s, and she was married to Diego Rivera, the famous Mexican muralist. But, according to Davis, 'Andy didn't know who he was either – *and he wasn't even embarrassed!*' It was then that Warhol took a Polaroid of Davis. *FLASH!* As Warhol walked away, with his Polaroid in hand, Davis tells us that Louise Nevelson, the 1950s abstract sculptor, stated that she knew who Davis was supposed to be all along, and the sculptor even proclaimed, 'in her "*grande Madame*" way' that Davis looked like 'a walking installation piece'. Davis states, 'this wasn't the first time I met Andy nor was this the first Polaroid he took of me'.

The first time Davis met Warhol was in Los Angeles at the Brave Dog Nightclub, which was later renamed Café Troy, and which was co-owned by Bibbe Hanson, 'the daughter of famed Fluxus artist, Al Hanson, and the mother of musician/artist, Beck'. Bibbe Hanson, according to Davis, was the youngest Warholian Superstar, and she starred in Warhol's

underground film *Prison* (1965) alongside the most famous Warholian Superstar, Edie Sedgwick. Davis goes on to state – or, to be more accurate, gossip – 'Bibbe left her husband for a horse-hung Chicano named Sean Carrillo, and during this period in Bibbe's life she also began managing my band, ¡Cholita!: The Female Menudo'. Davis goes on to recount how she often collaborated with Bibbe's own punk band, Black Fag!, in which both would perform on stage 'with Bibbe doing male drag – sex and gender were getting fucked then'. Indeed, Davis unveils the rich punk and queer cultural history of Los Angeles, which is chronically omitted from the official written histories of the city – even progressive historians, such as Norman Klein whose book is (ironically) titled *The History of Forgetting: Los Angeles and the Erasure of Memory*, have forgotten (and even erased) the queer and punk communities which have given much to the cultural and political vitality of Los Angeles.[17] Nonetheless, Warhol chatting it up with Davis in the Brave Dog Nightclub took his first Polaroid of the drag queen/performance artist – she looked fabulous and he couldn't get enough of her. *FLASH!*

During her performance, Davis wanders through a list of names – for example, George Byron, who was often called 'Mommy George' and who helped get Davis into all the 'hip LA parties' – and she also wanders through a series of places (e.g., shops, clubs, and parties) most of which most are outside New York, the so-called art centre of the world. Indeed, Davis charts bodies and places that are important, if not to the Getty, then to the queers who were a part of these communities, which have been chronically elided or erased from the scripting and staging of (art) history.

After her verbal *flâneurie*, Davis jumps forward in history, to circa 1984, and she tells of another time she met Warhol, this time at the punk store, Retail Slut, on Melrose Avenue in Los Angeles, where Davis worked at the time. She recalls that she was wearing self-made Polaroid earrings with portraits of Tina Chow, the model and actress who was married to Michael Chow, the owner of the restaurant Mr Chow, which was one of the 'hipper' places to eat in the 1980s. In the words of Davis, 'Andy loved my earrings, and he told me that he wished he had thought of taking a portrait of Tina – because she's so great'. According to Davis,

Michael Chow was a 'prissy homo' and the marriage ended. Davis then laments that Tina Chow died of 'Ms. AIDS' – Tina Chow was the first female celebrity to die from the epidemic. Her earrings are a memento of this lovely Asian-American actress who rocked the art and television worlds. *FLASH!* Indeed, Davis is performing a eulogy – an 'adieu' – to Tina Chow, and, most importantly, Davis does not speak for Chow, but rather speaks to her. As opposed to objectifying, Davis personalizes and politicizes the life and times of people who have been elided or erased from the museum/archive.

Davis recounts an incident that took place between Tina Chow and supermodel Marissa Berenson – both of whom were photographed by Warhol in the early 80s, even though Davis claims she did it first. At a party, Davis states, 'both beauties were drinking vodka gimlets and acting very lesbionic ... and they were also snorting cocaine off of a silver platter'. According to Davis, Marissa Berenson 'looks like Sarah Bernhardt from the Nadar photograph of 1864'. And Tina Chow also looks like Finette, a dancer at a 'disreputable dance hall' in Paris who was also a high-class call girl. Nadar took Finette's photograph in 1858.[18] For Davis, Berenson and Chow – as well as Bernhardt and Finette – were glamorous women. These comparisons foreground the sexual proclivities of all the women (if we are to believe the gossip), but this should not be understood as a moral critique by Davis of the celebrities, but rather as a surfacing of that which is left out of the Getty's discussion of their lives; Davis's gossip can be read as a celebration of perversions and queerness. On a similar note, Davis compares Alphonse Daudet, the Parisian author of *Lettres de mon Moulin*, photographed by Nadar in 1861, to the US author, Truman Capote – Warhol's early love and a subject and muse of numerous drawings and photographs by him.[19] Again Davis makes this comparison – as well as noting both authors' 'swishiness' and notoriety – in order to highlight the sexualities and the communities that are often elided in a discussion of these literary figures.[20] *FLASH!*

At this stage of the performance it becomes clear that Davis is giving an alternative history – a rhizomatic one. She cuts across the traditional art-historical hierarchies in favour of dislocations, ruptures

and intensities that spread out vertically as opposed to horizontally – she levels the hierarchies, the filing cabinets, and photographs in queer ways, via queer tactics.[21] Furthermore, she is intensely surfacing what is suppressed in the traditional accounts of these two art-historical figures. She also surfaces the sexuality and the queer communities that Warhol belonged to. Indeed, Davis gives us alternative knowledges and counter-memories.

In Davis's reading of her letter, she surfaces and highlights the *mal d'archive* – the malice in the archive, the sickness that can be caused by/ in the archive, which is to say those elisions and erasures that would make any queer (or, for that matter, any numerical-majoritarian subject) troubled by the injustices launched and guaranteed by the museum/ archive proper, which supports the ostensibly official and legitimate history.[22] Additionally, her performance dupes the archons of the museum/archive into not knowing what does and does not belong inside: is Davis's story legitimate, are these connections, marginal figures and stories important, and does any of this deserve archiving? Throughout Davis's performance it is impossible to know whether or not she is telling the 'truth': did she meet Warhol on all of these occasions? does she know the people that she is gossiping about? But Davis, in giving her story, is not concerned with so-called truth and fact. In this way, Davis performs a perversion by way of contamination and confusion. She effectively queers the museum/archive by putting things 'where they don't belong', confusing the archons, deconstructing binary oppositions, and showing what is suppressed by/in the museum/archive proper – in a phrase 'by being improper'. From this performed tactic boundaries become porous and start to leak and the museum/archive is contaminated. The contamination drenches the proper, and through the performance sparks arise causing combustion from the flashes – the slow burn of the Polaroids, the stories, is just enough to cause chaos. The archive is on fire...[23] it is *flaming*. The black bombshell in the white cube has exploded.

According to José Muñoz, Vaginal Davis engages in 'terrorist drag' in that she radically criss-crosses and undercuts the binary systems that are found in any practice that reifies the dominant.[24] In the way

that Davis performs herself in and around any 'stage' (be it a museum, gallery, nightclub or street) she actively 'clears out space, deterritorializing it and then reoccupying it with queer and black [and brown and Asian and female] bodies'.[25] She deploys what de Certeau has called 'the tactics of the marginal'.[26] And it becomes clear that even though Davis was invited to the Getty Center on the occasion of an exhibition celebrating two canonical, white, male artists, Warhol and Nadar, and the connections between them, Davis turns the tables and announces that *her* favourite artist is Frida Kahlo. Indeed, Davis makes the place of the museum/archive into a space via her tactics, and even though this does not last forever (the Getty is still doing art-historical business as usual) the point is that it did happen – the 'other' was foregrounded and resuscitated in queerly tactical ways.

Davis, a self-proclaimed 'African-American and Mexican-America mutt' who was 'conceived under a table during a Ray Charles concert at the Hollywood Palladium in the early 1960s' and who has always been 'the poor little darling from the inner-city',[27] refuses to celebrate and further canonize Nadar and Warhol and all of the conventional connections between them. By performing her queer memoir/memories, Davis, in effect, clears the walls of the museum and hangs images of black and Latino drag queens, Asian-American women, and a room full of effeminate men, big dicks, drug users and sex workers – who were already there, in a sense, hanging on the wall, but whose histories and connections were suppressed under the official life and times and trajectories of the *Nadar–Warhol: Paris–New York* exhibition that was produced by the archons of the Getty Center.

Through her performance, Davis allows the hills of Bentwood and the Getty Center to be overrun by 'coloureds', 'fags', 'dykes' and other 'misfits'. Davis creates another world via her performative construction of viable and valuable histories and spaces. Like a flash – like the burst of light that comes from the Polaroid camera, which is that central motif in her story – she blasts us out of the continuum of History. Now I want to turn to this 'flash', which I have read as a moment of combustion, and which caused a spectacular fire in the museum/archive, and I wonder

what can be read through the flash and the flames that were caused by this 'terrorist' drag act.

In Walter Benjamin's often-cited 'Theses on the Philosophy of History', he states, 'To articulate the past historically does not mean to recognize it "the way it really was". It means to seize hold of a memory as it flashes up at a moment of danger.'[28] This Benjaminian flash is like the Polaroid flash that frames each moment when Davis recalls – seizes hold of – a memory of Warhol, but, it should be stated, this Polaroid, this memory, is itself non-archival – it will not last but rather fade away just as it appeared: slowly, softly.[29] The 'moment of danger' comes about via the Polaroid and Davis's story, and these are dangerous for what they can do to the ordering of art history, of Warhol, of the museum/archive. I argue that through Davis's performance we can see the practice of a performative tactic that cites with a difference. I understand there to be a relationship between the 'flash' that Benjamin articulates and queer tactics.

The flashes that are scattered across Davis's memoir unhinge and disrupt the linear narrative that sets in order the chronology of events and gives historical 'accuracy' and 'truth' to the trajectory of history proper. I argue that in the linear narrative of art history the subjects in the present can project themselves into the past and simultaneously forward into the future, and thus identify unproblematically with who they are for what they were in the past and what they will become in the future. The museum/archive presents objects that we should like to surround ourselves with in order to better articulate ourselves to others and ourselves.

The line of history is also the line that underscores the subject as s/he who is a wholly complete, unified and seamless self. This ties back to the notion of history and the archive – all of them 'line up' in an orderly fashion. But Davis's account of history deconstructs this modernist notion of the self, which is staged by the archive, museum and art history as the triangulation of the modern(ist) subject.[30] As presented by Davis, the collection of stories, the accumulation of Polaroids, which aren't even 'real' photographs, the presentation of people, places and events only demonstrate the falling apart of any attempt to present a seamless

self. Indeed, Davis's presentation shows the self to be a performance that is not based on fact and truth but rather technologies of self-fashioning and presentation. Furthermore, Davis shows that instead of coming from a linear narrative, a progressive history, she (and, I am sure, all of us) comes from, and is set within, a discursive and multi-angled framework that can be entered from various, and often competing, points. The flash is representative of the moment – not of some moment that is 'how it really was', but rather the moments as a collection, an archive, of various re-collections, memories, histories, which are multiple and shifting as opposed to singular and fixed. This, to be sure, goes against the rules and regulations of the museum/archive proper. Davis in performing and presenting her queer body/self disidentifies with hegemonic and dominant modes of history writing, archival work and the collection and presentation of memories – personal and/or cultural. In the words of José Muñoz, 'to perform queerness is to constantly disidentify, to constantly find oneself thriving on sites where meaning does not properly "line up"'.[31] And this 'not properly lining up' is that dangerous moment – not so much for Davis but for the archons and the archive as a whole. The *flash* disrupts the linear, the orderly, the singular direction of the archive/museum, and through this disruption multiple and parallel worlds emerge.

Gossiping in the Museum/Archive; Or, Davis *Does* Art History with a Whisper

In viewing, or more importantly for my point here, listening to 'My Favorite Dead Artist' I argue that Davis's use of gossip further disrupts the archive. According to Irit Rogoff, 'gossip turns the tables on conventions of both "history" and "truth" by externalizing and making overt its relations to subjectivity, voyeuristic pleasure and the communicative circularity of story-telling'.[32] Without a doubt, Davis employs gossip as a way of telling her history with Warhol and the queers that criss-crossed both of their lives. I argue that she deploys gossip as a way to foreground the subjective and voyeuristic pleasures in the staging and scripting of traditional histories, which are concealed in its presentation. Indeed, in traditional history writing the

historian conceals his erotic and phantasmatic projections and desires; he passes off the scripting and staging of the historical as an objective pursuit that is driven by the articulation and promotion of historical facts. But Davis, in deploying gossip as the *modus operandi* of her story, foregrounds that which is suppressed; thus, she deconstructs the objective/subjective and fact/fantasy binaries in ways that show its masculinist and modernist tendencies.

As Rogoff has argued, '[g]ossip within trajectories of historical evidence exemplifies in Derrida's words "a principle of contamination, a law of impurity, a parasitical economy … a law of abounding, of excess, a law of participation without membership"'.[33] As I stated above, Davis contaminates the archive through the dissemination of her story, and with the archive saturated by her contamination and the flashes of the Polaroid popping, the place combusts into a beautiful site of flames – created by the black bombshell. After this dies out we are left with the ashes of the archive, and we can read through it other histories that bring forth alternative modes of scripting and staging the world, in ways that do not grasp and colonize the world, but that nurture difference.

A Conclusion towards a Beginning

My point in this paper has not been to argue for the simple inclusion of other histories and lives into the museum/archive, because this has already been done poorly by so-called multiculturalists and multiculturalism (or, tokenism *par excellence*), which is nothing more than the Euro-American hegemony telling people of colour and others what and who they ostensibly are. Rather my point is to show that the archive is always already open and permeable to multiple and various readings and meanings – depending on where you stand in it, and in the world, as a particular subject. I argue that Vaginal Davis's performance shows the imaginative and potential worlds that can and do exist within and without the archive/ museum. I argue that in viewing this particular performance by Davis I can see and hear other possibilities. I, and I hope others, can imagine other gendered, perverse, queer historical narratives, and enact other modes of presentation and production. In the

flashes and flames detonated by Davis, we can see a world ablaze that melts off the veneer in order to show a queer and perverse world which is difficult to see and hear in a museum/archive such as the Getty. Indeed, new knowledges and alternative epistemologies are made available in and for the present with such enactments, tactics, performed by Davis and read by me.

So, ironically, it was in a place like the Getty Center, the museum/archive, with Vaginal Davis inhabiting and disrupting the place of it, that I realized that we must begin to be more open and honest about the work that we do: we have to admit that art history and the museum/archive – far from being an objective history or display – is a deeply ideological, political project that actively elides or erases other peoples, other histories, and it perpetuates the myths of unity, linearity and coherence that, I argue, are no longer acceptable to believe in and promote (if they ever were). So what I am calling for is the surfacing of our investments and political agendas, which all art historians and museum/archive workers have – be they overt or covert.

Finally, throughout this paper, I have shown how one performance on a typical Southern California day in 1999 productively disrupted and re-imagined the museum/archive via the 'terrorist tactics' of a performance piece. From my point of view, Davis *did* art history differently. But what happened in Davis performing, *doing*, art history in and through the museum/archive? For me, she did nothing more than its temporary destruction by flashes and flames, and nothing less than showing that it can be performed vastly differently, which, I argue, must be done in order to dramatically change (or eradicate) art history, since its *modus operandi* is completely outdated, out-of-touch and fascist from the perspective of the 'numerical majority': women, people of colour, immigrants, queers and the working class and working poor, all those people who go not only to the museum/archive but also to Davis's performances, exhibitions and performative lectures. Ironically, I believe that it is time for a performative manifesto – one that does what it says, but without an authoritarian prescription – but, nonetheless, a 'manifesto' that acts as a challenge, an ethical call, to the archons of the 'traditional' museums/archives that dominate the West.[34]

NOTES

1 Michel de Certeau, *Practice of Everyday Life*, trans. Steven Rendall (New York and London: Routledge, 1995), p. 152

2 Michel Foucault, *The Archeology of Knowledge*, trans. A. M. Sheridan Smith (New York: Pantheon Books, 1972), especially pp. 199–211.

3 Here I would like to thank Stephen Bowersox, Young Chung, Douglas Crimp, Matthew Lipps, Nick DeVillers and all of the brilliant grad students at Cornell's Art History Conference 'Queer Eye or the Art Historian', where I first presented aspects of this paper in 2004.

4 De Certeau, *Practice*, pp. 117–18.

5 I would like to thank Donald Preziosi for directing me towards de Certeau's work in my thinking on and about the museum/ archive. I would also like to thank him for conversations and e-mail exchanges on the issues that are brought up in this paper

6 De Certeau, *Practice*, p. 93.

7 See the large body of academic work by Amelia Jones, Peggy Phelan and Jose Muñoz.

8 See Donald Preziosi, *Rethinking Art History* (New Haven, CT, and London: Yale University Press, 1989), chapters 1 and 2. See also Donald Preziosi, *The Brain of the Earth's Body* (Minneapolis, MN, and London: University of Minnesota Press, 2003).

9 Jacques Derrida, Archive Fever, trans. Eric Prenowitz (Chicago and London: University of Chicago Press, 1995), p. 2.

10 Personal e-mail correspondence; this is also on her webpage, http://www.vaginaldavis.com

11 See http://www.vaginaldavis.com

12 Gordon Baldwin and Judith Keller, *Warhol–Nadar: Paris–New York* (Los Angeles: Getty Publishing, 1999). The performance by Vaginal Davis was part of a one-day conference on pop art and celebrity. The Getty did not record Davis's performance, but *LA Weekly* did take some photographs of the conference and the performance.

13 Baldwin and Keller, *Warhol.*

14 Derrida, *Archive*, p. 2.

15 Preziosi, *Rethinking*, chapter 2.

16 These silkscreens are portraits of black and Latino drag queens from New York.

17 Norman Klein, *The History of Forgetting: Los Angeles and the Erasure of Memory* (New York and London: Verso, 1997)

18 See also Baldwin and Keller, *Warhol*, p. 97.

19 Warhol made artworks – specifically drawings – for and about Truman Capote.

20 See also Baldwin and Keller, *Warhol*, p. 64.

21 Gilles Deleuze and Felix Guattari, *A Thousand Plateaus: Capitalism and Schizophrenia* (Minneapolis, MN: University of Minnesota Press, 1987).

22 Herman Rapaport, *Later Derrida* (New York and London: Routledge, 2003).

23 Rapaport, *Later Derrida.*

24 José Muñoz, *Disidentifications: Queers of Color and the Performance of Politics* (Minneapolis, MN, and London: University of Minnesota Press, 1999), pp. 97–99.

25 Muñoz, *Disidentifications*, p. 115.

26 De Certeau, *Practice*, pp. 93–95

27 See Muñoz, *Disidentifications*, p. 95 and http://www.vaginaldavis.com.

28 Walter Benjamin, 'Theses on the Philosophy of History', in *Illuminations*, ed. Hannah Arendt, trans. Harry Zohn (New York: Schocken Books, 1968), p. 255.

29 I thank Matthew Lipps, an LA-based photographer, for sharing this insight with me.

30 See the large body of work by Donald Preziosi and also Jacques Lacan.

31 Muñoz, *Disidentifications*, p. 78.

32 Irit Rogoff, 'Gossip as Testimony: A Postmodern Signature', in *Generations and Geographies in the Visual Arts*, ed. Griselda Pollock (New York and London: Routledge, 1996), p. 58.

33 Rogoff, 'Gossip as Testimony', p. 58.

34 I am calling for a 'manifesto' in the spirit of McKenzie Wark, who wrote a *Hacker Manifesto* (Cambridge, MA, and London: Harvard University Press, 2004), which argues that it is time to manifest an argument against the status quo and the keepers of a reactionary and conservative public sphere.

5

Performativity, Cultural-Politics, and the Embodiments of Knowledge

AN INTERVIEW WITH AMELIA JONES
CONDUCTED BY JONATHAN HARRIS

Amelia Jones is well known for her books and essays on the uses and meanings of the body in modern and contemporary art. Her distinctive accounts have intertwined feminist, phenomenological and poststructuralist perspectives, simultaneously addressing the social, sexual, political and intellectual contexts and conditions of late-capitalist culture and society. In 1996 she organized the extensive exhibition *Sexual Politics: Judy Chicago's 'Dinner Party' in Feminist Art History* (UCLA-Armand Hammer Museum). Her books include *Postmodernism and the En-Gendering of Marcel Duchamp* (Cambridge University Press, 1994), *Body Art/Performing the Subject* (University of Minnesota Press, 1998), *Irrational Modernism: A Neurasthenic History of New York Dada* (MIT Press, 2004), and *Self/Image: Technology, Representation and the Contemporary Subject* (Routledge, 2006). Amelia Jones is currently Professor of Art History and Visual Studies and Pilkington Chair at the University of Manchester.

The interview begins by examining the links between Amelia Jones's background in art history and her early work on 1960s and 1970s 'performance'. This category, however, has always been problematic for Jones and the discussion moves on to consider its significance and value in accounts of twentieth-century art, culture and society. This is inseparable from a wider critique of theories of 'avant-garde' and the modernist artwork. Jones and Harris examine some elements of this critique in their discussion, and then consider its relationship to

neo-Marxist analyses of capitalism centred on the notion of the
'spectacle'. This is related to the television coverage of the Iraq war in
2003 and the following occupation. Jones stresses the social and political
function of art-historical and art-theoretical knowledge, discussing the
work of some artists who have attempted to confront capitalism and its
new imperialism in the Middle East and elsewhere.

The interview was conducted in Manchester, England, in September 2004.

1: Introduction and Background

JH I'd like to begin by asking you some questions about your
background and how you got into the areas that you've worked on and
how they relate to what you're doing now. Could you start by telling me
at what point in your academic career you began to think and write
about performance art?

AJ That's very easy to remember. I had started to teach at the University
of California at Riverside. I began in 1991 and as I was teaching I got
more and more frustrated with how limited the books were that were
available to teach modern and contemporary art. I mean, for example,
the fact there was obviously a canonical set of artists – even if you were
thinking about the women who had started to be introduced into the
history, the selection had already been reified by that point.

So I started looking through a lot of art magazines from the late
1960s and early 1970s and I started realizing that in about 1967 or
1968 (right about the time minimalism really became a central
movement in New York) all of a sudden you started to see all these ads,
in *Artforum* magazine in particular, with artists appearing themselves
in the ad (there's a great example of an ad with Ed Ruscha in bed with
two women in January 1967, with the text 'Ed Ruscha Says Goodbye to
College Joys'). Now this was the trigger for me, because I started
looking into the performance and body art that was starting to emerge.
I began to look into these figures – there was a little bit of information
about people such as Vito Acconci and Carolee Schneemann – and to
see the connections this development had to minimalism. That is, in a

less direct way, minimalism was also addressing issues of the body and space and so on. And the more I thought about it the more it appeared linked to the kind of poststructuralist theory I was then becoming interested in. So my book *Body Art: Performing the Subject* (1998) actually traces the trajectory I went through organically – the parallel between the theory and the contemporary artistic practice; in other words, the artists were pushing the boundaries, questioning aspects of subjectivity and meaning, just as philosophers such as Derrida were, if on a different register.

JH Can we go back a little bit earlier to your own undergraduate and then postgraduate experience? Were you aware then of the category of 'performance art'?

AJ I had a vague awareness that it existed, but art history at Harvard University was extremely conservative and canonical when I was there as an undergraduate (1979 to 1983) – you were lucky if they got past Jackson Pollock and really pretty much the furthest they got in my undergraduate programme was Morris Louis. Of course, I now know that's the classic trajectory, because Clement Greenberg had lectured at Harvard in the 1960s where Michael Fried and Rosalind Krauss were studying. Fried had supported Louis and the other colour field painters, so the whole thing was actually institutionally over-determined. But I didn't know that at the time, and what was conveyed was just this deeply entrenched modernist (and formalist) point of view, deeply connected to the Fogg Museum of Art. The academic methods were characteristically connoisseurial, and the history ended with Jackson Pollock and Morris Louis.

JH Hans Namuth's famous 1950 film of Pollock painting has become understood as a document of a kind of early 'performance art' before the term was coined. Did you have any sense – when you dealt, then, with Pollock's and Louis's art, and Fried's criticism – of the arguments about 'theatricality' and 'spectacle'? Were you aware of them in some obscure way?

AJ No. I'm sad to say that there was no theoretical analysis: to the point that I did not even read Erwin Panofsky or Heinrich Wölfflin in the art history department, or even Michael Fried, which would have been interesting.

JH Were you aware, then, that modernism was a theoretical construct?

AJ Yes, though the Greenbergian/Friedian logic was embedded and implicit, and at no point was it ever stated as a theory, because it was completely naturalized as the basis of the analytical and pedagogical perspective.

JH Did you deal with European post-World War Two art?

AJ No. Postwar European art was completely invisible within the standard discipline of art history in its most elite form, which would be Harvard.

JH Not at all, not even Joseph Beuys?

AJ No. I never heard of Beuys until after I graduated from Harvard. I worked at an art book publishing company in New York called Abbeville Press between 1983 and 1985, where there was a proposal for a book on Beuys and that's where I first became aware of him. Then I went to the University of Pennsylvania in 1985 for my Masters degree, still not really having any direct interest in or awareness of performance art *per se*. And there was really no one at Pennsylvania with whom to study contemporary art.

JH Why did you decide to go there? Was it a particular course that you knew about?

AJ I had applied to six good schools where they had strong art history PhD programmes, and Penn offered me the best financial support. And so I went there, and actually it wasn't such a bad thing, because it was the

first time in my art history career that I was assigned a reading that was overtly theoretical, which was Edward Said's *Orientalism* (1978)**.** Frankly, I don't know why I had stuck with art history up to that point, it was so boring. But I started reading on my own Rosalind Krauss's *The Originality of the Avant-Garde* (1981), and books by Linda Nochlin, and, you know, those texts were just starting to become available then. I was like a starving person in the desert, though from the beginning I was a bit resistant to Krauss (although I still think she's brilliant) – that's when I started resisting what I would now call 'Octoberism' – the dominance of Krauss and her students or colleagues working on the journal in modern and contemporary art history, and the solidification of their covertly formalist or structuralist point of view. I realized that this material was continuing aspects of the modernist mentality that I thought was very limiting.

JH Could you expand a little bit on what you were saying just now about the link between identifying this area of study – something called performance art – and poststructuralism and other intellectual currents, for instance, to do with Said? Did you have a clear sense that these were related, or could be articulated?

AJ I started to have that sense only in the early 1990s, when I began to teach. After Penn I went to the University of California at Los Angeles for my PhD and that's where I really became immersed in theory – you know, in pure, delicious philosophy. I studied Jacques Derrida's *The Truth in Painting* (1987) with Donald Preziosi – we had an entire seminar on that one book, so it was a really brilliant introduction. And I also studied film, so I read a lot of British feminist film theory. Then, only really after I had begun to teach, did this burgeoning of artists working with their bodies in the late 1960s start to stick in my mind, and I wanted to teach this performance work. It was mostly instinctive at that point. I hadn't articulated the themes and connections with the confidence that you see in the *Body Art* book, but I knew that's what interested me about the performance work. The fact that it hadn't been written about and that it had been excluded was precisely exemplary of

the fact that it disturbed the modernist, formalist logic that dominated art history up to that point. I became more and more compelled by it because I was interested myself in disturbing those structures.

JH Was it at that stage an interest in comparatively recent performance art?

AJ No, it was really material from the late 1960s and early 1970s that initially drove my interest.

JH Was there a connection with feminism immediately, with feminist art, women's art?

AJ Yes, I had already, by the late 1980s – I was at UCLA from 1987 to 1991 – started to crystallize my feminist commitment, and I took a lot of feminist film classes. And so, yes, by the time I was looking at performance I was already looking at it from a feminist point of view.

JH You mentioned British film theory and feminist film theory. Who are you thinking of? Laura Mulvey?

AJ Yes, though I really mean *Screen* magazine. That was hugely important at UCLA's film department. People had been reading seminal texts from the early 1970s such as Stephen Heath's 50-page-long article called 'Difference' (1978) – stuff like that we were reading then, engaging with that, having these intense...

JH Were you aware of the political context to *Screen*, in terms of European Marxism, as well?

AJ Not entirely, but we did make a start, in a fragmented way. At one point I started reading Louis Althusser. I pieced together a probably still fragmentary understanding of it.

1 Carolee Schneeman, *Fuses*, 1965 © ARS, NY and DACS, London 2007

JH We'll come to that question of the radicalism of performance and how it relates to political activity in a minute. Before that, though, could you say a little bit about how you saw performance in relation to modern and contemporary art, say, up to the 1970s, and the usefulness of modes of film analysis to the study of art?

AJ Well, there's no way you can avoid that with someone like Schneemann, because she was a filmmaker – although, as you can imagine, at UCLA in the film department there wasn't a whole lot going on dealing with experimental film, as analysis was obviously dominated by Hollywood. But there was one class taught by Janet Bergstrom, one of the co-founders of *Camera Obscura* magazine, on experimental film. We didn't see the Schneemann films in that class, but it did give me a kind of framework, so that I became somewhat of an expert on Surrealist film because I had studied Dada and Surrealism quite a bit. And then, when I started looking at Schneemann's performance work, her films – obviously, for instance, her influential *Fuses* (1965) – that kind of work became really interesting to me.

JH The reason I ask is that, obviously, there's one sense in which certain filmmakers have associated themselves – and/or had their work directly linked to – notions of performance, but the category of performance, as we know, is so capacious that it can be applied to virtually all kinds of phenomena, including that not intended to be seen as art, never mind 'performance art'. Were you aware of this problem in those early days – that there was a way in which you were actively *inventing*, as much as simply recognizing, an area of practice? Or were

you concentrating on producers – artists – who had clear ideas themselves about performance and the nature of their activity?

AJ No, I would say more the former. What I loved was the rawness of all of the stuff. Nobody had written about that, or very few people had. For example, there's an American magazine published by Willoughby Sharp called *Avalanche*. There was a lot of this publishing in New York, and even in Los Angeles, in the 1960s – cheap newsprint, artist-run magazines, and Sharp produced these extraordinary issues of *Avalanche* where there's material on Vito Acconci and Acconci is talking about philosophy and performance and performativity. The people I was interested in were from this brief period – from the late 1960s to the early 1970s – who were doing performance in a way that was inherently interdisciplinary. They were coming from other places: Vito Acconci was a poet, his performances always interwoven with video and poetry. And photography played a key role in Hannah Wilke's work, and Carolee Schneemann was making films... These people, during this extraordinary period, especially in New York, were active in a place where all these different worlds – dance, theatre, music, film – were all enmeshed in each other.

The thing that really captures my interest and upsets me as a historian and a theorist is when those kinds of historical complexities are underplayed or erased, because of the narrowness of the disciplinary logic. And so that question is exactly what I started intuitively to want to investigate: why were these artists doing this work during that period? Why, all of a sudden, does the artist's body return to the scene? And then why, in turn, does that return become so threatening to the conventional models of art history?

JH These developments must relate to an earlier 1960s moment in New York as well, don't they; to, for example, work organized at the Judson Memorial Church?

AJ Yes, you can trace it further and further back, you can trace it back to Robert Rauschenberg and John Cage at Black Mountain College doing

events in the early 1950s. There are all sorts of threads that go back all the way to Dada and Surrealism.

JH That's important, but there are two ways of looking at the history. One is that you could trace it back to earlier phases; or you could see the specificity of this later moment as a kind of rupture in some way. Do you think both of those approaches are necessary?

AJ Yes, I do.

JH You don't value one more than the other? Because I'm thinking particularly about the politicization of artists during the 1960s.

AJ Yes, that's another important aspect of it, the role of identity politics.

JH To me, the rejection of many aspects of the Warholian pop art practice in the 1960s, certain aspects of developments in mixed media that were going on – the later phase presumably more directly politicized by the 1970s – meant that some artists, such as Victor Burgin or Barbara Kruger, weren't just interested in creating an art 'scene' or spectacle.

AJ Well, you know, it really varies from artist to artist, and even from piece to piece – I think it's important to be really specific. But I think there are all sorts of different trajectories and obviously the Warholian one is a specific trajectory that has to do with a very sharp consciousness of the market. Schneemann and Acconci were not interested in negotiating the market in that way, they were really doing stuff that was alternative to that. And of course that was a period in which that was possible. It's not possible today in that way.

JH On this question of mixed media – though, interestingly, you used the phrase 'interdisciplinary', or 'multidisciplinary' – related to changes in contemporary art, and its study in art history and theory. There's a way in which the artists you're talking about were (or, at least, appeared) much more philosophically well-read and literate, able to bring in those

ideas. Are we also talking about a change in the nature of – not so much philosophy – as art theory or writing about art which radically affects the way these practitioners are making art?

AJ Yes, definitely. There are a number of things to say about that. The first thing is that the art historian Howard Singerman has written a book on the trajectory of the American art school, which is one way of looking at it [*Art Subjects: Making Artists in the American University* (Berkeley: University of California Press, 1999)]. He examines the way in which art schools, because of acts of Congress such as the 'G.I. Bill' in the United States after World War II [a law granting demobbed soldiers a number of years of free university education, depending on their length of military service] led to a rapid development of the schools, which then also became more and more professionalized and, in curriculum terms, increasingly intellectualized. In addition, art students from the 1950s onwards were taught to develop strategies of self-marketing, and to acquire other business and 'professional' skills unrelated to traditional artistic training.

The second thing is that there was an explosion of philosophical developments: the rise of French poststructuralism in the 1960s and 1970s, a reinvigoration of German philosophy that was crucial as well, and then the rise of a sophisticated British version of cultural theory in, for example, *Screen* magazine. By the later 1960s and early 1970s there is the emergence of cross-disciplinary cultural theory for the first time: a group of people who began to articulate theoretical as well as artistic practices in tandem (such as Laura Mulvey and Peter Wollen). It's an amazing period really, from the later 1960s through to the mid-1980s.

JH Your account is very similar in some ways to what I've described as the 'new artistic-critical art history' [in *The New Art History: A Critical Introduction*, London and New York: Routledge, 2001], a formation intrinsically connected to extra-academic socio-political activity and with strong Marxist and feminist influences. It's also very heavily invested in psychoanalysis in some ways, something else

we haven't really discussed yet – the notion of the subject and all the related psychoanalytic conceptual apparatus. Were you aware of psychoanalytic thinking as a distinct part of this whole formation in the mid-1980s?

AJ Oh yes, more so than Marxism, which is much more watered down in the United States, where students of cultural theory often don't read Marx at all. You *do* tend to read – if you study feminist film, like I did – a lot of psychoanalysis; you read a lot of Roland Barthes; you read a little bit of Althusser and so on. So I'd say my Marxist credentials are much weaker than my psychoanalytical ones.

JH Because of the way it's been –

AJ Because of the way it's taught in the US. I mean Marxism is in some senses absolutely central to everything I do, but it's very 'second-degree' Marxism, because I'm really not an expert in Marxist thought.

JH But weren't there ways in which, for example, what's regarded as 'Marxist-Leninism', or the various 'Freudianized' extensions of Marxist theory in, for example, the writings of Wilhelm Reich, were introduced, and attacked too, by writers in *Screen*, at times in the 1970s and 1980s? An attack, really, on mechanistic Marxist notions of culture that regarded it a secondary human process dependent upon economic production? And in which notions of 'subjecthood' or identity were effectively rendered peripheral to those other processes claimed to be primary?

AJ Yes, that was very formative for me – the way that there was a certain discourse in *Screen* that meshed a very sophisticated Marxism (opposed to those mechanistic accounts) with a very sophisticated psychoanalysis, and it was a discourse almost always inflected by feminism.

2: 'Performance Art', the Baroness Elsa von Freytag-Loringhoven, and Problems of Definition and Analysis

JH Moving away for a moment from what we've identified as these broader intellectual and formative circumstances of your work, can we turn now to the category of performance, because it's a term that is used all the time, and obviously it's gone through changes, even revolutions, in meaning. In a way, I'm trying to get you to talk about the origins of a discourse around it, I suppose, and how that might have developed up to now. Would you say that the term now has a stable, or critical, meaning? Can you – would you want to – define performance now, or is that not part of what you want to do?

AJ It's never been part of what I want to do. I don't like legislating terms and values.

JH But when you teach, you have to do a little bit of that, don't you: you have to give students some idea of what you mean?

AJ No, because I don't teach, like, 'today we're going to do performance art'. I teach: OK, it's the late 1960s, all of a sudden artists start using their bodies, in advertisements, in performances, in video, in photographs – now why does this happen? That's how I teach it. I don't teach according to categories.

JH So you don't separate it out as a particular genre or idiom in modern art. But, then, do you get into questions of whether it's 'live' or 'documented', those sorts of distinctions?

AJ Yes. In *Body Art* and elsewhere I've made an intellectual argument about, on the one hand, live performance being ontologically different from, let's say, photographs of Cindy Sherman or Hannah Wilke. But, on the other hand, I make a very strong argument that live art is not therefore privileged; it does different things, but it doesn't give us some authentic, unmediated relationship to the artist – which is implicit in

most writing about performance, the fantasy that somehow this is more 'real' and it's giving us direct access to something.

This is one of the examples I use: I wrote an article in *Art Journal* where I make that argument very strongly, and in fact I was just attacked for it in an article in *Third Text* magazine [Catherine Elwes, 'On Performance and Performativity: Women Artists and Their Critics', *Third Text* 18, 2 (2004), pp. 193–97]. I use the example of myself personally going to an Annie Sprinkle performance, after having read a bit about her, going to see the performance: there she is, live, her body, her genitalia, her mouth, her sweat, and so on; and then coming home and, over the next year or so starting to write about her work, and literally forgetting whether I had actually seen something or not, or whether I had read it somewhere. And I think, yes, there is an ontological difference, but at the same time, memory is very complex, and we all know that you can argue with someone you know very well about what happened in a certain interaction – the fact is, the way in which that live act remains in our minds, even, not to mention the way it's written about and contextualized and documented, is very complex. There's nothing to guarantee that a live performance will have a simple, memorable effect; and obviously that effect would be different for each person.

JH OK. Would you agree it was true to say that your original and continuing essential interest is in the representation of the body? You'd use that category much more than 'performance'?

AJ Yes, absolutely, that's why the book is called *Body Art/Performing the Subject*, because it's about the body – it's not about 'performance art' proper at all. I explain in the introduction why I decided to call it *Body Art*.

JH All right. Could I ask you in that case to characterize what you think 'performance art' has come to mean, as it were, in popular or art-historical discourse of an orthodox kind. If you refuse the category. And how has it changed in terms of how it's been used?

AJ I don't refuse it – it's just not what I do, to belabour a definition of it.

JH But you don't want to defend the idea of it, either?

AJ No, I don't. I don't have a stake in it.

JH That brings us back to the significance of publishing, doesn't it? How the books and articles on performance relate to what's going on in the art market.

AJ Well, there are two things. One is the massive shift that occurred in the 1980s, really from the mid-1970s into the 1980s, where visual artists in general stopped doing body art, stopped doing performance or whatever you want to call it, and there was a shift towards people trained more in theatre, or in music – for instance, someone like Laurie Anderson. Performance art proper becomes this extremely marketable commodity (with Anderson, for example, performing to huge crowds at the Brooklyn Academy of Music) – in some cases; in other cases it's still marginal – it's done more out of the tradition of theatre, it's more about narrative, it's more about someone like Tim Miller getting up at the alternative 'Highways' performance space in Los Angeles that he runs and telling you his personal stories. It's less the kind of raw experimentation with the body that really interested me, from the mid-1960s to the mid-1970s.

JH In that case, would you say that 'performance art' is a curatorial invention, or an art-historical category that's been –

AJ I think it's invented by multiple sources, one of which is the artist, one of which is the venues, such as the Brooklyn Academy of Music, hosting a Laurie Anderson performance.

JH I'm just wondering if we can track the coinage of the term...

AJ One important source is RoseLee Goldberg, who has quantified, defined and historicized what she calls performance art in a series of books that have been published which are considered to be definitive. They're not deeply scholarly or theoretical books, but they document a range of performance art practices, going all the way back to Dada and Surrealism or focusing on the 1960s to the present. Goldberg is the person, more than any other, who has codified the notion of performance art as a discrete medium [see for example her book, written with Laurie Anderson, *Performance: Live Art Since the '60s* (London: Thames & Hudson, 2004)].

JH Did Goldberg either deliberately or inadvertently create a canon, therefore, of performance art activities and events?

AJ Oh yeah, absolutely, I would say that this recent glossy book, just published in paperback, is presented as the definitive book on post-1960 performance art.

JH When you're starting to deal with more contemporary practitioners, are we talking then about the early 1990s, mid-1990s? Because you've written about and become involved with some practitioners, haven't you?

AJ Well, I started doing that with the *Body Art* book. The last chapter of *Body Art* is about (then) contemporary work and the uses of technology, and this work actually leads into what will be my next book [*Self/Image: Technology, Representation and the Contemporary Subject*].

JH How did the publishing you started to do dealing with contemporary artists become bound up itself in some way with their activities as producers and with the marketing of this kind of material?

AJ Well, I'll tell you exactly what happened. When I started publishing first articles and then the book on *Body Art*, I started getting invited to give papers, sometimes just in general, and then I would give a paper on

body art because that's what I was working on, and then gradually over the years from the mid-1990s onward, I started getting associated with body art. So younger artists doing live art at the time started sending me their material, galleries started contacting me, and I started getting involved in a network of people, especially in Los Angeles, doing performances and body art. On my own I did keep pursuing my interest in people using photography, people using other media (again, that points to my next book project).

JH How did that involvement with artists affect the way you started to think about what you were doing yourself as a writer and as a teacher?

AJ I guess, in the best-case scenarios, the artists I think are the most interesting are the people who, when I see them perform or when I look at their work, I feel really inspired me to be more performative. And then as I got to be better known and I actually started knowing some of the artists, that situation creates a much more complex relationship in terms of writing about not just live art but also photography and all sorts of other media. Once you know the artist then, in a sense, whether you admit it or not, your relationship to the work is *itself* performative, because it's ongoing, it's in process.

JH By 'performative', what do you mean?

AJ I mean performative in the sense of 'in response to', in 'engagement with', 'reciprocal, in process, playing out over time'.

JH It may actually lead to development in the art work – you become dialectically involved with the artist?

AJ Yes, exactly. So my book *Irrational Modernism: A Neurasthenic History of New York Dada* [Cambridge, MA: MIT Press, 2004] is, in a weird way, reflective of my desire to actually see if that would work for historical material; to go back in history and see what it means if I engage with it in a kind of pseudo-live way, as it were. Because I think

when we do history we're also identifying with certain figures, we're engaging with them: what does it mean if we allow that to open up, instead of closing it down by trying to come up with a conclusive meaning?

JH Can we talk now about *Irrational Modernism* and its focus on the 'proto-feminist', 'proto-body artist' Baroness Elsa von Freytag-Loringhoven? Presumably you'd been aware of this figure and her life and world for a long time?

AJ I wrote my Masters dissertation on Man Ray, and I did my PhD on Marcel Duchamp, so I've always had this engagement with the 1910s and 1920s, and then with the post-World War II period. In fact, what happened was that I'd organized a huge show, the *Sexual Politics* exhibition [*Sexual Politics: Judy Chicago's 'Dinner Party' in Feminist Art History*, UCLA-Armand Hammer Museum, 1996] and it was so emotionally painful dealing with the criticism and flak – including dealing with feminist artists and scholars, some of whom were extremely difficult – that I then decided, strategically, to do a historical project. I wanted to go back to look at the Dada/Surrealism period, particularly the Dada period; but I wanted, again, to inflect it with this new understanding that I was gaining from working on performance. And the New York Dada material was particularly ripe, I thought, because there's a lot written on it that's very anecdotal, 'straightforward' – documentation of who was where when, what was going on – but there was very little theoretical analysis of this material.

I was dimly aware of the Baroness, because her picture appears in the one issue of *New York Dada* (the magazine they put out). But she started to leap forth, and I started to – without even strategizing it, I realize now – attach myself to her. So it seemed like a great way to play out this issue of historical engagement, in terms of, 'if we're watching live art, obviously you're attracted or repulsed by someone who's standing right in front of you: but what does it mean to take that same kind of awareness back to someone who died in 1927'?

2 Baroness Elsa von
Freytag-Loringhoven, 1915
© Bettmann/Corbis

JH It seems odd that this person hadn't really been written about much before, in art-historical terms. Is that right? But there must have been awareness of her existence. Or do you think there's a way in which she's been ignored within art history?

AJ Yes, one of the things that attracted me to excavating her and putting her front and centre was precisely the desire to examine that issue again of why she was marginalized. From the time in which she was with the New York Dadaists, she was already frightening to them, and they were already finding ways to marginalize her, and she was marginalizing herself. What can be made of all that from a feminist point of view?

JH In terms of the historiography of Dada and Surrealism, would you say that – although there's been a lot more work recently done on women within those formations – there's a particular problem that both male and female historians have with women in Dada and Surrealism?

AJ Well, the problems are complex. It's obviously not adequate just to excavate someone and put her front and centre, because the Baroness wasn't front and centre. The fact is that women *were* marginal within the modernist movement in the early twentieth century, they knew they were marginal, and some of them – I'd say most of them – participated in their marginality because that's what they felt their place was. So it's very complex. The Baroness was unusual because she was extremely aggressive. So unlike some of the famous wives of Surrealists who hung in the background, she really wasn't interested in that. She was very proactively sexual; she did all these things – if I engaged with them in a certain way, I felt, and strategically emphasized them – that could

perform this role of disrupting the orthodox narratives of New York Dada. So I wanted to confuse, deliberately confuse, her 'performativity' – including these weird objects that she picked up and made into art, as well as these costumes that she would wear, and the actions that other male artists would write about – I wanted to confuse all that in relation to the historicization of New York Dada.

JH She also remained unconnected to men, didn't she? That is, she wasn't involved in a long-term relationship with a man. That must have had an impact on her status as well.

AJ She haunted people; she tried to seduce people like Duchamp and William Carlos Williams. One of the fascinating things is that she's written about in so many of the texts from the period, but always – or usually – very peripherally; though in the case of William Carlos Williams for a brief period he was quite obsessed with her, but also very frightened by her. Again, examining the Baroness was a way of both rethinking New York Dada not just in the typical sense of looking at it from a different point of view, but also using the disruptiveness of this 'performative' figure to rethink the way we do art history.

JH Should it also be surprising that she wasn't picked up on, or doesn't appear to have been picked up on, by feminist historians writing in the 1960s and 1970s? Is there a sense in which she's also threatening to women?

AJ No, I think that's a timing issue. She has been written about a lot in the last three years.

JH By people working in what areas?

AJ Well, Irene Gammel is a literary historian who wrote a biography of her that came out just before my book [*Baroness Elsa: A Cultural Biography/ Gender, Dada and Everyday Modernity* (Cambridge, MA: MIT Press, 2003)]. So I don't think it's that she's threatening to feminists.

3 Baroness Elsa von
Freytag-Loringhoven,
*Portrait of Marcel
Duchamp* (gelatin silver
print, 245 x 195mm),
photograph by Charles
Sheeler, c. 1920, the Bluff
Collection

I think it's more the case that, if you look at the trajectory of feminism, you'll see that it's primarily in the 1980s and 1990s that the really serious work comes out which rehabilitates these lost women in modernism, including, for instance, Djuna Barnes. It's a much more powerful movement in literary studies than it is in art history, but there's some of it going on in art history.

JH Would you say that what art history is today is more able to begin to deal with some of these issues in general, or is it not really prepared to engage with these questions?

AJ Well, we'll have to see how my book is reviewed! I got a wonderful review in *Bookforum*, the *Artforum* book review magazine. I'm always frustrated because I write these books that I feel are intervening in this very dramatic way, and the problem is it takes a long time for that to show, because – my perception is, now that I'm old and wise [laughs] – that it's really the students who are the most affected by something that's really new. And I found that, with *Body Art*, it's the younger generation of people who come up to me at conferences and who say 'You're the person who wrote *Body Art*', that kind of thing. Whereas with my peers, though we'll use each other's work, sometimes there's also competition in terms of who came up with what idea, and there's less explicit acknowledgment on that level.

3: Avant-Garde and the Work of Art

JH Can we move on now to a further set of questions which are in some ways more general (though it would be wise to tie the issues they raise down to particular examples rather than talk too abstractly)? I want to broaden out some of the things we've been talking about into a

discussion of developments in art, culture, the study of art and culture, history and politics.

We've touched on some of these questions already – with mention of *Screen* magazine, feminism and socio-sexual political theory from the 1970s up to the mid-80s. I think it's always useful to consider some key concepts that, complex and difficult as they are, never really go away and people go on using them. We've talked about 'performance' and some aspects of your relationship to that term; 'body' was also raised. Others that I think we should examine are: 'avant-garde', 'spectacle', 'document', and 'art work'. I remember you sounding very sceptical, at the Tate Liverpool conference on performance art [held on the occasion of the exhibition 'Art, Lies and Videotape: Exposing Performance', Tate Liverpool, November 2003–January 2004], about the ways in which it was possible to think now about the existence of a serious contemporary avant-garde – how contemporary art might be defined as avant-garde in ways in which, historically, that term has been used.

AJ My *Irrational Modernism* book is, among other things, a rethinking of the notion of the avant-garde and a critique of the way in which the term has become reified. So one of the things I examine, for example, is the idea – and my Duchamp study also deals with this at some length [*Postmodernism and the En-Gendering of Marcel Duchamp* (Cambridge: Cambridge University Press, 1994)] – that the Duchampian readymade is the *Ur*-historical avant-garde object. This assumption or claim comes really out of Peter Bürger's *Theory of the Avant-Garde* [1974; English edition Minneapolis, MN: University of Minnesota Press, 1984]; it's just a thread in there, but it becomes absolutely reified in the dominant notion of contemporary art that gets codified from the 1980s onwards in New York in the work of art critics such as Benjamin Buchloh and Hal Foster.

So, again, a figure like the Baroness, for me, is a way of complicating that story historically, and saying: wait a minute, there was a lot of other stuff going on, and a lot of it was really irrational. In a sense, to take the readymades and make this neat lineage is a rationalizing move that

4 Marcel Duchamp,
Hat Rack (metal) and
Urinal (ceramic), 1917,
private collection,
photo © Cameraphoto
Arte Venezia/Bridgeman
Art Library © Succession
Marcel Duchamp/ADAGP,
Paris and DACS, London
2007

actually erases the complexity of history, it erases the practice of bodies
in performance, it erases the practice of women, it erases people who are
inconvenient, who don't fit into that logic. Just to extend that, I think the
notion of the avant-garde – that was a very useful notion, by the way, I'm
not dismissing...

JH Bürger's account?

AJ Bürger's account and Hal Foster's account, and Rosalind Krauss's. I'm *not* saying they should just be dismissed, because obviously the notion of avant-garde was extremely important for a certain movement that took place in theorizing and historicizing art in the 1980s. But I think we can no longer pretend that this model makes sense in relation to contemporary practices in 2005. In fact, we have to re-evaluate the whole history of what we're thinking of with the avant-garde.

The final point I make about the Baroness really is that the reason that I'm not the only person suddenly to start writing about her is precisely that this irrational, messy kind of practice speaks more to the present moment. It's not that the readymades no longer matter, but it's that there are different moments when different historical practices become useful as touchstones. Right now we need to rethink what cutting edge or avant-garde practice *is*, because the readymade model just doesn't accommodate this other kind of irrational practice, which is much more to the point with someone like, for instance, Tracey Emin.

5 Tracey Emin, *My Bed* (1998), mattress, linens, pillows, rope, various memorabilia, 79 x 211 x 234 cm, courtesy the artist and Jay Jopling/White Cube (London), photograph by Stephen White

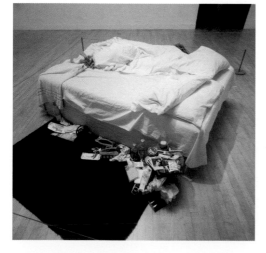

JH The problem with the category of the avant-garde is that it has all sorts of historical baggage which we need to deal with one way or another. Hanging over it, and going back to Greenberg's famous 'Avant-Garde and Kitsch' essay (1939), for instance, is this idea that there has to be a 'mainstream' of art against which the avant-garde is pitted. That's one reason for saying we can't have this category any more, because there appears to be *only* avant-garde in art now, or something that calls itself, or gets called, avant-garde –

AJ Well, that's the joke, right? Artists had figured that out by the 1980s, by the Reagan/Thatcher era. This is the Warholian dilemma – every act gets read as 'critical', and yet much of

what he did overtly embraced spectacle and the commercial realms of the art market and celebrity. So the avant-garde can no longer be thought of simply (in Bürger's terms, or Benjamin Buchloh's) as art practices that 'critique' capitalism. In Warhol's case, clearly it's about confusing the boundaries between avant-garde and kitsch.

JH Yes, that's certainly what happened at least then, if not earlier in some ways – you can see it in Rauschenberg's prints and combine-paintings.

AJ You can see it in Dada to some extent (for example, the single issue of *New York Dada* [1921] includes ridiculous, parodic imagery that plays on women's fashion advertisements).

JH Of course. So: on the one hand we're dealing with the idea that there has to be a mainstream or opposition that makes the term 'avant-garde' meaningful in the first place, that's one big problem with it. Secondly, there is, as you say, this idea that 'avant-garde' has in various ways been idealized by different camps. There's the formalist idealization of the idea, associated with Fried, or Greenberg's later writings; and then you've got the Marxist idealization of the idea of the avant-garde as well, haven't you? So there are three or four different necessary critiques all in there together.

AJ Yes, and Bürger's, of course, is the kind of Marxist version. But in some ways it is quite compatible with Greenberg's opposed, Modernist, version.

JH Yes. Would you say that the category 'avant-garde' – in fact, the idea of *the* avant-garde, because that tends to be the phrase that is used, in which the idea of plurals is almost lost as well – would you say that the notion of *the* avant-garde is no longer a useable notion, that it has no purchase or critical value in dealing with contemporary art?

AJ I would say that's pretty close to my position.

JH OK. Once that's clear then there are various different perspectives that are taken on this situation, aren't there? One is to say that that is a defeatist way of denying the possibility of any kind of contemporary art *ever* having a critical, subversive role. Now, presumably, you're not saying that?

AJ Not exactly, although I would say that I think the fact that we keep reverting to the idea of 'criticality' or 'subversion' is part of the problem, because that is in itself part of this avant-garde idea, and, in fact, what artists are telling us – whether consciously or not, artists like Matthew Barney and Tracey Emin – is that there is no opposition. There is no – you can't – I mean for God's sake, look at what's happening in the world! You can't just 'critique' something. Obviously, in every way, the idea of 'critique' is a failed operation. As Warhol made clear almost forty years ago, it just doesn't make any difference: because late capitalism will simply accommodate whatever critique you make.

JH The danger is that this could be read as a defeatist position.

AJ It's not defeatism, though – it's realism. The point is that you have to acknowledge it and then...I don't have an answer for what to do. But I will say I fight every minute of every day to try to figure it out, and I think all interesting and smart people do that. I, personally, am revolted by Matthew Barney, for reasons I haven't entirely figured out. But I do think that on some level, whether it's instinctive or not, like Tracey Emin, he is trying to figure out what to do. He comes across as incredibly smug and self-promotional, but there's no question in my mind that the most interesting people making culture in any field are still trying to figure out what to do. They're not just defeatists, but they acknowledge that the idea of critique as it was posed in the 60s and 70s doesn't hold any more.

JH It doesn't hold partly because we don't associate contemporary artists – and again, there's a way in which this is also a historical delusion – with socialism or Marxism, for instance. Even up to the

1960s, a lot of artists, even (especially?) the ones who were, in Greenbergian terms, 'formalists', held Marxist or anti-capitalist anarchist views – Barnett Newman, for instance. But it's pretty clear from the comments that someone like Tracey Emin makes, and she writes and is interviewed endlessly in Sunday supplements, that she doesn't have any kind of political analysis, or that she rarely brings anything like that into anything she says.

AJ Right, but maybe what she's doing is political in a different way – that's what we have to figure out.

JH But what I'm getting at is that there was an idealization in the 1990s of 'Brit-art' from one perspective that it *was* a continuation of a subversive, left-wing –

AJ But how can you have that view when it's being marketed by an ad agency person? I mean for God's sake, it's in the Saatchi collection!

JH Exactly. You have to bring in notions like 'appropriation', don't you?

AJ Brit-art's a perfect example: before it even gets out there it's already incorporated into the market so thoroughly that it can't be critiquing it – at least, not in the way that was historically thought to be the aim of the avant-garde. Think of the Chris Ofili painting of the Virgin Mary that drove Rudolf Giuliani [then Mayor of New York] to paroxysms of reaction when it was exhibited at the Brooklyn Museum in 1999. There's a powerful example: obviously the work is already incorporated into the Saatchi collection; this show was one of the first times in history that a collector, who's also a businessman, is orchestrating the hanging of his own collection. Talk about a conflict of interest! But at the same time you have the potential for a work within that show to provoke this intense reaction that creates a debate all over the United States about censorship. That's what we need to look at, those moments when something – even if it's already incorporated into the market – provokes and creates dialogue,

and maybe shifts the debate slightly, makes people more aware of the importance of certain issues.

JH Yes, though its effects may be, or appear to be, very minimal or small-scale.

AJ Well, the irony is its effects would have been nothing if the forces of reaction hadn't decided to make a big deal out of it. That's exactly what happened with Jesse Helms and the whole censorship controversy in the US in the 1980s and 1990s – whoever would have heard of Karen Finley, one of the performance artists targeted by Helms and his crowd for making 'obscene' work, if that hadn't happened?

JH Well, Tracy Emin's bed may not have had much press in America, but it had an impact in Britain because it was photographed in the newspapers containing condoms and all the rest of it, bottles of whisky strewn over the floor around it – it had a similar kind of rhetorical power that the Ofili piece had. It could be linked and related to – and it was, by various hopeful people – feminist or proto-feminist positions, and seen as 'political' in various ways.

AJ Well, I used to dislike Tracey Emin's work a lot because of the self-marketing, self-promotional aspect, but I've actually grown to appreciate it a lot more living in Britain. I can see how it works much better living here. In the US it just comes across as the art of another apparently white feminist – even though she's actually part Turkish, but she's marketed basically as a white person. She comes across as yet another middle-class mainstream person trying to do Warhol, or the Jeff Koons kind of trick. Whereas here, over and over again I've been corrected when I've presented that view, and I've come to realize that, in fact, it *is* much more complex in terms of how she's identified, how her 'working-class transgression' reads here very differently. In the States it just reads like another brat, another middle-class white feminist, or pseudo-feminist, or post-feminist, whatever. I think it's much more interesting if you know more about the class structure here and how it functions.

JH OK. You seem fairly clear, though, that you no longer believe that the category of the avant-garde is useable, is that right?

AJ Not at all, not in the sense in which it was articulated historically or by Peter Bürger, no.

JH Arguably, two things follow from that. One is that there has been some fundamental break in modern art, which has rendered the situation unlike any in the past. If we take Bürger's category of the oppositional, anti-capitalist 'historic avant-garde' seriously, then at some point something happened to modern culture and society –

AJ It's called late capitalism!

JH – Or do you think that there was *always* basically a rampant idealization of avant-garde art and culture?

AJ Both and neither, because I wouldn't say it's a radical break. I would say it's a rupture, but it took place at the time the first historical avant-garde piece was created.

JH Which was when?

AJ I don't know ...If you say it's the readymades, you can say from the moment Duchamp picked up a bicycle wheel in 1913, the seeds of its own dissolution are there, because once you break down the boundaries... That's the paradox, right? There's nothing to say that this is anything but a bicycle wheel except for the fact that Duchamp is considered an artist, so what do you do when the bicycle wheel's been so successful that there's no such thing as being an artist any more?

JH Can you just talk a little bit about why you choose the readymade as the emblem of authentic avant-garde?

AJ Largely because it's been discursively produced as such – in Peter Bürger and it gets pulled out by Hal Foster and Benjamin Buchloh in particular as the kind of *Ur*-avant-garde object.

JH And are you agreeing with that view, or are you just seeing it as a pivotal moment in the history writing?

AJ It's discursively real, in the Foucauldian sense of 'discourse': it's a discursive phenomenon that thereby is 'true'. But what I'm doing with *Irrational Modernism* is pointing out that there was a lot of other stuff going on – let's rewrite the history to return some of the conflictedness and irrationality, thereby enriching our way of understanding what we're doing now. To me, there is no history that pre-exists discourse.

JH But that perspective can lead two ways art-historically, can't it? You can rewrite or attempt to critique the idea of avant-garde either by saying that you shouldn't isolate elements from the flux of life, from a whole set of phenomena, a position I agree with. Or you can say that a critique of the avant-garde means saying that artistic conventions were being examined and reorganized as well as new ones added in traditional media much earlier. This was T. J. Clark's argument about Gustave Courbet – that the avant-garde starts with Courbet, and then Edouard Manet. [*Image of the People: Gustave Courbet and the Revolution of 1848* (London: Thames and Hudson, 1973); *The Painting of Modern Life: Paris in the Art of Manet and His Followers* (Princeton, NJ: Princeton University Press, 1984)]; once you start pushing the origins back...

AJ That's why I refuse to have debates like that, because to me there is no fact that you can excavate that will prove who was the 'first' avant-garde artist. It's discursive. If Clark says Courbet was the first avant-garde artist and everybody then reframes the way they understand the avant-garde, then Courbet *is* the first avant-garde artist. What's the point of that? It's a mildly interesting point of debate maybe, but it doesn't tell us anything true about history.

JH Well, it's a different history of the avant-garde isn't it?

AJ Yes. I mean that's fine, in a sense that's perhaps analogous to what I'm trying to do. I'm trying to do it with more self-consciousness about the performative nature of how history gets written.

JH It's very hard not to reify interpretations into 'facts' – it seems that academic disciplines, history in particular, and art history, tend to form categories of objects.

AJ Oh yes, more so than other disciplines in the humanities, because the objects themselves are 'unique' and they're worth money, so the stakes in categorizing are much higher. What Peter Bürger had to offer was the awareness of that particular nature of the art market, which absolutely underlies everything that art historians do; we may want to distance ourselves from connoisseurship, but...

JH I remember reading Bürger's book as an undergraduate, and it was very convincing and exciting to read in some ways, but it strikes me now as being based on an idealization – an idealization of what art could do and what artists are.

AJ And, by the way, the lure of Duchamp – as much as I want to critique those simplistic models – I do keep coming back to Duchamp because he is so fascinating and so complex; the more you study his work the more you realize it resists precisely these simplistic notions about 'avant-garde' that are applied to it.

JH Again, it's this matter of separating out elements and calling them 'artworks' or whatever.

AJ Exactly; that's the greatest irony of all. That was his primary point with the readymades, and yet his designation of readymades was precisely what enabled people to establish him as the originator of

postmodernism – it was precisely the paradox which then got reified as a radical gesture.

JH So, if we have this radical instability to the category of art, and the work of art – what a work of art involves, which is partly what Duchamp represents – what about that term 'artwork' as a category that might have some contemporary purchase? Or has it just become bland as well, like 'avant-garde'?

AJ It's an empty category. And again, I refuse to have debates about whether or not something is or isn't an artwork. It's pointless; it's a tautological exercise, because it's based on what you conceive an artwork to be, so you can only argue endlessly. But I am fascinated by the debates that accrue around particular things. Here's an example: David Blaine, the guy who hung in his little cage over the Thames in London in 2003 – he's a magician. I was fascinated by the way, over the weeks, this event started being articulated by the *Guardian* and by other newspapers as an 'artwork', when in fact my perception, at least in the beginning, was that he wasn't presenting it as an artwork at all – though it evolved into a performance art piece. I'm fascinated by that – I have no interest in debating whether or not it *'really is'* performance art, or art, but I'm fascinated by that shift that occurred, and the way in which it's discursively performed. The way in which it's written about and perceived establishes what it ends up 'being'.

JH In the tradition of thinking about the avant-garde that we associate with Greenberg and later with Fried, writers tend to drop the term 'avant-garde' and start to use 'modernism', supposedly a less politicized or politicizing category. Then, through to Clark, arguments are centred around the defence of the idea of the modern artwork, and specific, selected artworks. Clark doesn't make essentialist arguments, but he *does* want to identify certain artefacts as having value, very high value: 'aesthetic value', to use the Greenbergian/Friedian phrase.

AJ Well, the interesting thing is when aesthetic value *becomes* political value, for the art historian, right?

JH I wanted to ask you about value and how – obviously, given you don't want to elide debates around meaning and value and significance – how do you see the question of value in relation to all the things we've been talking about?

AJ Oh, I think it's really central. Value for me is part of the larger question of identity and meaning. The book after the next book I'm writing is called *Identity and the Visual*, and it's about two things. It's about how we give what we perceive to be an artwork or a performance art piece value, how we give it meaning, and what that has to do with the artist – because value usually, almost always, is conflated with the artist. And then the second thing the book is about is how identity politics have informed the way art is produced and the ways in which it's interpreted and institutionalized.

JH This seems to me to be a way in which the category of performance remains important – not in terms of being a narrow, orthodox thing; instead you're talking about the *active constitution* of things, aren't you, and that's what performance in a way means, doesn't it?

AJ Yes; but I would probably use the word 'performative' rather than 'performance', though it's certainly related.

JH 'Performance' has all sorts of connotations, doesn't it?

AJ Yes – 'performative' is its adjectival form. The performativity of meaning and value is what has always interested me, but for the *Identity and the Visual* book, I really want to focus on it in terms of aesthetics: Kant, all the way through to Greenberg, but also in terms of what happens when identity politics starts to play an overt role. My next book is called *Self/Image*, and it follows on from the last chapter of *Body Art*, dealing with the body and technology. It's about the way in which artists

have pushed the boundaries of various imaging technologies in order to interrogate aspects of value, meaning and subjectivity, all of which are often interconnected in the visual arts.

JH It's subjectivity, or 'subjecthood', that we haven't directly talked about yet, isn't it?

4: Subjectivity, Specialism and Spectacle

AJ Subjectivity is at the core of what I'm interested in, in the same way that value is, because to me they're interconnected.

JH How do they relate to the body, to mention that other indispensable category?

AJ Well, my *Body Art* book is about how, for artists in the late 1960s, suddenly the body gets enacted as the means through which meaning – otherwise known as the identity of the artist, otherwise known as aesthetic value, and so on – gets articulated. So the question that that book asks is: why does the body suddenly re-emerge in that way, why? It doesn't finally answer the question but it explores it.

JH One of the problems with the term 'body' and the way it's often used is that it lends itself to fetishization, doesn't it? To distinctions avoiding the relations between mind and body?

AJ I think what happens is that the body becomes abstracted as a term of analysis. I'm editing a book on contemporary art now that in many ways is addressing in a really interesting way all of these issues that you're pointing out, because each chapter is by a different person: Christine Ross writes the chapter on the body, where she asks: why is it that suddenly everyone's talking about the body, but they're not really doing anything different, because they're abstracting and it becomes simply another term of analysis? Her point is that few people have deeply understood the body as the means through which art is being produced and received [Christine Ross, 'The Paradoxical Bodies of

Contemporary Art', *A Companion to Contemporary Art Since 1945*, ed. Amelia Jones (Oxford: Blackwell, 2006)].

JH It's also that – as you can see in a lot of contemporary art (I'm deliberately not using the term 'performance art' here) – the use of bodies is so easily swallowed up by the mass media, overtly sexualized into a kind of pornography, isn't it?

AJ Well, in the *Self/Image* book I look really deeply at the ontology of different media; so, for instance, there's a chapter on analogue photography. What does it mean when Claude Cahun or Cindy Sherman repetitively represent themselves in photographs?; how does this kind of self performance get played out?; how do we understand the work in relation to the artist?, and so on. And then I work my way through to the present, I deal with video, robotics and digital media. There are also some 'intertext' chapters which are very brief and which foreground particular performative practices. Some of the people I want to foreground are people like Guillermo Gómez-Peña, an absolutely brilliant Mexican-American artist working in California. He does group performances, including the one at the 'Live Culture' event at the Tate Modern in spring 2003.

JH What does he do?

AJ Well, this series of performances is called *Ex-Centris*. He gets these different performers, each of whom has a subtly different ethnic identity, and they get on these platforms as if they're in ethnographic museums. They're very powerful – talk about breaking down the opposition between avant-garde and kitsch! They're funny, but they're also very unsettling. I've never laughed so hard in my life: in a 'lecture' he gave during 'Live Culture', he was doing a fake BBC interview, talking about his work and then it degenerates into this rant about how mad he is about Bush and the Iraq war and the mistreatment of Mexican-Americans, and he starts getting bleeped out, he's just bleeping himself out. Very funny. Daniel Martinez is another (also based in California). He made a robot of himself, it looks exactly like

6 Guillermo Gomez-Peña and La Pocha Nostra, *Ex-Centris*, performed as part of 'Live Culture', Tate Modern, 2003, photograph by Manuel Vason

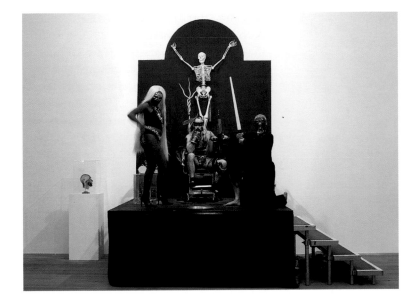

him and it's life-size, and it sits in the gallery and it repetitively slits its wrists. This is what I'm interested in: it doesn't have to be live art per se, it's work that is still in some way negotiating the border between live art and representation.

JH On this question of technology: has there been some clear, or more complicated, change since video, since that moment when it became possible to play back stuff quickly and break things down and fragment them?

AJ I think the shift has more to do with generational dynamics – *when* artists were born, and what kinds of culture they were exposed to as they were growing up. For instance, you can really tell the first generation of artists who grew up watching television.

JH How can you tell? What are the signs?

AJ Well, I think the people who start goofing around with video are the people who *might* have watched television; it's hard to say, because they'd have grown up in the 1950s. The nth degree example, though, is Pipilotti Rist, a Swiss artist who is obviously deeply immersed in MTV and is a rock star and uses video in this very sophisticated – *seemingly* very sophisticated – but actually technologically very simple ways. So the difference would be between Vito Acconci's generation and Pipilotti Rist's generation. She's exactly my age, she was born in the early 1960s. And it'll be interesting to see the people who are now kids in more or less privileged environments who have grown up with the internet. They're going to articulate their whole sense of embodiment differently, because they're wired to the world.

JH Does this relate to the category or concept of live art? 'Live art' is one of those terms I've never really been able to pin down. When did that term come into usage, do you know? It's quite recent, isn't it?

AJ Personally I became aware of it as a more codified term through the people who organized the 'Live Culture' event at the Tate (in particular Lois Keidan, and her collaborator Adrian Heathfield, who's an academic; Keidan and Daniel Brine run the London-based 'Live Art Development Agency'). Through such efforts they have revitalized performance (or live art) far beyond what's happened in the States.

JH Why is that, do you think?

AJ Although there's a lot of performance going on in the States, there isn't really a feeling that there's some new wave of people thinking about performance, and that's what I really feel here in Britain.

JH Can we talk now about the category of 'spectacle'? I've always been rather dubious about it in some ways, a bit like 'avant-garde'. If you read Guy Debord's *The Society of the Spectacle* [Detroit: Zone Books, 1977 (1967)], you realize it's a bit like some of Marx's very prescriptive writings (such as *The Communist Manifesto*), basically a set of rhetorical

assertions. At the same time, I tend to look around and think 'Debord's right, it is like that'. However, I don't think 'the spectacle' is finally valuable as an analytical category – it's too rhetorical and polemical. Is it a term that you use?

AJ Yes. Though I do think, exactly as you have just said, that on the one hand you read Debord's text and it's almost fascistic, in a left-wing sense. Rather like the way that, you know, Jean Baudrillard can be incredibly irritating, especially his writings on Disneyland as simulacrum and so on, if you've actually lived in southern California for a long time. But at the same time, you read Debord and, though things have not panned out quite the way he suggests, and it is way too programmatic, it's clear that what he calls the spectacle *has* to be dealt with. It's so pervasive; it pervades even the more staid media like the newspapers, they're all, in some weird way, spectacularized. They're not just about conveying the news, they're about playing on, and playing up, and re-creating their own spectacles.

JH I've thought about this question for years and never really managed to clarify it: do you think there's a way in which, since the 1960s the reorganization of 'the visual', 'visuality' – 'visibility', 'visuality', whatever we call it – has somehow radically, fundamentally and forever outstripped what artists can do in visual terms? That the spectacle pre-empts, always, whatever developments you might see in an exhibition, that somehow they're already writ large, to a gross excess, in the visual structure of our culture and society now?

AJ That sense might get someway towards why I find Matthew Barney such a failure, because, precisely, as you've said, you walk into the Guggenheim Museum and you're literally assaulted by obnoxious 'art' video, movies, ridiculous objects – and yet, as you say, it's so pathetic, compared to walking into Times Square, a mile or so away.

JH Or turning the TV on and getting challenged –

AJ Right. And then you have the deification of Matthew Barney by the art world, and these endless eulogies about how brilliant he is: but what is he doing that hasn't already been done much better in feature films or in Broadway theatre?

JH Well, the justification tends to be that there is some level of *critique* going on.

AJ Exactly. So it's slipping right back to what I think is an untenable, outmoded avant-gardist argument. There's no critique there. And if you read what Barney says he's doing, there's no 'intended' critique at all, as far as we can discern what he means to do.

JH Well, who's making the claim that there's a critique going on?

AJ It's implicit in everything that's said about him in the art press, that somehow his work is *commenting on* spectacle.

JH There's a way in which the professionals involved in writing about art – academics or critics or whatever – need to hang on to certain illusions about what they're doing and what it means.

AJ Oh yes. Myself included – that's very hard to get away from, this idea that every contemporary artist you write about is in some way 'critiquing' or 'subverting' something. I mean I certainly haven't escaped that at all. I'm aware that it's a kind of knee-jerk response, but...

JH What lies beyond that?

AJ Well, that's the question. One of the things I think is so excellent about being in Britain and seeing this group of people working with 'live art' is that I do feel they're trying to push beyond that, and I'm trying to do that as well, but... I guess for me it's about connecting to artists like Guillermo, who I feel are doing something much more interesting than just critiquing or subverting.

JH Do you think that we also have to invent new institutions that will make this work meaningful in a different way? Do our cultural and art institutions lag behind new work? That we're stuck with the same old institutions, cultural spaces, and that they always/already appropriate fundamentally the meanings and the kinds of work that might be done?

AJ Absolutely. Well, why are we teaching art history as a separate field? Anyone who's teaching anything after 1900, for God's sake, should be teaching performance and film and I'm trying to do that but it's not easy, because the university as an institution is not set up for me to do that. Do you know how hard it is just to get equipment? It's very hard, in practice, to break down those boundaries. Art history is programmed to be taught through dual slide projectors. It's not that people are horrified that I'm trying to do this, it's just that it's profoundly difficult to do logistically as well as ideologically, because as you say, the literal structure of the rooms does not lend itself to doing it, the whole structure of the curriculum doesn't lend itself to doing it, the equipment's not there. And of course my own mindset: for better or worse, I went to Harvard, and I use PowerPoint now but I still use dual images most of the time. Sometimes I use more than two, I try to mess that up, but it's very hard for me to get beyond those boundaries as well, even though all the work I'm interested in does that.

JH OK. Could we talk now more about the broader contemporary social-historical context and how this relates to developments in art, and in art history and theory? Before, we were talking about the idea of spectacle, and trying to think of ways of characterizing transformations in visuality, or in what we might call the 'macro-structure' of the visual world, and how that has developed and changed within 1960s late capitalist/consumer society. You seemed to be suggesting a minute ago that art history is anachronistic now. Is that true, in some basic way? Could you talk about that a bit more in relation to contemporary art? How is this situation related to developments in technologies of visual representation – is that one of the things you might have meant by it being anachronistic?

AJ Yes. Well, it's anachronistic and it's extremely limited and it drives me crazy, but at the same time I think I need it [art history] as a kind of site of resistance on my own. One of the things that interests me about artists such as Guillermo Gómez-Peña is precisely the way in which his performances destroy all possibilities within the conventional discipline of art history of placing what he's doing.

JH This goes back to some of the earlier discussions we had when you were suggesting that the interdisciplinary aspect of this area of practice – call it whatever you like, 'performance' or 'live art' – was in some way itself a radical critique of the organization of knowledge, is that right?

AJ I think that's right. The best of it is, I think.

JH Would it be pushing it too far to say that there's a way in which the most interesting contemporary practice in the visual arts – very broadly defined, including film; areas outside of 'fine art', as it were – pose some kind of challenges to the organization and the study of culture?

AJ Yes, I think that's right.

JH And that art history represents the most conservative, orthodox –

AJ In *some* ways it's the most conservative, yes.

JH Tricky, isn't it, because 'art history', on the one hand is just the name for an area of study, a university department, it's quite vacuous in one sense; but then we fill it up with orthodox practices in the way that the subject is organized and broken down into specialisms and all the rest of it. But there's also a sense that since the 1970s we've had radical developments in art history that have in some ways changed it and pushed it on. But I think I agree with you, probably, that by the mid-1980s those developments ran out of steam, for all kinds of reasons – for extra-academic reasons, really – and settled back themselves into new kinds of orthodoxies.

AJ Yes, and because art history has been notoriously unwilling to allow its own disciplinary boundaries to be eroded; and so at the same time as people are writing treatises about avant-garde artists breaking down the boundaries between such-and-such and such-and-such, they are vigorously maintaining the boundaries that allow them to stay in a position of authority. And one of the things I've critiqued from the very beginning of my career is exactly that kind of hypocritical dual project, where you're talking about the readymade as a radical critique of the institutions of art, at the same moment as you're using that argument to establish your own position; or you're talking about Duchamp as the father of postmodernism, which is an obvious contradiction in terms, since postmodernism is supposed to be about the unsettling of origins and centres. Those are the kind of things that fascinate me – if you compare art history to, well, at least in the US, to 'literary theory' or an art history department to what would be called an English or 'Comp Lit' department, the people in literature-related areas have not been afraid to question the limits of these disciplines; and as a result a lot of literature or English departments have hired film, 'visual culture' or 'new media' people; they're not worried about it (although, in practice, they may know nothing about art history – which has become a relatively isolated field in some ways). You have to ask why: what is it about art history that makes it so anxious about allowing into its purview anything other than what can be projected on dual slide projectors?

I could just add that one of the suggestions I made when I first came to the University of Manchester was to change our name to 'Art History and Visual Studies'. I actually would have preferred just 'Visual Studies', but in Britain I think art history has actually been much more permeable and dynamic, so perhaps it does make sense to keep both terms. In the US – strangely enough, because obviously it's much vaster and you'd think there would be more diversity – art history departments are much more conservative. You can count on one hand the number of programmes that call themselves anything other than 'art history' – one of the main ones is at the University of Rochester (the Visual and Cultural Studies department).

JH Is it the case that in the orthodox teaching of art history there is still what you would call an ideological commitment to certain key notions that underpin the survival of it?

AJ Absolutely.

JH – traditional notions of 'the author', 'the artist', 'the artwork'? Because all those notions have gone through generations of being criticized, in the last ten or twenty years, politicized, endlessly deconstructed – and they're still here, thirty years on –

AJ Thirty-five years; it goes back at least to to Roland Barthes' essay 'The Death of the Author' [1968; reprinted in Barthes, *Image Music Text*, trans. Stephen Heath, New York: Hill and Wang, 1977].

JH The challenge posed by writers and theorists and artists to all those orthodox formulations had an effect, didn't it, and there is an effect in terms of what people now *read* in art history courses – but it hasn't fundamentally unsettled the organization of the discipline, has it?

AJ No. That is what interests me at the core, that's why I realize that I'm probably not ready to give up the discipline of art history, because I'm comfortable being uncomfortable within a discipline where I feel like I don't belong, and it's what stimulates my resistance.

JH And if we all lived in a future world where there was no art history, it was all cultural studies, we might not know what to do any more?

AJ That doesn't bother me at all. In fact I think that's the direction we're moving in. But what I would say we *don't* want to lose – I teach a 'Methods and Historiography' class, so I'm very interested in the specific historiography of art history – what would be sad would be if *that* were lost; if the knowledge of how this discipline developed, and the knowledge, for example, of aesthetics – and, ironically, this knowledge is, sadly, lacking in many traditional art history departments! So while

art historians are clinging to banal orthodoxies, there's also an erasure going on of the very things that are the most interesting and important to know, in my opinion.

JH Is that to do with what we might call the 're-depoliticization' of art history that has taken place over about the last ten years? Can we talk a bit about how this relates to differences between Britain and the US? It seems to be quite common in the States, for example, to have departments combining art and art history, which doesn't really happen here; it's very unusual in this country.

AJ Unfortunately it's not very common in the US either now – it used to be more common, and UC [University of California] Riverside where I taught for twelve years is a perfect example: art and art history used to be joined, but they separated thirteen years ago just before I got there.

JH Why did they decide to separate them?

AJ Because of ideological struggles. In the case of UCR, as far as I can tell, it was anxiety on the part of art historians that art was being taught as a university subject, because they thought it wasn't intellectual enough; and resentment on the part of the artists that their way of thinking and learning wasn't being taken seriously. And so there was a split.

JH But the positive image you might have of a department that shared the teaching of art and art history would be that there would be some productive interaction between the practitioners and the historians.

AJ Oh yes. Frankly, if I had the choice I would rather be in a department that was a joint department because of that potential synergy.

5: Practice, Production, Politics and Knowledge

JH This discussion of collaboration relates to the question that I want to concentrate on finally, which is the relationship between practice,

production in contemporary visual art and culture, and its relation to the production of knowledge, teaching, scholarship, around art and art history. But given that we've talked quite a bit about how sceptical we both are about the capacity of contemporary art and contemporary artists to offer any real challenge, in the context of the dominant global spectacle, can we finish off by talking not about art, but rather the visual coverage – televisual coverage, much of it – of the war in Iraq? I don't know whether this is something you've thought about much, but it strikes me that it would be a useful case study to think about how visuality, knowledge, meaning, is being organized right now in the present – and theatricalized, in all sorts of ways. This obviously didn't start with the contemporary situation in Iraq, and we could genuflect to Baudrillard's infamous comments about the first Gulf War 'never really happening' and all the rest of it [Jean Baudrillard, *The Gulf War Did Not Take Place* (Bloomington, IN: Indiana University Press, 1995)]; but I'm thinking particularly of the moment in June 2003, I think it was, when the Bush administration wanted to stage-manage and have visualized the supposed 'handover of power' to what was called the 'interim Iraqi government'. They pre-empted this planned event in order to try to wrong-foot the Iraqi resistance to the military occupation, by doing it a few days early. Do you remember this?

AJ They were also pre-empting John Kerry being announced as the Democratic nominee.

JH And, if you remember – I watched it on television here in England, anyway – you could tell that they'd worked out very carefully how this 'event' of 'handover' should appear visually, in terms of television coverage, and what little bits of dramatic narrative would be released at certain points in the day. One bit that stuck out was the American administrator, Paul Bremer, who'd been in overall charge, was shown 'flying out on a plane back to America'. That was part of the literal dramatization: meaning 'his job had been done', 'he was no longer needed' –

AJ Ostentatiously flying out –

JH Yes, on a jet back to Washington because 'his job was done', that was the way it was announced through the Pentagon and through the White House channels, to the press and television media. Considering the Gulf War and the Iraq war and the coverage on television, have you got any thoughts on that?

AJ Well, the first thing I would say is that I don't want to be misunderstood as saying that it's hopeless and that artists aren't important and they shouldn't be doing anything and there's nothing for them to do, because I don't feel that way at all. I just think that neither artists nor people who write about the visual arts have been able to articulate a cohesive, convincing model to explain how important work is still being produced, and how it can actually make a difference. So I think I would want to be careful to restate that.

For example, I just went to a conference in Northampton, and saw a piece by the performance artist, Lois Weaver, who is relatively well known in performance circles in the US for being a founding member of the lesbian performance collective 'Split Britches'; and there was a panel on the ageing woman's body and performance. It was actually fantastic: there was a trapeze artist, there was an actress, there was an Indian dancer, there was a mime artist, and there was Lois Weaver, who got up and did this piece that related to a protest performance that had been done in New York during the Republican convention [August–September 2004] so that's why I'm bringing it up – artists are desperately trying to do something, as are people like me, in resistance to this horror that is happening. Especially in the United States. I mean, it's bad in Britain, but it's horrifying what the Bush administration has done.

So what Weaver did initially, with this other group of artists in the States – they call themselves the 'Axis of Eve', instead of Bush's 'axis of evil'! – they did what's called a panty raid: they wore underwear which had printed, on the top part, 'Weapons of Mass Seduction', and on the bottom part 'Give Bush the Finger'. And they did this very dramatic performance in New York – Weaver didn't say exactly where it was sited,

and this is a crucial issue, because of course they couldn't get into the actual convention (that's how the right wing manages to maintain the sealed universe of their own spectacle that can never be interrupted). But they did do it in the streets, where hundreds of thousands of people were protesting, and they got a fair amount of media attention. So what they're doing, obviously, is using the very tools of late capitalism and spectacle to try to become visible with a pretty direct, old-fashioned critique of Bush's administration.

JH It's a very risky strategy, using –

AJ Well, you could be arrested, it's risky in that sense...

JH Also, what you do could be read in all kinds of other ways as well. Was part of the same thing the nude protest, when they just took their clothes off and got arrested by the police?

AJ Right. And every feminist knows – and Lois Weaver's a very smart feminist – that for a woman to use that, as you say, can easily be interpreted in the other direction, so it's a double-edged sword.

JH This is going back to suspicion of the body and what we were saying about fetishism.

AJ Well, at the Northampton conference, which is a totally different environment, it's very safe – and I'm sad to say 99.9 per cent of the people there were women, because it was a feminism conference – Weaver, discussing the aged body, was talking about how her performances, until she entered her early 50s, always involved a reverse stripping: so she'd come out naked and in various ways during the performance would re-clothe herself. And then she talked about how she began to resist that, intuitively resist it, and had to confront her own anxieties about having an aged female body and exposing it to the public. So I'm bringing that up just because, instead of abstracting the body again, it was very visceral and she actually did a striptease, not a

reverse striptease, where she took off her clothes and she had this panty-raid underwear on, and then she took that off as well.

JH I was just going to mention that there's been a competition to put a sculpture on the presently empty fourth plinth in Trafalgar Square in London and the authorities are going to install a statue of a disabled pregnant woman by Marc Quinn. The images of naked bodies that we associate most with the Iraq war, of course, recently, have been the ones in Abu Ghraib prison in the photographs taken by US military personnel now under investigation and detention for torture and abuse of their prisoners. The use of the body – and the body here meaning the naked body, the uncovered body, the nude body, whatever – clearly is a very powerful tool and it can be used in lots of different ways. Is the revelation of the body still linked to some notion about an ultimate truth; is that what's partly at stake in this? And what do you think about that?

AJ Well, I think that's what often happens when it's talked about: it's often brought back to this idea of authenticity – the body as 'unmediated'. Now I would really resist that and I would say that – in a way maybe I'm hedging around that – yes, the naked body can have an effect profoundly different from a representation, but I wouldn't say it's unmediated. And, given the effect that is has, one has to be very careful about the absolute specifics of the moment, the situation, the site, the audience, the way in which the body is unveiled.

JH Yes. Aren't those factors to do with the *control* of mediation? Somehow what's really very crucial in all this is that unless you have control over those factors of mediation, and *want* to have control over those factors of mediation, you can't in a sense restrict the use of the material that you are producing, as artists who use the body. Is that right? In other words what undermines what may be the intended subversion, use of art in a subversive way, is the artists' relative lack of interest in the conditions of mediation. They're not seeking out venues and circumstances, spaces, where they actually can retain control over how the meanings might be generated?

AJ So they're willing to take the risk of being perceived in different ways.

JH It's linked to postmodernist theories of meaning in a way, 'polyvalence', lack of a single meaning, and all the rest of it. All that critical discourse and the history of it, where it comes from, in a sense, undermines – and deliberately undermines – the idea that there can be an intended, single and subversive meaning to something.

AJ Yes, absolutely. Now you've just gotten to the core of what bothers me about those theories of radicality that get codified: of course they're a contradiction in terms, because as you just said, you cannot ensure a radical effect.

JH Yes. I was thinking about this earlier on in relation to the body again, and images of bodies, and of course we talk about images in terms of pictures in books, photographs, or film and TV, but when we look at each other we're looking at images as well – I'm thinking of Yoko Ono, the 1964 *Cut Piece*, which she just did again recently [in Paris, 2003]. That was about this confrontation between actual bodies – people, in fact, not 'bodies', because to call them 'bodies' is reductive again – but to say that we look at each other as images, we look at people on the street in terms of images, but that we're not *just* images; in the way that 2D and 3D art objects are 'only' images or objects.

AJ Then what's required is a phenomenology, a theoretical model for explaining the difference between looking at someone *as an image* and being in a room with a person; and when I started reading Maurice Merleau-Ponty that really clicked for me [see his *Phenomenology of Perception* (1945), trans. Colin Smith (New York: Humanities Press, 1962)]. There's a way in which that *is* the specific nature of 'live art', a particular way in which we engage with living people – but, at the same time, I'm the first to say that when I try to remember the performance by Annie Sprinkle I saw, the photographs of these performances are meshed in my mind with the three-dimensional, 'live' Sprinkle...

And part of that is precisely because she performs on a proscenium, and that's why the more narrative performances are less interesting to me in this regard, because they do construct themselves as pictures – you know, traditional theatre is constructing itself as a discrete world; whereas some of the other body art – for example if you had been in the room when Dan Graham was doing his *Performer/Audience/ Mirror* [1975] piece – you would have been encompassed in this phenomenological exchange that he establishes.

JH What happened there?

AJ Well, in that piece – and of course now as we view the piece through the video footage we are also encompassed in the piece but in a different way – he stood in front of a very large mirror with an audience sitting on the floor, so he's among the audience but then he's walking back and forth; at the same time there's a camera person

7 Dan Graham, *Performer/Audience/ Mirror*, 1975

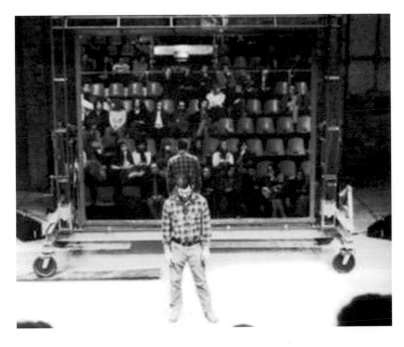

filming the whole thing. In the video version you see the audience, you see the reflection of the audience, you see Dan Graham, you see the reflection of Dan Graham, sometimes you see the reflection of the actual camera filming itself; but it moves around, so you're in this circuit. And Dan Graham throughout the whole thing is moving back and forth and simply describing what he's doing, so he's saying, 'Now I'm walking back a pace, now I had my hand on my chin and I'm stroking my chin'; it's a classic 1970s body art project for me, because it tries to get at the deepest level of what it means ontologically to be in a group of people, what it means to be filmed, what it means to be engaging with an artwork – all of those things. And actually the Graham piece that was at the Tate Liverpool 'Art, Lies and Videotape' exhibition in 2003–04 [*Present Continuous Past(s)*, 1974] was a variation on that exploration, where you're walking around and all you see is a video monitor and you see yourself on the time-delay and it's very disorienting; but it's all about you being a spectator but also being the work, and its relationship with the artist and space and time... I still love *Performer/Audience/Mirror*; I still get excited when I talk about it because these artists were just fascinated with the most profound ontological issues about making and viewing art.

JH Did they know Merleau-Ponty's texts, were they aware of the philosophical implications?

AJ Sure. Vito Acconci read Merleau-Ponty, Robert Morris almost certainly did, and Carolee Schneemann, when I talked to her about it, said 'Oh my God, the guys used to talk about it all the time, it was so boring', so obviously each person took a different perspective on it. It was something that people were talking about – not just Merleau-Ponty but –

JH Fried talks about him too, there seems to be a way in which it was available and you can see how it comes through...

AJ It started coming out, yes. Well, to her credit it was Rosalind Krauss actually, and Annette Michelson, who first wrote about it in

the context of the visual arts, and they did that pretty early on, talking about Robert Morris [see Annette Michelson, 'Robert Morris: An Aesthetics of Transgression', in *Robert Morris* (Washington, DC: Corcoran Gallery, 1969); and Rosalind Krauss, *Passages in Modern Sculpture* [Cambridge, MA: MIT Press, 1977)]. But it wasn't just Merleau-Ponty; there were also, for example, the 'presentation of self' ideas of Erving Goffman [*The Presentation of Self in Everyday Life* (Garden City, NY: Doubleday, 1959)]. So there were many different ways in which people were starting to address these interests. And then of course feminism and identity politics added a whole other dimension to it, because then the issue became more about the *specific* body, the way in which the body was specifically identified and elicited particular responses. Whereas the white men – well, someone like Dan Graham – these issues weren't really on his radar screen. Although for Acconci it was. To his credit, Acconci was one of the only men who was really pushing the boundaries of the sexual, gendered body.

JH Do you think it's true that all fixed, as it were, visual representations, in terms of images, photographs or whatever, intrinsically, necessarily, *fetishize* the body – do they fix it, compared to this live confrontation?

AJ I think by definition they do. If you look at Freud's theory as it permeates out into Laura Mulvey and then –

JH I'm thinking about the Abu Ghraib photographs and the televisualization of protests such as the anti-war nude event in New York.

AJ Yes, I suppose by definition the body becomes an object, it becomes –

JH I'm not saying it's necessarily a *bad* thing –

AJ – a substitute phallus, it fulfils whatever that model is, but then...

JH I'm just wondering whether that's at the root of some of the early theorized, as it were, defences of 'live' or 'performance' art: that it was a way of trying to avoid that fixing and fetishizing.

AJ Definitely. If you look at the feminist work by someone like Schneemann [in her 1975 piece *Interior Scroll*, for example] it's absolutely explicit: you know, 'I am here as a live body because I'm sick and tired of being objectified by men'. It's as clear as day.

JH And it comes out of the mid- to late-1960s when there were lots of artists thinking that about different kinds of art, weren't there?

AJ Yes. For Carolee it comes specifically out of the fact that she was in some of Stan Brakhage's films; she was in Robert Morris's event *Site* [1964] too. It was supposed to be a collaborative performance, with Robert Morris playing this role of male labourer, but Schneemann was forced to play the 'Olympia' role of a still, fetishized, naked female body [partly because New York City had anti-porn laws that required her not to move in order to avoid arrest]. And so then she made *Fuses* to represent herself as the desiring subject of the film, and then she did these performances to articulate a moving, live body.

JH Making herself active, and controlling?

AJ Yes, absolutely. Now, of course, the paradox is, as Lucy Lippard pointed out very early on, Hannah Wilke, Lynda Benglis and Carolee Schneemann are all spectacularly beautiful according to codes of ideal beauty: they're all white, or at least apparently white. So for Lippard this is a real problem, because they *were* being fetishized: they were performing themselves but they were immediately then made into these ideals – the document of the performance, which shows Carolee naked, does become a fetishized object [Lippard, 'The Pains and Pleasures of Rebirth: European and American Women's Body Art', *From the Center: Feminist Essays on Women's Art* (New York: E.P. Dutton, 1976)].

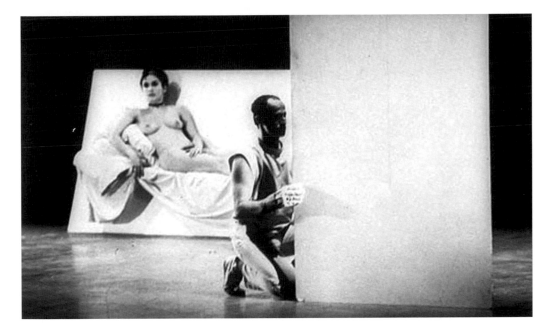

8 Carolee Schneeman in
Robert Morris, *Site*, 1964
© ARS, NY and DACS,
London 2007

Still, I believe in the idea of working through or with the body – yet
resist the fantasy of 'authenticity' or unmediated presence that live art so
often seems to promise. In this day and age, scepticism about avant-
gardism and a kneejerk notion of critique is crucial, but so is maintaining
some kind of hope that persistent, angry protest – whether through
marching against the invasion of Iraq or, as Gómez-Peña has done,
working on multiple registers (from live performance to writing books
and mass emails) and continuing to produce something we might call 'art'
– can make a difference, can in some way slow, rupture, or disturb the
workings of late capitalism. Can, who knows, expose the endless stream of
lies that, if they go unquestioned, substantiate the power of systems such
as the Bush and Blair administrations. The question is how we, as
theorists and historians, can find ways to keep up with what artists are
doing by finding new ways of conceptualizing radical practice for the
twenty-first century. I tend to think this is the most important underlying
agenda for cultural practitioners today.

6

The Fantasy of Privacy
Performance after Minimalism

FRAZER WARD

American performance art from the late 1960s into the 1970s, especially its more systematic, less gestural or expressive versions, has most commonly been related to conceptual art.[1] Yet Vito Acconci and Chris Burden, certainly two central figures in American performance art of the period, have identified their work with minimalism as well. In 1977 Acconci described his performance work as 'a last gasp of minimalism',[2] and twenty years later referred to minimalism as 'the father art', while the conceptualists were 'over there, doing their own thing'.[3] In 1996 Burden recalled training as an artist when 'minimalism was in vogue and conceptualism was beginning', and having been a 'young minimalist'.[4] Without denying conceptual art's relevance, clearly Acconci and Burden were quite deliberate in their reflection upon minimalism.[5] And before that, in the early 1960s, important minimalists had clearly operated in a New York milieu in which minimalist or proto-minimalist practices were developed alongside different kinds of performance.[6] These connections make sense: the logic by which minimalism's focus on perception as an embodied process raised questions about artists' and/or viewers' bodies, relevant for a consideration of performance art, seems clear.

Minimalism's construction of aesthetic experience as *public*, however, and the importance of that to performance art, remains to be fully explored. For a significant strain of performance art, exemplified here by the work of Acconci and Burden, the unresolved character of minimalism's version of what was public was a crucial point of

departure, such that the work may be seen to have been both enabled by and critical of aspects of minimalism.[7] This is not to suggest that Acconci or Burden recognized the limitations of minimalism's public realm in advance, or addressed it programmatically. Rather, this recognition emerged in and through their performances; it was frequently inchoate, implicit or hesitant. Centrally, it might be observed that both Acconci and Burden, in different ways, concealed their desiring, needy selves and bodies within minimalist spaces, with the effect of confronting, even defiling, the abstractly 'public' character of those spaces.

The Public Space of Minimalism

Minimalism punctured the supposed autonomy of modernist art by foregrounding the embodied, temporal quality of the viewer's experience of art. Morris's *Untitled (Slab)* (1962), for instance, was an eight-foot square, one-foot high, plywood plinth, painted grey, suspended a few inches above the floor. Ideally, the large scale of the object, combined with the absence of conventional compositional interest, would direct attention to the relationships between the object, the space in which it was encountered, and the 'kinesthetic demands placed upon the body'.[8] For Morris, the greater distance from one's body necessitated by large objects, in order for them to be seen, structured 'the non-personal or public mode' of perception.[9]

Following from this emphasis on embodied, contextualized perception, two of the main characters in the story of minimalism's reception should be the categories of public and private. Intimated by Morris, this emerged more fully in Rosalind Krauss's attempt to track minimalism's legacy, 'Sense and Sensibility: Reflections on Post '60s Sculpture' (1973). Krauss argued that the significance of the art of the minimalist generation was that it 'staked everything' on the truth of a model of subjectivity and meaning 'severed from the legitimizing claims of a private self'.[10] The achievement of Frank Stella's black paintings, Krauss's example, was 'to have fully immersed themselves in meaning, but to have made meaning itself a function of surface – *of the external, the public, or a space that is in no way a signifier of the a priori, or of the privacy of intention*'.[11] The achievement, that is, was to bracket interior or

1 Frank Stella,
*The Marriage of Reason
and Squalor II*, 1959
(enamel on canvas,
230.5 x 337.2 cm),
New York, Museum
of Modern Art, Larry
Aldrich Foundation Fund.
725.1959, digital image
© 2007 The Museum of
Modern Art, New York/
Scala, Florence © ARS, NY
and DACS, London 2007

private realms in favour of the public; but the minimalist wager
nonetheless retained and even relied on the opposition between public
and private – its strength, conceivably, was the force with which it
repressed interiority. For Krauss, the hand was played out in the work of
a subsequent generation, including Mel Bochner, whose works, tellingly,
accomplished 'a kind of necessary purging of the fantasy of privacy from
his art'.[12] Minimalism banished from art a version of meaning that issued
from an imagined, private, interior mental space. Instead, meaning
became subject to negotiation in the newly open, exterior – not fantastic
– space of minimalism (the space of Morris's slab, for instance).

Whether or not this negotiation actually happened, the *meaning* of
minimalism was arguably to posit a space in which it might.
Yet however radical a re-envisioning of aesthetic experience this
represented, it can only be termed public in a rather formal, abstract
sense. For Morris's implication is that largeness of scale rendered
minimalist space public, Krauss's that publicness was self-evident.
Such abstraction seems inconsistent with minimalism's introduction
of the viewer's body, with its uncertain peculiarities, into the equation.

It sits comfortably enough, however, with that phenomenological 'the body', which tends to make all bodies equivalent, in Morris's and Krauss's influential rhetoric. Hence, critical discussion has largely focused on an ideal, singular viewer.

However restricted or mandarin this version of experience as public, it was central to minimalism's questioning of modernist tenets. It went hand in hand with a demand for a new understanding of relations among artist and viewer and artwork – relations between subjects and objects. That is, it marked a rejection of the specifically modernist understanding, which Krauss described critically in a later essay dealing in part with Acconci's work, that the 'very possibilities' of the artist 'finding his subjectivity necessitate that the artist recognize the material and historical independence of an external object (or medium)'.[13] The slight hesitation of Krauss's parenthesis – 'external object (or medium)' – reveals a tension in the modernist idea of medium. Medium refers to a material substance, for instance, paint, the artist's manipulation of the properties of which allows us to distinguish the qualities of brushstrokes *and* psyches. But medium also refers to a discourse or discipline, for instance, painting; that is, it refers to an account of the historical development of conventions for manipulating paint. In terms of the modernist version of medium, the importance of a work of art is 'the authenticity with which it bears the imprint of [the artist's] very being'.[14] But that supposedly private being is always already suspended in and legitimated by its relation to a body of specialized knowledge. The circularity of this legitimation of supposedly private but actually conventional expression is in part what minimalism exposed, in abandoning traditional mediums and expressive relations to them. For if the viewer brought meaning to minimalist objects from outside, as it were, then the authenticity and legitimacy of the work were no longer bound to an individual being, but opened up to a realm of intersubjective experience.

However, Hal Foster's precise rereading of minimalism's crucial texts demonstrates that if it opened up a new space of subject/object relations, the project of establishing meaning and subjectivity as public was not without its own internal contradictions. As Foster observes, Morris's

'Notes on Sculpture' announced a 'death of the author' and birth of the viewer: 'The object is but one of the terms in the newer aesthetic'.[15] Yet Morris was uncertain about the implications of this shift towards experience as public:

> even as Morris announces this new freedom, he seems ambivalent about it: in a flurry of contradictory statements he both pulls back ('that the space of the room becomes of such importance does not mean that an environmental situation is being established') and pushes forward ('Why not put the work outside and further change the terms?').[16]

Morris's hesitations perhaps reflect the instability of the equivalences between interior and private, exterior and public, and the equally unstable dichotomy between private and public, upon which rested minimalism's version of what was public. Those unstable relations were nonetheless asked to support the insistence that meaning and subjectivity were just that, public, in their most important dimensions. This points to the urgency of the insistence, in response to the perceived inertia of then-regnant, modernist ideas of subjectivity.

Michael Fried's 1967 attack on minimalism, 'Art and Objecthood', forcefully championed modernist subjectivities, on a ground of antipathy towards and anxiety about the very notion of a public dimension to art. In Fried's medium-specific modernism, minimalism's aspiration 'to discover and present objecthood as such' doomed it to slip from the category of art into the preterite realm of theatre where works of art are nothing more than objects.[17] Fried's fundamental objection to minimalism was that it confused the relations between subject and object that he saw as appropriate, even necessary, to art. Regarding Morris's interest in control of 'the entire situation' in which artworks are encountered, Fried commented, with a tinge of indignant incredulity, that 'the entire situation' means exactly that: '*all* of it – including, it seems, the beholder's *body*. There is nothing within his field of vision – nothing that he takes note of in any way – that, as it were, declares its irrelevance to the situation, and therefore to the experience, in question.'[18] Fried describes a creeping failure of distinction or propriety. The minimalist emphasis on artworks as objects appears in Fried's rhetoric as an example of poor aesthetic hygiene, with all the moralizing

overtones that such an accusation might be expected to carry: objecthood, and concomitantly theatre, 'pervert', 'envelope', 'corrupt' and 'infect'.[19] Minimalism, in Fried's account, presents the experience of art as 'public' (a term he only uses suspended in quotation marks), insofar as it is an embodied experience of the relations between a subject and an object or objects that happens within specific spatial coordinates, which may be affected by the presence of other people ('the entire situation'), and which extends in time.

Against this, Fried posited as the authentic experience of art a subjective experience of 'continuous and entire presentness', or 'instantaneousness', in which the viewer's conviction of aesthetic quality is compelled *forever*.[20] This version of aesthetic experience, at once instantaneous and eternal, risks being removed from any historical circumstance, despite Fried's insistence on the viewer's knowledge of canonical works as the context for this experience. The radicality of Fried's account lies in this description of a one-to-one relationship between the disembodied yet individuated subjectivities of artist and viewer, floating free of objects, but suspended in an artistic medium. Medium, here, as if in its occult sense, connects subjects whose relation to history is at best rendered uncertain by the transcendental nature of their connection. Just as medium provides for this instant, almost magical connection, it also serves to remove the viewer from the everyday world, from the public realm of museum or gallery. This is a version of subjectivity with no public dimension whatsoever. The value of the experience lies in being driven to believe that the modernist work stands up to comparison with canonical, historical works. But the experience tends to remove the viewer from the historical aspects of the comparison (whether we view this as actually transcendental, or merely idealist), so that what remains crucial to the experience is not the history, which fades into the background, but the compulsion to believe.

Here, value resides in the artwork and emerges as it is encountered by the single, gifted (elect?) viewer. Krauss described a variant of this as 'a psychological model in which a self exists replete with its meanings, prior to contact with the world'.[21] That the minimalists wanted to void this model is confirmed not only by Morris's explicit interest in 'the

2 Robert Morris, *Untitled (L-Beams)*, 1965–67. Fibreglass 3 units, 244 x 244 x 61 cm. Installation view, Stedelijk Van Abbemuseum, Eindhoven, 1968 © ARS, NY and DACS, London 2007

non-personal or public mode' of aesthetic experience, but also by Judd's grounding his (albeit nationalistic) opposition to relational composition in a critique of Cartesian rationalism, and implicitly the subjectivity that went with it: 'All that [European art so far] is based on systems built beforehand, *a priori* systems; they express a certain type of thinking and logic that is pretty much discredited now as a way of finding out what the world's like'.[22] Minimalism's emphasis on aesthetic experience as public, that is, emerged in a contest over what the world was like. Modernist certainties – like Fried's, that the 'literalist' sensibility was the 'expression of a general and pervasive condition' that was bad[23] – could no longer pass without question. This is seen as clearly as anywhere in Judd's famous, bluntly provocative substitution of interest for quality: 'A work needs only to be interesting'.[24] The minimalist exploration of the public nature of meaning – however flawed – served as the ground for a critique of Cartesian interiority and of the idealist separation of thought from perception. Instead, the minimalists posited an embodied subjectivity that must negotiate a world of spaces and things.

For Krauss, it followed that part of the meaning of minimalist work 'issues from the way in which it becomes a metaphorical statement of the self understood only in experience': 'Morris' three *L-Beams* from

1965, for instance, serve as a certain kind of cognate for this naked dependence of intention and meaning upon the body *as it surfaces into the world* in every external particular of its movements and gestures'.[25] Morris's affectless box, that is, is a metaphor or cognate for subjectivity as it is generated in external, public encounters. The problem here is the idea that subjectivity is dependent on a body that 'surfaces into the world', where the world in this context means the exterior, the public. The minimalist critique of Cartesian subjectivity (in which thought and bodily perception are separate) runs the risk of simply reversing its terms, so that instead of the body appearing as the tool of the cogito, subjectivity appears as the reflex or creature of a purely public body. For in what aqueous, subterranean or interior realm has the body been,

3 Robert Morris, *Untitled (Corner Piece)*, Green Gallery, New York, 1964 © ARS, NY and DACS, London 2007

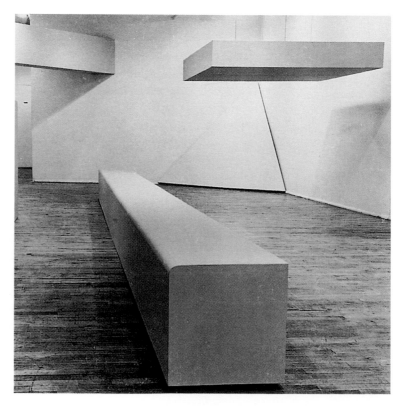

before the world? The answer must be that the body perpetually surfaces into the world, from the world.

In this light, Fried's suspicion of minimalism's 'public' seems not entirely unwarranted, if not in his own terms. Minimalism retained a tendency towards abstract and generalized subjectivity, rooted in its conception of the public. The dichotomy of interior/private and exterior/public, upon which minimalism's claims rested, was (and remains) artificially clear cut. Heuristically, it was able to support minimalism's critique of modernist subjectivity, allowing expressionist universals to be negatively recast as private utterances, private concerns, and hence severing subjectivity from the inherent logic of a medium, whether conceived of as the working through of the properties of a substance or the developing conventions of its use. But the public/private split already needed to be seen as approximate at best. It seems a pointed coincidence that technology guru Marshall McLuhan's *Understanding Media: The Extensions of Man* first appeared in 1964, the same year as Morris's important exhibition at the Green Gallery, New York. In that popular book, McLuhan saw subjectivity as prosthetically continuous with mass media.[26] Minimalism, that is, emerged when the effects of mass media on the formation of subjectivity were available for consideration in relatively accessible forms, and certainly for an audience extending far beyond the art world. Of course, there was also already a long Marxist interpretative tradition in place, in which relations between people were intimately tied to relations between commodities – things – that altogether undermined the possibility of a purely private or autonomous subjectivity.

By the mid-sixties, that is, it was clearly possible to see that mass media, and concomitantly processes of commodification, affected the structures of domestic or 'private' life in which any supposedly distinct private interiority must be formed. Beyond that, minimalism could not irrevocably establish an understanding of subjectivity and meaning as public, because the diffusion of mass media meant that the distinction between public and private had become fictional or ideological (if it had not always already been so).[27] This was the case not only in the privileged social and theoretical realm of art, but generally, in late capitalist

societies.[28] In this context, minimalism's public realm was no guarantee against the 'fantasies of privacy' that it exposed. This was not simply because of its mandarin quality, but because as with all accounts of the public it must struggle, both in its encounter with the specificity of subjects and their differences, and in relation to the banal, amorphous imaginings of mass media – 'the general public', 'the American people' – whose very function is to efface differences.

The Interior of Performance Art

Fried saw the culture at large as pervaded by theatricality, but was unable to predict that artists after minimalism would embrace it as a positive value, or that the incorporation of 'extra-artistic' elements would provide for a critique of the abstraction of minimalism's account of subjectivity and the public. In this context, performance after minimalism took what is at one level the crude step of replacing objects, their presence 'just like people',[29] with people. Undermining the public/private distinction by performing 'private' acts in public – and minimalist – spaces, and in the same gesture undercutting the abstraction of minimalism's public realm, artists like Acconci and Burden provided a level of specificity in their engagement with the categories of public and private that emphasized the effects on subjectivity of the *collapse* of that distinction.

In January 1972, famously, Acconci masturbated in public; or not quite. He did exhibit a low wooden ramp in the Sonnabend Gallery, New York. Two feet high at the back, it merged with the floor in the middle of the room. Alone, the ramp might have stood as a stolidly empirical post-minimalist examination of the architectural and, by extension, institutional conditions of looking at art; that might be related to Morris's *Untitled (Corner Piece)* (1964), for instance. The sloping floor drew visitors' attention to their own movement through the familiar white cube of the gallery.[30] But a speaker sat in one corner of the ramp, and underneath was something less self-evident. Twice a week, six hours a day, visitors could listen to Acconci, underneath, speaking into a microphone the sexual fantasies triggered by the sounds of those above, and masturbating: 'you're on my left... you're moving away but I'm

4 Donald Judd, *Untitled*,
1965. Galvanized iron,
lacquer, 38 x 203 x 66 cm.
Collection, Walker Art
Centre, Minneapolis ©
Judd Foundation. Licensed
by VAGA, New York/
DACS, London 2007

pushing my body against you, into the corner... you're bending your head
down, over me... I'm pressing my eyes into your hair....[31]

Acconci used a low-tech PA system to broadcast into the gallery a
normatively private activity. Doing so, Acconci took the viewer into the
realm of his own sexual fantasy, or used the viewers to go there. If this
was a fascinating or titillating experience for visitors, it might also have
been disconcerting. Not only was this not what you might have expected
to hear in a gallery, but the condition of entry into Acconci's fantasy
world was as the anonymous representative of the anonymous public, so
that sexual fantasy was made into something impersonal, a projection,
even an imposition. For while viewers might have responded in various
ways, it was Acconci who set the terms for the exchange. This effect
remains pointed, even if it was rendered hypothetical, for viewers who
knew beforehand what they were getting into.

Perhaps the experience was embarrassing, too, for viewers were
implicated in Acconci's fantasy involuntarily, with little choice in the
matter other than to leave if they didn't like it, and that only after the
fact. Embarrassment is a response to the social forms of dirt, words or
actions out of place, inappropriate to their context (let alone the
conventionally 'dirty words' of sexual fantasy). *Seedbed* confused the
categories of public and private, breaching the divisions between them.

Specifically, Acconci took sexual fantasy out of any presumed or normative context of privacy (the privacy of one's own room, for instance), or of intimacy between individuals (so denying the reciprocity of mutual masturbation). If there remains an ideological version of fantasy as private, it denies the commodification of bodies in consumer culture. That consumption was at issue is implicit in the way that *Seedbed* undermined the packaging of sexual fantasy, by introducing uncertainty into the relations between artist and viewer, subject and object, consumer and commodity. Acconci's use of the shifter 'you', opening a space which any listener could fill, paralleled the interpellations with which advertising disguised its generality, while the work's openly if absurdly sexual nature provided a contrast with such interpellations. In the intermediate, semi-public space of the gallery, fantasy was presented as neither wholly particular to Acconci nor at the level of generality of advertising. Acconci blocked the visual field of his own fantasies: this sensory deprivation might have tested or sharpened fantasy, but it also depersonalized it. And if the separation of fantasy from privacy was unlikely to have been entirely surprising, Acconci's introduction of desire into minimal space nonetheless disrupted a visual system that relied on stable relations between public and private.

5 Vito Acconci, *Seedbed*, 1972. Photo © Acconci Studio

A familiar account of *Seedbed* sees it manifesting performance art's tendency to 'activate the viewer'.[32] On the contrary, following from the way that it collapsed public and private together, seen most clearly in its presentation of sexual fantasy as at once specific and general, *Seedbed* not only undercut reciprocity, but also reversed or confused the dichotomy of active and passive. If Acconci lay passive before anyone set foot in the gallery, then the entry of visitors activated him. In turn, Acconci's response (a type of response he had anticipated) 'activated' viewers. But their exchange with Acconci was not fully reciprocal (Acconci set the terms); while their simple presence was a condition for Acconci's activity, their only effective options were to stay or to go. Viewers remained ignorant of the actual circumstances of the performance (was it 'real' or 'fake'?), while their ignorance was the condition for Acconci's pleasure: it didn't matter who they were, Acconci could make of their presence what he willed, and/or desired. Desire extends beyond volition, so its invocation here furthered the confusion of active and passive. If the activity of Acconci and his viewers was not reciprocal but interdependent, the parties to the event were neither fully active nor completely passive. But the persistence of Acconci's desire in this context, along with the specificity of his language, suggests that the merging of public and private meant that what had been private was not simply cancelled out without remainder. If there remained something unidentifiable, irreducibly specific, some private residue of the collapse of public and private, where was that located? This question, it seems, lay beneath the ramp of *Seedbed*, where Acconci shuttled between public and private in such a way as to call into question both modernist and minimalist circuits for the legitimation of subjectivity.

Burden's first performance, *Five Day Locker Piece* (26–30 April 1971), similarly demonstrates a critical engagement with minimalism. In the MFA programme at the University of California, Irvine, from 1969 to 1971, Burden made a series of sculptural works, each one an 'apparatus that was similar to physical exercise equipment. For the viewer, the "art" occurred during the physical interaction with the apparatus.[33] After the fact, at least, Burden's move into performance rested on his understanding of something emphasized by minimalism,

'the physical interaction with the apparatus': 'The only problem with this body of works was that the apparatus was often mistaken for traditional object sculpture. In a further refinement, I realized I could dispose of the apparatus and simply have the actual physical activity as the sculpture.'[34] Hence, his MFA thesis show:

> I was locked in locker number 5 for five consecutive days and did not leave the locker during this time. The locker measured two feet high, two feet wide, and three feet deep. I stopped eating several days prior to entry. The locker directly above me contained five gallons of bottled water; the locker below me contained an empty five gallon bottle.[35]

Despite Burden's remark about disposing with the apparatus, reprises of minimalist conventions are immediately evident in the objective elements of the work. The standardized, industrially produced bank of lockers as a whole formed a simple geometric shape, and individual units were repeated in a grid format.[36]

Once Burden had entered locker number 5 and usurped its use (and that of the ones above and below), the space was charged in a way that translated into functional terms Krauss's later definition of minimalist sculpture as 'what is in the room that is not really the room',[37] an effect intensified by the somewhat liminal, transitory character of the institutional spaces in which such banks of lockers are found, hallways where you go to put something or pick something up on your way somewhere else. Where Krauss referred to the distinction between the artwork and its architectural context, Burden shifted the distinction between artwork and context from a principally spatial register to one emphasizing function (neatly drawing together minimalism and the readymade). Doing so – together with his treatment of his own body – suggests a commentary on or critique of minimalism's phenomenological emphasis on bodies visible in space. Minimalist subjectivity depended on a body that 'surfaced' into the world. Burden's public, physical *withdrawal* from the world in *Locker Piece* challenged that idea. Burden's gesture might be seen as a retrograde reaffirmation of a traditional version of artistic subjectivity, via a romanticized asceticism. But Burden's withdrawal points to a critical aspect of his work's departure from

minimalism. At first glance, *Locker Piece* might seem to have addressed the generality of minimalism's subject directly, even crudely. The body and subjectivity being put through the ordeal were Burden's own. Hence the argument made by the post-conceptual artist, Mary Kelly, that performance art is a last gasp of modernism. After minimalism's abandonment of a traditional relation to a medium, the 'signifiers of a unique artistic presence' returned in performance: 'the artist *is* present and creative subjectivity is given as the effect of an essential self-possession, that is, of the artist's body and his inherent right of disposition over it'.[38] On the contrary, the qualification of presence in Burden's work – and Acconci's, hidden or partly hidden as they were – offers no such unproblematic affirmation of 'creative subjectivity'. In *Locker Piece*, for instance, Burden barely appeared physically. There were no gestures and no images, save the single, blank, black-and-white photograph of the bank of lockers, which together with Burden's equally affectless written description and the padlock serves to record the work. While Burden conversed with visitors through the locker door, his experience remains mainly at the level of identification, especially for viewers restricted to the documentation: far from being bound to Burden's presence, the experience becomes a fantasy or imagining of one's own body. A convention within positive critical responses to performance art holds that the artist's own body became his or her medium.[39] *Locker Piece* so qualified Burden's presence as to evade this convention with Houdini-like adroitness, effectively problematizing both Kelly's criticism and enthusiasts' claims for the 'realness' and immediacy of performance.

Burden's presence was first qualified in that he removed his body from sight (as if to engage the sense of minimalist objects as hollow). Although Burden spoke to his visitors, he largely removed himself from sensual perception. His presence was subsequently qualified, after the fact, in being restricted to the form of its documentation (which does not include his image). The implications of this reservation of presence are seen most clearly in a consideration of Burden's approach to the critique of interiority that Krauss argued was central to minimalism. For if in its

conception *Locker Piece* was a hyperbolic 'fantasy of privacy', it was structured as a series of interiors within interiors, like a set of Russian dolls, the centre of which was, in a sense, empty.

The institutional architecture of the art school contained the room that contained the locker that contained Burden. Within the somewhat unstable space that such lockers occupy (administratively, it is easy enough to move them, when space is scarce), individual lockers function as 'private' enclaves. This privacy is immediately circumscribed by whether or not it is, for instance, legally viable, and by its generic quality, which consists in the personalizing of institutional property with mementos, snapshots, graffiti, etc., alongside books and materials that are common to numbers of students. Burden carried personalization to its limits by inhabiting the locker, substituting a self for the objects that are ordinarily used to express it. He might have raised the question of how private those spaces were (and implicitly, those selves). He certainly encountered the possibility that there were legal or administrative limits to that privacy, as he did not seek official permission for the performance, and discussions took place as to whether he should be forcibly removed from the locker.[40] Burden's occupation of the locker, as one of a repetitive series of identical spaces, the privacy of which was qualified and of which the user, or occupant, did not have sole proprietorship, transformed the locker into a highly ironic model of the kind of interiority that minimalism sought to dispense with. This irony was emphasized by the setting in an art school, so that the locker became, specifically, a model of artistic interiority (isolated, hungry, cramped, uncomfortable). So *Locker Piece* conformed to the minimalist project of producing a definitively post- or anti-expressionist art that rendered meaning and subjectivity public. But it simultaneously put into play notions of privacy and ownership, however problematic, which minimalism banished in its desire for public meaning.

The residual physical apparatus of *Locker Piece*, activated by Burden's use, served, up to a point, to pursue the (minimalist) question of how private private interiority actually was. Yet the performance implied the *naïveté* of any conception of the public realm as simply exterior or self-evident. For the experience of bodily constraint,

sensory deprivation and physical and mental endurance that took place at the centre of the work was invisible, recalcitrantly Burden's own, but at the same time neither entirely private nor entirely public. Just as lacking in incident as minimalism's objects, in appearance, *Locker Piece* contained an extreme, but hidden experience. It was hidden in public, though, to the extent that people knew about it within an art-institutional and in fact bureaucratic context; it was Burden's MFA thesis exhibition, that is, his professional qualification as an artist depended on it, so that as with minimalism, subjectivity was at stake, but in this case in a very specific form. Burden's 'official' subjectivity as a 'qualified' artist was bound up with the work, and it is possible to see in his unofficial withdrawal from view a challenge to that process of legitimation.[41] This remains the case, even though Burden's withdrawal was not total, and is better regarded as a parodic experiment into the minimal presence required of a 'visual artist'. So it cannot be described as private in any uncomplicated way, as Burden's 1973 account makes clear: 'I didn't know what it was going to feel like to be in that locker, that's why I did it. I thought it was going to be all about isolation; it turned out to be just the opposite. I was seeing people every single minute for thirteen, fourteen hours a day, talking to them all the time.'[42]

Neither can the work be described as public in any straightforward way, especially in any way that equates public and spatial relations. Burden's statement allows the suggestion that the visitor's experience was *not* bound to an orientation in space. Similarly, it might be said that *Locker Piece* served as an explicit demonstration that intention and meaning might depend upon the *disappearance* of the body from view. It might then provide a sardonic contrast to minimalism's version of the public. The meaning of Morris's *L-Beams*, for instance, depended on the reduction or generalization of viewers' bodies to their spatial orientation; the meaning of the *L-Beams* may even be said to *be* their ability to perform this relativizing function; then everyone is equal, and has an equal role in establishing that meaning (except, it seems, the artist, who, having made the objects and put them in the space seems curiously absent from subsequent proceedings).

Locker Piece, by contrast, did not communicate what was apparently its central experience by the conventionally visual means of the artist, or by the manipulation of an object. That experience was not public, in that it was neither immediately shared nor able to be appropriated as the object of a recognizable body of specialized knowledge. Instead, Burden described it, in conversational exchanges. These exchanges seem to replicate a quotidian sense of public interaction (say, people discussing or debating something they have seen), rather than the phenomenological exchanges entailed by minimalism. However, they too rested on a paradoxical disembodiment, though one that was more explicitly integral to the performance. These conversations depended, that is, on the split between Burden's effectively disembodied voice, privileged by his invisible ordeal, and the hidden body undergoing that ordeal (not visually self-evident, requiring explication). *Locker Piece*, then, presented a complex account of the relations between subjectivity, meaning and the body, in which the body – Burden's own, his treatment of which determined his subjectivity as public, both in the terms of the work and bureaucratically – was both crucial, as pretext, and visually irrelevant.

In this sense, Burden's description of his body as a kind of minimally transformative conduit, linked to full and empty water bottles, above and below, is telling. *Locker Piece* provides a commentary on the absence of the artist from the spaces of minimalism, suggesting that meaning is no more entirely public than it is entirely private. Burden, for whom 'what I do is separate from me as a person',[43] was not accounted for either by self-imposed, if unpredictable, physical conditions, or unplanned conversations with visitors. Rather, the subjectivity generated by the work occupied each of a series of different kinds of interiors, from the interior of Burden's body to the locker to the room to the 'internal' workings of the art school bureaucracy. Their infiltration by the subjectivity generated in Burden's semi-public semi-withdrawal revealed what minimalism had repressed, the unstable relations of interiority to the categories of public and private.

NOTES

1 See, for example, Gregory Battcock (ed.), *Idea Art: A Critical Anthology* (New York: E.P. Dutton, 1973); Lizzie Borden, 'Three Modes of Conceptual Art', *Artforum*, v. 10, no. 10 (June 1972); Lucy Lippard (ed.), *Six Years: The Dematerialization of the Art Object from 1966 to 1972* (New York: Praeger, 1973; reprinted Berkeley: University of California Press, 1997); Ursula Meyer (ed.), *Conceptual Art* (New York: E.P. Dutton, 1972); Cindy Nemser, 'Subject-Object: Body Art', *Arts Magazine* (Sept.–Oct. 1971); Willoughby Sharp, 'Body Works', *Avalanche*, 1 (Fall 1970); Frazer Ward, 'Some Relations Between Conceptual and Performance Art', *Art Journal*, v. 56, n. 4 (Winter 1997). More expressive work has been seen in terms of a loose tradition of 'actions', thought to derive from abstract expressionism. See Paul Schimmel, 'Leap into the Void: Performance and the Object', in *Out of Actions: Between Performance and the Object 1949–1979* (Los Angeles: MOCA/Thames and Hudson, 1998).

2 Quoted in Bruce Barber, 'Indexing: Conditionalism and Its Heretical Equivalents', in *Performance by Artists*, ed. A. A. Bronson and Peggy Gale (Toronto: Art Metropole, 1979), p. 197.

3 Interview with the artist, 16 April 1997, though Acconci also allowed in 1997 that if his work hadn't appeared 'at a time of conceptual art, then there wouldn't be any place for me'; Acceptance Speech, United Nations Sculpture Center, Annual Award for Distinction in Sculpture, 10 December 1997. Courtesy Acconci Studio.

4 'Interview with Jose Antonio Sarmiento: "Hacer arte es verdaderamenta una actividad subversiva"', *Sin Titulo*, 3 (September 1996), p. 57 (translation courtesy Chris Burden Studio). Burden also referred to his pre-performance work as 'minimal sculpture' in 1979; Jim Moisan, 'Border Crossing: Interview with Chris Burden', *High Performance*, v. 2, n. 1 (March 1979), p. 9. As Anne Wagner observes, this is corroborated by undergraduate works from 1968: 'fully realized minimalizing works [which] illustrate how promptly a particular version of minimalism was institutionalized and how fully and easily it could be assimilated by a talented student'; Anne M. Wagner, 'Reading *Minimal Art*', in *Minimal Art: A Critical Anthology*, ed. Gregory Battcock (New York: E.P. Dutton, 1968; reprinted Berkeley: University of California Press, 1995), p. 9.

5 Some commentators have addressed this. See Barber, 'Indexing: Conditionalism and Its Heretical Equivalents'; Maurice Berger, *Labyrinths: Robert Morris, Minimalism, and the 1960s* (New York: Harper and Row, 1989); essays by Yvonne Rainer including 'A Quasi Survey of Some "Minimalist" Tendencies in the Quantitatively Minimal Dance Activity Midst the Plethora, or An Analysis of Trio A', in Battcock (ed.), *Minimal Art*.

6 Yvonne Rainer is a key figure here, see for instance Carrie Lambert, 'Other Solutions', *Art Journal*, v. 63, n. 3 (Fall 2004). For Morris's engagement with performance (his *Passageway*, 1961, for example, held at Yoko Ono's loft), see James Meyer, *Minimalism: Art and Polemics in the Sixties* (New Haven, CT, and London: Yale University Press, 2001), and Kimberley Paice, 'Catalogue', *Robert Morris: The Mind/Body Problem* (New York: Guggenheim Museum Publications, 1994).

7 Other artists whose performances might be considered in this context include Dan Graham, Tehching Hsieh, Joan Jonas, Yayoi Kusama, Yoko Ono and Yvonne Rainer.

8 Robert Morris, 'Notes on Sculpture, Parts I and II', first published in 1966, reprinted in Battcock (ed.), *Minimal Art*, p. 231.

9 Morris, 'Notes on Sculpture', p. 231.

10 Rosalind Krauss, 'Sense and Sensibility: Reflections on Post 60s Sculpture', *Artforum*, v. 12, n. 3 (November 1973), p. 48.

11 Krauss, 'Sense and Sensibility', p. 47.

12 Krauss, 'Sense and Sensibility', p. 48.

13 Krauss, 'Video: The Aesthetics of Narcissism', *October*, 1 (Spring 1976), p. 58.

14 Krauss, *Passages in Modern Sculpture* (Cambridge, MA: The MIT Press, 1981 [first published 1977]), p. 71.

15 Morris, 'Notes on Sculpture', p. 232.

16 Foster, 'The Crux of Minimalism', *The Return of the Real* (Cambridge, MA: The MIT Press, 1996), p. 50.

17 Michael Fried, 'Art and Objecthood', first published in 1967, in Battcock (ed.), *Minimal Art*, p. 120.

18 Fried, 'Art and Objecthood', p. 127, original emphasis.

19 Fried, 'Art and Objecthood', pp. 136–37. In this pathologizing vein, Fried also referred to the meaning and the hidden quality of minimalism's anthropomorphism as 'incurable', p. 130.

20 Fried, 'Art and Objecthood', p. 146

21 Krauss, 'Sense and Sensibility', p. 46.

22 Bruce Glaser, 'Questions to Stella and Judd', in Battcock (ed.), *Minimal Art*, p. 151.

23 Fried, 'Art and Objecthood', p. 117.

24 Judd, 'Specific Objects', first published in 1965, reprinted in *Complete Writings, 1959–75* (Halifax: Press of the Nova Scotia College of Art and Design, 1975), p. 184.

25 Krauss, 'Sense and Sensibility', p. 49, emphasis added.

26 'During the mechanical ages we had extended our bodies in space. Today, after more than a century of electric technology, we have extended our central nervous system in a global embrace.' McLuhan, *Understanding Media: The Extensions of Man* (New York: McGraw Hill, 1964), p. 3.

27 This is implicit in Jürgen Habermas's programmatic account of the social structures of the eighteenth-century European public sphere: 'The fully developed bourgeois public sphere was based on the *fictitious identity* of the two roles assumed by the *privatized* individuals who came together to form a public: the *role* of property owners and the *role* of human beings pure and simple.' *The Structural Transformation of the Public Sphere*, trans. Thomas Burger with Frederick Lawrence (Cambridge, MA: The MIT Press, 1989), p. 56, emphasis added. It is explicit in his account of the effects of the continuation of the processes of cultural commodification which had made the public use of reason possible: 'When the laws of the market governing the sphere of commodity exchange and of social labor also pervaded the sphere reserved for private people as a public, rational-critical debate had a tendency to be replaced by consumption, and the web of public communication unraveled into acts of individuated reception, however uniform in mode', p. 161.

28 If penetration of private spaces by the public address of the television is a somewhat literal marker of mass media rendering the public/private distinction amorphous, it is telling that within ten years of its introduction, by 1956, there was a television in roughly 75 per cent of United States households. According to Rolf B. Meyersohn, citing a 1956 survey, 'television's expansion in the first ten years of its life has been relentless. By now almost three-quarters of all the homes in this country are equipped with a TV set and

approximately 75 million adults watch it for an average of over eighteen hours a week.' 'Social Research in Television', in *Mass Culture: The Popular Arts in America*, ed. B. Rosenberg and D. M. White (Glencoe, IL: Free Press and Falcon's Wing Press, 1957), p. 345.

29 Foster, 'Crux', p. 43.

30 On *Untitled (Corner Piece)*, see Annette Michelson, 'Robert Morris: An Aesthetic of Transgression', in *Robert Morris* (Washington, DC: Corcoran Gallery of Art, 1969).

31 Vito Acconci, 'Power Field—Exchange Points—Transformations', *Avalanche*, 6 (Fall 1972), p. 62.

32 For example Kate Linker, *Vito Acconci* (New York: Rizzoli, 1994), pp. 44–46.

33 'Interview with Jose Antonio Sarmiento', p. 57.

34 'Interview with Jose Antonio Sarmiento', p. 58.

35 *Chris Burden: A Twenty Year Survey* (Newport Beach: Newport Harbor Art Museum, 1988), p. 48.

36 Christopher Knight also observes that the lockers, 'as a repetition of industrially-manufactured, stacked geometric units, were unmistakable as a reference to Minimalist sculpture'. 'Chris Burden and the Potential for Catastrophe', *Art Issues*, 52 (March/April 1998), p. 15.

37 Krauss, 'Sculpture in the Expanded Field', *The Originality of the Avant-Garde and Other Modernist Myths* (Cambridge, MA: The MIT Press, 1985), p. 282.

38 Mary Kelly, 'Re-Viewing Modernist Criticism', first published in 1981, reprinted in *Art After Modernism: Rethinking Representation*, ed. Brian Wallis (New York: New Museum of Contemporary Art, 1984), p. 95.

39 For instance, Sharp, 'Body Works'; Nemser, 'Subject-Object: Body Art'; Lea Vergine, *Il Corpo Come Linguaggio* (Milan: Giampolo Prearo Editore, 1974).

40 Regarding permission, Burden has said 'I knew if I asked they wouldn't let me do it. And if I asked it would imply that they had the power to tell me I couldn't do it, and they didn't have the power.' 'Chris Burden: The Church of Human Energy, An Interview by Willoughby Sharp and Liza Béar', *Avalanche*, 8 (Summer/Fall 1973), p. 59. Elsewhere, Burden reported hearing rumors that on the fourth day, 'the Dean of the University, whose office was on the top floor of the building expressed concern and the possibility of having to utilize the campus police to forcibly remove me from the locker.' 'Interview with Jose Antonio Sarmiento', p. 53.

41 Burden subsequently heard 'that many of the New York based art historians, who were on the faculty at the time, opposed granting me a degree. Other faculty members, such as Robert Irwin, were adamant and insisted on granting me an MFA. In the end, I did get my degree.' 'Interview with Jose Antonio Sarmiento', p. 53.

42 'The Church of Human Energy', p. 54.

43 'Chris Burden: Interview with Robin White', *View*, v. 1, n. 8 (January 1979), p. 17.

7

Deterritorializing Bodies
Body Art and the Colonial World Expositions

JANE CHIN DAVIDSON

Since the period of the 1960s to mid-70s, body art as a mode of performance art has been known for its radically different practice of engaging the viewer with the artist's *body* and *self.* Amelia Jones, in her book *Body Art/Performing the Subject*, explains that the term body art 'emphasizes the implication of the body... with all of its apparent racial, sexual, gender, class, and other apparent or unconscious identifications'[1] The bodily implication has the potential to transform the engagement between viewer and art object as well as provide a different access to subjectivity, and, thus, puts forth the means to question the cultural significations and values that have descended from the Western understanding of the human subject.

In recent performance history, artists such as Guillermo Gómez-Peña, Coco Fusco and James Luna have staged their own 'ethnic' bodies in order to challenge the way viewers think about race and the way ethnicity has been constructed in history. In 1992 Gómez-Peña and Coco Fusco embarked on their 'Guatinaui World Tour', a performance work that was staged for audiences in locations such as the Plaza de Colón in Madrid and the 1993 Whitney Biennial in New York. The artists put themselves on display in a cage for three-day periods as 'undiscovered Amerindians' from the fictional island of Guatinau. Acting the part of 'authentic primitives', they used costumes and props that mixed the tropes of the mytho-native with that of mytho-television culture. Known also by the title, 'The Couple in the Cage',

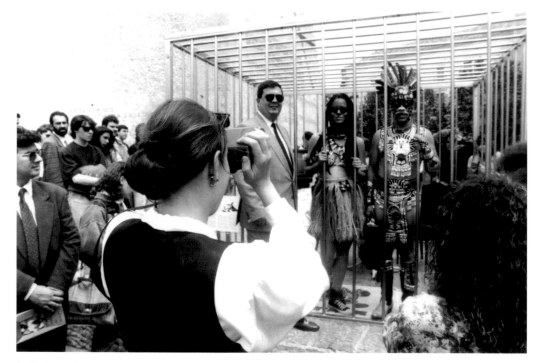

1 Guillermo Gómez-Peña and Coco Fusco, "Two Undiscovered Amerindians Visit Madrid," Plaza de Colón, Madrid, 1992. Photo courtesy of the artist

the performance has come to be known as a conspicuous parody of the 'human showcases' that were exhibited to large numbers of viewers at the European and American world expositions of the late-nineteenth/early-twentieth-century.[2] Gómez-Peña and Fusco's revival of this method of display revealed how its process of communicating visual and corporeal knowledge was highly effective since both artists wrote in hindsight about the large percentage of audience members who believed the exhibition was a 'real' presentation of indigenous natives[3] The artists concluded that their performance functioned as a form of 'reversed anthropology'.

Artist James Luna had the same focus of reexamining the colonial identification of people in his earlier work entitled 'Artifact Piece' (1987), exhibited at the Museum of Man in San Diego, California. Luna displayed his prone body in a vitrine in order to retrieve and

exploit the modern scientific method of displaying 'human specimens'. By performing at the site of the natural history museum instead of in the context of an art museum, Luna's work questions the function of the classification of the 'native' in the Western order of knowledge. The nineteenth-century creation of human showcases was part of the scopic regime that brought about the means to separate the civilized West from the primitive Other. In the colonial theatre of science and entertainment, the staging of people as objects of curiosity and scientific specimens culminated in the development of the 'Midways', the entertainment strips established within the ethnological villages of the world expositions.

My objective in this essay is to establish a connection between the display of 'race' in colonial exhibitions of the body and recent efforts in performance and body-oriented art to put *identification* itself onto the stage of contemporary art. Diana Fuss introduced her essay 'Interior Colonies: Frantz Fanon and the Politics of Identification' with two claims: first, 'that identification has a history – a colonial history; and second, that this colonial history poses serious challenges for contemporary recuperations of a politics of identification'.[4] Under this premise, I shall argue that the contemporary staging of the 'ethnic' body has inherited this colonial history, if only by nature of the trajectory of engagement linking the viewing subject and the viewing object.

There are important differences, however, among the set of relations that govern the perceptual organizations and the discursive practices behind colonial and postcolonial identifications. A study of the history of the staging of the ethnographic body in the colonial exhibition reveals the deep impact of what Michel Foucault acknowledged as 'system and discourse' in the history of Western knowledge[5] According to Foucault, system (which would include the visual elements) and discourse produce each other because 'theoretical choices exclude or imply, in the statements in which they are made, the formation of certain concepts'.[6] During the nineteenth century, the direct aim of formulating scientific concepts was to ascertain the 'truth' and make claims for an authenticity that secular reality would be based upon. In this period, the new identification of the cultural Other through visual depiction was

never more than a tendentious representation of the superiority of the Western imperial subject. In order to make a case for the contemporary recuperations of identification that body art has functioned to serve, it is important to examine the relationship between the colonial system and current theories of identification as they relate to the visible signifiers of the skin/body. As Fuss has articulated, modern psychoanalytical theories of the Self and the Other were established as models to explain the 'norm' of the white ego. The other of the unconscious relies on the metaphors of an alienated mirror image not unlike the visual differentiation of the cultural Other during the nineteenth century.[7]

Both the 'Couple in the Cage' and 'Artifact Piece' brought up questions about why the world expositions were so effective in their organization and dissemination of visual and corporeal knowledge. Timothy Mitchell, in his essay 'Orientalism and the Exhibitionary Order', argues that the distinctions of the West and the non-West came into being during the colonial age of representing global power.[8] The division of territory corresponds to the exposition's 'show' of claims to a constructed anthropological reality that contrasts with the 'external reality' of the existing world. Mitchell provides this explanation: 'In the binary terms of the world-as-exhibition, reality is the effect of an external realm of pure existence, untouched by the self and by the processes that construct meaning and order'.[9] The process of setting people apart by creating the Other was part of the new model of viewing a world in which 'reality' was constantly being invented and seen anew. In this way, the modern quest for authenticity and 'the real' was (and still is) an ideological construct.

The idea of the real was integral to the formation of the modern scopic regime, and in England, the quest for seeing something 'true' was constructed around two different modes of spectatorial curiosity. The viewing public continued to be entranced by the objects of curiosity that descended from the cult of supernatural spectacles of religious fervour.[10] But the desire to be amazed was also fulfilled by opportunities to 'see' foreign lands and their respective inhabitants. As historian Richard D. Altick suggests in *The Shows of London*, the painted scenery of the panorama, diorama and cosmorama offered the manufactured

experience of 'being there' at sights of faraway places that only the
wealthy could afford to travel to.[11] By the first half of the nineteenth
century, the need for the 'real' was paramount to the spectator's desires,
and in fulfilling the search for an authentic experience in which 'seeing
is believing', the British gaze was intent on the worldly and the foreign,
held to be commensurate with the phenomenal and strange.

The panorama often served as a journalistic account, substantiating
the imperial subject on behalf of the British occupation of new
territories. The subject-matter of military conquest and expanse of
empire included commemorative portrayals of the British admiral
Codrington's destruction of fleets from Turkey and Egypt at Navarino,
as well as victorious images of the subjugation of Calcutta, Bombay,
Benares, the Himalayas, Delhi and Lucknow. The oft-repeated subject
of the British campaign that resulted in the Opium Wars against China
was depicted in such narratives as Canton on the eve of the 1840 war,
Hong Kong and Nanking during the 1844–45 aftermath of war, and the
destruction of Peking's Summer Palace in 1860.[12]

The imperial narrative was visualized through the panorama,
and its effectivity as an educational outreach to the multitudes was
accomplished through its respected form of theatre. From the beginning,
the panorama's success was judged by critics according to their ability
to *convince*. The ultimate experience as one *London Times* reviewer
noted was when the 'beholder is involuntarily transported to the
identical scene of his admiration'.[13] A circular panorama transports the
spectator into another world, an illusion of reality existing only through
the viewer's belief of the illusion created by enwrapping her or him on
all sides. The understanding of foreign lands and foreigners was duly
considered factual through the lens of a colonial gaze upon views of
imperial subjectivity.

The viewer's desire for a sense of reality would thus come to define
the success of exhibitions of human subjects during the mid-1800s. At
places such as the Egyptian Hall, the Royal Bazaar and the Cosmorama
Rooms, the human as object was added to the exhibitionary complex
that served all at once the ideals of education, journalism, historical
archive, theatre, curiosity cabinet and freakshow. William Bullock's

Egyptian Hall showcased a variety of entertainers 'in the flesh' in addition to staging moving panoramas and exhibiting an assortment of collected objects from pre-Columbian carvings to Napoleon's personal memorabilia.[14]

To audiences in the first half of the nineteenth century, the staging of human anomalies was a spectacular attraction, and the most telling of these shows in terms of incorporating scientific management, entertainment and ethnography were the popular exhibitions of medical 'freaks'. The Siamese twins, Chang and Eng, became marketable products when a British merchant signed a contract with the twins' father in Siam to tour the United States before exhibiting them at the Egyptian Hall in 1829.[15] During the period of their London exhibition, the twins' 'medical attendant' presented a paper to the Royal Society addressing scientific and scholarly questions such as the psychological states and the biological union of his specimen. Altick speculated that if 'the proprietors had something really genuine to show, they sought public expressions of professional interest because, as always, the cachet of scientific merit would add dignity and box-office potential to what the discerning would otherwise have dismissed as just another fraudulent attraction for the curious and ignorant'.[16] Scientific authenticity determined who were the 'real' freaks and their marketability was complemented by the aims of the medical community.

As an added attraction, ascribing a foreign origin to the freak was always advantageous, and thus created the incentive to link human anomalies with native origin. In this way, the greater commodity value of freaks who could be classified by race increased their worth in the exhibition business. Altick explains that 'at the same time that early nineteenth-century showmen continued to exploit the ancient popular association of physical eccentricity with exotic origin, additional value was attached to human show pieces whose attraction lay not in their individual singularity but in the oddity, physical and behavioral, of the whole race to which they belonged'.[17] Nothing exemplifies this more than the nineteenth-century sexual fixation on Sarah Bartmann (known also as Sarrtjie Baartman or Saat-Jee) who was billed for viewing as the 'Hottentot Venus' at Piccadilly in 1810.[18] Sander Gilman's important

analysis on the Hottentot Venus makes the argument that the exhibition of Bartmann's protruding buttocks along with her deformed genitalia played a 'role as the semantic signs of "primitive" sexual appetite and activity'.[19] Whereas numerous studies on the Hottentot were conducted in the name of medicine and biology, linking the ethnic freak to beasts and to pathological illness, the fascination was always on her exaggerated buttocks.

The Hottentot Venus was the archetype for other 'Venuses' of foreign, 'primitive' descent such as Tono Maria, 'the Venus of South America', who was a Botocudo Indian from Brazil. Her 104 scars representing individual acts of adultery attracted people to her 1822 exhibition at Bond Street. Maria's viewers reacted with disgust at her 'laziness and nastiness' as judged by one journalist at the time. Her suggested promiscuity was linked to her overall 'loathsome' nature, and as voyeurs of the abject, people showed up to be repulsed by the sight of her eating food. This connoted that the primitive woman's appetite for sex and food were both abominable and immoral. However, there was no shortage of viewers for her laconic show with nothing to see but a human being with scars. These human showcases prevailed as object lessons in abjection. One reporter commented that those men who thought less of their own 'countrywomen' before, 'will probably leave the show "clean... an altered man", and for life after pay the homage due to the loveliest works of creation, enhanced in value by so wonderful a contrast'.[20] Tono Maria was used as a standard of visualized beauty, established in order to make possible comparison with other female objects – a comparison through which value could be judged in terms of moral deliberation.

It was here, at the site of exhibitions of the freaks of nature in association with the primitive and the foreign that the bodies of ethnicity became signifiers of the Other – incorporating the aberrant, the grotesque and the immoral under one sign. It is clear, however, that the Other was a product of a scopic curiosity that had much to do with the fetish desires of the British viewing public. The visual attributes of desire – exaggerated sexual anatomy, scars as the inscription of sexual appetite and the act of eating as flagrant satiation – were the objects of the viewers' repugnance, and yet their obvious titillation was thinly

veiled by repulsion. Not unlike the allure of shocking images, the desire to see the 'real' anomaly was more or less a narcissistic practice of fetish fixation and self-disgust.

The greater problem was how the association of the anomaly to race was incorporated into corresponding theories of evolution under discussion in scientific circles at the time. Altick had this conclusion: 'There can be scarcely any question that the various exhibitions of specimens of other races – so different from, supposedly so inferior to Caucasians – contributed plentifully, in conceptions, prejudices, and stereotypes, to the prevailing climate of those last pre-Darwinian years'.[21] By the time that Darwin's *Origin of the Species* was published in 1859, the visualization of the grand narrative of Caucasian superiority had reached its climax with the 1851 Great Exhibition of the Works of Industry of all Nations, known best as the Crystal Palace.[22]

Judging by the steady decrease in newspaper advertisements and handbills, the number of exhibitions devoted to single subjects in London diminished by the late 1850s.[23] The great spectacle of the Crystal Palace had surpassed the popularity of the theatrical exhibitions. Moreover, the Great Exhibition was organized under the supervision of Prince Albert's royal commission and the Royal Society, which began a regulative shift in the administration of London exhibitions in general. Altick considers that 'it was at this point that [the Exhibition's] hitherto tentative and isolated efforts to initiate, control, and support exhibition places for the common good were converted into policy'.[24] Whereas the shows of 'ethnic people' were first conducted as entrepreneurial ventures, the ethnographic shows at the world expositions would be conducted according to the policies of an overarching imperial and nationalist agenda.

If the stated objective of the first Great Exhibition of 1851 was to 'promote and increase the free interchange of raw materials and manufactured commodities between all the nations of the earth', as Charles Babbage observed, the less obvious ambitions became more prominent in the fairs that followed.[25] Babbage interprets accurately the exposition's underlying aim of promulgating advancement 'in knowledge, in industrial skill, in taste, and in science'.[26] The point was

to instil modern ideals, and a progressive aesthetics and ethnology could 'acquire *permanent* existence only through the *publicity* given to their enunciation and discussion'. Babbage goes on to say that when these progressive principles 'are accepted as truths', they 'become the universal property of mankind'.[27] The epistemological terms of system and discourse advocating the ideals of the Crystal Palace constituted an ideology that all forthcoming expositions would accept as their model.

2 Arabic Women,
Midway Plaisance,
Columbian World
Exposition, photo, H.H.
Ragan, *Art Photographs of
the World* (Chicago: Star
Publishing Co., 1894),
Getty Special Collections
ID 1361-768

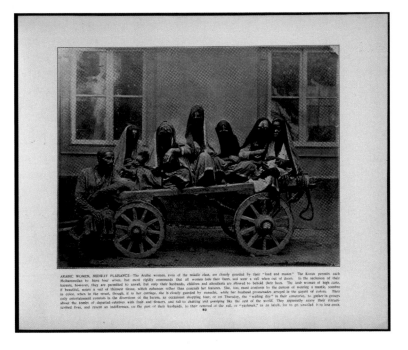

The 'Midway Plaisance' was first established at the 1893 World's Columbian Exposition in Chicago, in which entire groups of 'ethnic' peoples were exhibited under the direction of anthropology departments of leading universities. The Chicago fair had followed the earlier example of the 1889 Paris Exposition where French officials organized a village of non-white peoples for display near the Eiffel Tower. Robert Rydell, who has conducted extensive research on world

expositions, acknowledged the popularity of the displays that became an integral part of the world's fair: 'No subsequent world's fair lacked a variation on this ethnological exhibit, and for the better part of the next fifty years, such arrangements of nonwhite colonials often bore the name "ethnological villages"'.[28] As late as 1933, the Midway delights were advertised in the official guide of the Chicago fair, now given the title, 'A Century of Progress'. The guide encouraged visitors to '(r)ide the breath-taking roller coaster' at the same place where the spectacles of the 'circus cacophony' included 'the 'apotheosis of America's womanly pulchritude', the 'living wonders', the Siamese Twins, giant people and other 'freaks' that were 'gathered from the four corners of the earth'.[29] The same spectacles that attracted viewers to the early nineteenth-century exhibitions in London drew audiences in equal measure to the Midway; however, the day-to-day behaviour of 'ethnic peoples' was now on show.

In its entirety, the 1893 World Columbian Exposition could be viewed as publicity for the superiority of the United States. The Beaux Arts buildings designed for the primary grounds inspired the pseudonym the 'White City', a name that in every way expresses the hierarchical contrast to the classes of 'race' at the Midway Plaisance.[30] The primary difference between the ethnological villages and their forerunners, the British exhibitions of 'ethnic' freaks, was the Midway's incorporation of 'all the world' into the 'evanescent panorama' of its one-mile concourse. Harvard professor Frederick Ward Putnam, the fair's chief of the Department of Ethnology, was first signed up to organize the Midway display. In conjunction with the 'living' exhibits, Putnam published a portfolio series called *Oriental and Occidental, Northern and Southern, Portrait Types of the Midway Plaisance*, which served as a photographic guidebook for viewers to identify the villages of 'Arabs, Singhalese, Javanese, Chinese, Samoans, Hawaiians, Esquimaux, Laps, Soudanese, Turks, Japs, Dahomeyans, Abyssinians, Algerians, Bedouins, Cossacks, Indians, Parsees, Hindoos, Greeks, Egyptians, Syrians, South Americans'.[31] The viewer could experience an entire world of different peoples according to ethnographical classification and order at the Midway.

3 Igorots eating dog meat in the Philippine exhibit at the 1904 St. Louis Louisiana Purchase Exposition. Photo from John Wesley Hanson, *The Official History of the Fair*, (St.Louis, 1904) reprinted in Burton Benedict, *The Anthropology of World's Fairs: San Francisco's Panama Pacific International Exposition of 1915*, (London and Berkeley: Scolar Press, 1983). 49.

In his *Anthropology of the World's Fairs*, Benedict Burton explains that a San Francisco entrepreneur who was experienced at staging Algerian 'dancers, acrobats, glass-eaters and scorpion swallowers' was eventually hired to increase the entertainment value of the Chicago Midway show.[32] Burton suggests 'behavioural traits can be used to create "freaks"' and the 'sword swallowers, glass eaters, and cushion men' all served to de-naturalize the common act of 'eating'.[33] The continuation of linking abject behaviour with race was illustrated at the 1904 St Louis Louisiana Purchase Exposition where viewers could watch Filipino Igorots eating dog meat. Portraying an act that was considered grotesque was visible proof that people of colour were essentially not capable of development.

The consolidation of racial Others was most effective in the way that the individual villages were viewed all together in one place, producing the sense that all the various 'tribes' shared something in common by virtue of their difference – the strategy of showing difference by repetition ascribed sameness to them all. Viewed as curiosities, specimens, scientific objects, trophies of colonization, or as traditional craftsmen making 'primitive' things, the people on display had little control over the contexts in which they were being shown. This was the way that 'ethnic

bodies' were culturally inscribed by whites, and in the negation of their self-representations, the foreclosure of their subjectivity would remain uncontested as a privilege of the white viewing public. Through the pretexts of judgements of 'taste' and the legitimacy of 'science', like that which Babbage initially prescribed for the viewers of the Crystal Palace, the Other was created to show what whites were *not* – primitive, aberrant, immoral and ignorant. The Other in the context of the fair could have been anyone of ethnicity so long as the body presented was not like the white viewer's. Putnam expressed these terms in 1894 when he referred to the Viennese and German pavilions nearby: 'We must not forget however that in the midst of peoples so new and strange to us there were others nearer akin'.[34] As stated in his guidebook, Putnam reminded the Occidental reader of the virtue of 'we' and 'us' who are 'akin'.

The problem presented by the ethnological villages is not in the way one culture portrayed another in colonial history, but in how the individual from outside the imperial order was assigned meaning and value. Judith Butler's analysis on gender is relevant here. History, she states, 'is the creation of values and meanings by a signifying practice

4 James Luna, 'Artifact Piece,' Museum of Man, San Diego, California, 1987. Photo courtesy of the artist

that requires the subjection of the body... a body, described through the language of surface and force, weakened through a "single drama" of domination, inscription, and creation'.[35] Butler recalls Foucault's description of the 'single drama' as the way cultural values emerge from continuous acts of inscription upon the body.

In James Luna's parody of the colonial practice, the artist subjected his own body to the inspection of museum visitors. Luna placed classificatory labels alongside his body to identify the injuries and scars he received during a moment of 'excessive drinking'. In separate displays, ceremonial and personal items were laid out as proof of his origins as a member of the Luiseño reservation. Luna's derisive reconstruction of the colonial display contained all of the visual and discursive elements that were used to constitute the Other: the scientific catalogue of indexical scars, documentation of alcoholism as proof of aberrant behaviour, props that support tribal authenticity and, most importantly, the corporeal native as object. The history of identification cannot be disavowed, and the depth of the colonial transgression towards people of different skin colour can be understood by comprehending the absolute foreclosure of self-derived meaning and subjectivity that continues to dominate the viewing of the 'ethnic' body.

Contemporary artists such as Luna, Gómez-Peña and Fusco, who stage their own subjectivities, call into question the continuing impact of the colonial management of the ethnographic subject. The powerful inscription of *all* racial bodies under one sign – the Other – presents a continuing need to 'reverse anthropology', as Gómez-Peña and Fusco once put it. The effort to deploy this reversal requires not only the reinstatement of the body, as body artists have aspired to do, but also a deconstruction of the psychoanalytical and philosophical theories of self–other relations.

Based on her interpretation of Frantz Fanon's theory, Diana Fuss states that Otherness itself 'may be appropriated exclusively by white subjects. Fanon considers the possibility that colonialism may inflict its greatest psychical violence precisely by attempting to exclude blacks from the very self–other dynamic that makes subjectivity possible.'[36]

I want to extend Fanon's theory via Fuss to include the raced bodies that were expressed at the colonial expositions.

Jacques Lacan's explanation of 'I' as an 'Other' refers to the symbolic difference of the unconscious, and Lacanian 'otherness' has been interpreted as the means to gain entry into subjectivity. Fuss proposes that 'subjectivity names the detour through the Other that provides access to a fictive self'.[37] The psychical Other is produced to reflect the unconscious self in order to claim subjectivity. In the colonial exhibitions, the ethnographic Other represented the anxiety and fear of the abject that existed solely in the minds of the white viewers. The 'abject', defined by Julia Kristeva as the object of secular 'filth' as distinct from the 'clean' of the Christian norm, came to be associated with non-white bodies.[38] And yet, at the same time, the drive to be titillated or shocked by the 'freaks' of race on display was a way for viewers to transgress their own moral sensibilities. These appear to be negotiations of fear and desire at work within the white unconscious. For, if Lacan's field of the Other determines the function 'which institutes an identification of a strangely different kind', this process of alienation from the 'self', this 'splitting off', enables a dialectic of pleasure in which 'hedonism is unable to explain the mechanism of desire'.[39] Homi K. Bhabha's analysis in 'The Other Question' suggests that the two forms of 'narcissistic and aggressive identification' in Lacan's Imaginary are articulated by fetishizing the non-white 'object' in view.[40] In the colonial gaze, 'freakiness' becomes fixed as a renewable fantasy in which the ethnographic Other 'is differently gratifying and terrifying each time'.[41] The Other never really 'represented' the ethnographic subject as a 'Subject'; rather, it was constructed to support and define the fetish desires and repulsions of the modern, secular and assumed to be Western male. Fuss explains it in this way: 'Through a psychical process of colonization, the imperial subject builds an Empire of the Same and installs at its center a tyrannical dictator, "His Majesty the Ego"'.[42] Since the ethnographic subject was foreclosed from the start, the ethnographic Other merely reflects the fetish object at play in the service of the white ego.

As Fuss points out, the problem originated with Hegel's dialectic in his *Phenomenology of Spirit*, which has been interpreted as directly modelled after the imperial strategies of the nineteenth century.[43] Robert Young considers the self–other relations expressed in Hegel's philosophical ideals as conceptually mimetic of 'the geographical and economic absorption of the non-European world by the West'.[44] Freud had inherited Hegel's principle of negating the self in order to incorporate into the self, and Fuss argues that Freud had developed the 'colonial-imperial register of self–other relations' in a particularly influential manner. In Freud's work, states Fuss, 'the psychoanalytic formulation of identification can be seen to locate at the very level of the unconscious the imperialist act of assimilation that drives Europe's voracious colonialist appetite. Identification, in other words, is itself an imperial process, a form of violent appropriation in which the Other is deposed and assimilated into the lordly domain of Self.'[45] As I have sought to argue, the most public means of the imperial process of identification was through staging the body of race at the colonial exhibitions. The physical attributes and processes that were the focus of curiosity came to be inscriptions of marked difference. It was there that the ethnographic body was stripped of its 'humanness' and transformed into a fetish object for viewing. Any contemporary restoration of subjectivity to the body marked by race also has to consider the restitution of the body of 'humanness'.

Luna's *Artifact Piece* deploys a resignification process by way of returning the marked body to the knowledge of its 'species being' – Karl Marx's understanding of the human, the self, as the 'present, living species... as a *universal* and therefore free being'.[46] I interpret universal here not to represent the modern homogeneous 'individual' but to mean the human-to-human connection that one could recognize in the face of another person. When the viewer approaches the living human body that Luna dramatically displays as a specimen – prone, breathing, sweating, heart-palpitating, alive – she/he recognizes her/his own vulnerability as well as the unnerving intimacy of 'staring' at someone in this way. The viewer becomes aware of her/his own breathing, sweating and palpitating heart. Luna's humanness is all too

prominent, breaking the spell of viewing the Native as fetish object, and hence refuting the accompanying display of discursive indicators pointing to alcoholism, irrational violent behaviour and unprogressive tribal traditionalism.

Body art's potential for self/other reciprocity is made clear in Amelia Jones's analysis of Maurice Merleau-Ponty's phenomenology. As Jones explains, 'Merleau-Ponty's insistence on embodiment and on going beyond vision-oriented models of self and other differentiate his work from Lacan's theories of self, at least as the latter have been popularized in contemporary cultural discourse in the United States...'[47] The contrast with optic engagements of the subject staged simply as an 'image' – disembodied though psychically invested – is the way that body artists such as Luna compel the sense of '*simultaneous* subject/objectification – one is *always already both at the same time*', as Jones explains.[48] Whereas the colonial gaze of repressed desire and repulsion forecloses the corporeal relationship as a result of the powerful influence of the imperial system and discourse, Luna's embodied subject/object, which is presented to the viewer at close range, affects the viewer's own sense of 'flesh'.

It is the staging of Luna's body that promotes a personally involved engagement. In this way, Merleau-Ponty's theory of '*chiasmic* intertwining of self and other' relates to Luna's work in that the viewer experiences the 'visible in the tangible and of the tangible in the visible'.[49] Jones adds that the '*flesh of the visible* indicates the carnal being – at once subjective and objectified'.[50] Between the viewer and the body artist, the body 'seeing' Luna's body shares an intersubjectivity, and through their relationship in the flesh, not the gaze, one can also understand their interobjectivity. Such an engagement calls for a different relationship – an interdependency – between the artist who is marked by race and her or his prospective viewer. Jones speculates that such a relationship may assert 'the necessary responsibility of the multiplicitous and dispersed, but fully embodied, social and political subject'.[51] In the politics of identification, the challenge for people who live in the 'raced' body of colour is in resignifying the cultural inscriptions that have descended from colonial identification.

However, this does not mean that cultural identity can be 'restored' as indicated by the current compulsion to reinstate an 'authentic' cultural representation. Not unrelated to the nineteenth-century desire for the anthropological 'real', Hal Foster argues in the *Return of the Real* that the 'Artist as Ethnographer' is the new method of resistance for theorists to discuss an authoritative alterity by way of 'a turn to the referent as grounded in a given identity and/or a sited community'.[52] To him, contemporary art over the last thirty-five years has shifted towards an 'ethnographic turn' in an expanded field of culture 'that anthropology is thought to survey'. In other words, the current cultural investigation of art (viewed through the postcolonial or culture as discourse) can be understood as an ethnographic return to the 'real' subjects of identity and ethnicity. Much like the modern insistence on proof and origins, such a reasoning relies on the notion of an authentic identity as the premise of cultural truth. My argument is that identity can never be assumed as fixed in terms of an 'original culture'. As Judith Butler expresses, the 'foundationalist reasoning of identity politics tends to assume that an identity must first be in place in order for political interests to be elaborated...'[53] In Gómez-Peña and Fusco's 'Guatinaui World Tour', the questioning of the foundationalist reasoning was central to their staging of the *invention* of culture and identity.

Against the logic of artists as ethnographers, the 'Couple in the Cage' was scripted from the tendentious drama of ethnography and not from any 'real' subjects of identity. The props and costumes of a made-up culture – for instance, *Guatinau* as Spanish/English for 'what now', Gómez-Peña dressed as an Aztec wrestler from Las Vegas, and Fusco refashioned from the television couture of *Gilligan's Island* (a US 1960s sitcom) – illustrated the given identity or sited community that was created by myth. In essence, the artists were mimicking the masquerade, or, I should say, taking as subject the staged masquerade of the primitive as the object of their mimicry. The method of identification that the Guatinaui World Tour revived in order to parody reveals how identity, in terms of race in the West, has always been a construction – whether seen as a product in support of colonial empire or as a product of instability

5 Ma Liuming,
*Fen-Maliuming
Walks the Great Wall,*
1998, photograph of
performance. La Biennale
di Venezia, 48 Esposizione
Internazionale d'Arte,
APERTO over ALL. Photo
courtesy Jack Tilton
Gallery, New York

6 Ma Liuming,
Fen-Maliuming I,
1993, photograph of
performance in Beijing.
Photo courtesy Jack Tilton
Gallery, New York

due to the unfixed nature of human lives that cannot be universally
identified by one's outward appearance.

 In viewing the photograph of Ma Liuming's 1998 performance,
Fen-Maliuming Walks the Great Wall, the artist's characterization
suggests a kind of reconciliation of the Western subject who seeks
to see himself but is always at the risk of assimilating into the
Orientalized, feminized or homosexualized self of alienation. In the
subjectivity of rethinking the self in the very exploration of narcissism,
Ma performs the construction of identity on many levels. How the
artist is 'seen' in the image of the Other cannot be separated from
the references to nationhood that the West has fastened to cultural
identification. Whether represented by the Great Wall, Tiananmen
Square or the Forbidden City, any number of symbolic objects
could serve as reference to national identity. Subjectivity, however,
as described by Jones 'is performed in relation to an *other* yet is
paradoxically entirely narcissistic'.[54] Ma shows the precarious nature

of subjectivity for one whose corporeal body is in itself a metonym for the Western Other – for alienation – and yet his portrayal exposing all of the elements that constitute self-estrangement begins to clear the way for envisioning outside the colonial gaze.

The selection of *Fen-Maliuming* for exhibition at the 1999 Venice Biennale reveals a significant shift in the evolution of global exhibitions and world's fairs. The Biennale's consolidation of artworks from all the nations of the world began in 1895 as a celebration of achievements in modern art. Since the end of the twentieth century, long-running global art fairs such as the Documenta, La Biennale di Venezia and Bienal de Sao Paolo function as political platforms for rethinking the global state of affairs in relation to artistic expression. The exhibitionary order of fairs and world expositions survives today in the most openly politicized and globalized venue for showing contemporary art.

At the 1999 Venice Biennale, Ma was one of eleven artists from China who exhibited body art or body-oriented images (some more explicitly in *embodying* subjectivity than others). In these works, we begin to see the surfacing of subjectivity – of particular life subjects and experiences – through the emanation of the self/body. However, more is required of the viewer if we are to regard Foucault's warning: 'Nothing in man – not even his body – is sufficiently stable to serve as the basis for self-recognition or for understanding other men'.[55] Nevertheless, it is acknowledging the foreclosures in history that allows for the acceptance of the 'culturally constructed body', one in which Butler sees the promise of liberation 'neither to its "natural" past, nor to its original pleasures, but to an open future of cultural possibilities'.[56] For such a vision, the narrow quest for authenticity and the 'real' must be relinquished in favour of something more expansive.

NOTES

1 Amelia Jones, *Body Art: Performing the Subject* (Minneapolis, MN: University of Minnesota Press, 1998), p. 13.

2 'Human Showcases' was the title of Paul Greenhalgh's chapter arguing that in the great exhibitions and world's fairs (between 1889 and 1914), 'objects were seen to be less interesting than human beings, and through the medium of display, human beings were transformed into objects'. Paul Greenhalgh, *Ephemeral Vistas: The Expositions Universelles, Great Exhibitions and World's Fairs, 1851–1939* (Dover, NH: Manchester University Press, 1988).

3 See Coco Fusco, *English Is Broken Here: Notes on Cultural Fusion in the Americas* (New York: New Press, 1995); Guillermo Gómez-Peña, *The New World Border: Prophecies, Poems and Loqueras for the End of the Century* (San Francisco: City Lights, 1996).

4 Diana Fuss, 'Interior Colonies: Frantz Fanon and the Politics of Identification', *Diacritics* 24, no. 2/3 (1994), p. 20.

5 Michel Foucault, *The Archaeology of Knowledge* (New York,: Pantheon Books, 1972), p. 73.

6 Foucault, *The Archaeology of Knowledge*, p. 73.

7 I am using Fuss's interpretation of Lacan's definitions for the 'other/Other' in which the other with the small 'o' indicates a specular relation to an imaginary rival that is dependent on the narcissistic relation. This 'other' is a product of primary identification in which the subject recognizes the self in her/his own image. The Other with the capital 'O' indicates a linguistic relation to the symbolic interlocutor, which marks the locus of intersubjectivity. The 'Other' is produced from secondary identification in which the subject shifts her/his point of address to another speaking subject. Whereas the cultural Other should ideally fit into the space of secondary identification, Fuss argues that Fanon implies the black man is relegated to an objecthood that forecloses intersubjectivity. As such, the complete foreclosure of the cultural Other can be understood as her/his subjecthood forever defined as part of the imaginary in the white narcissistic relation with the self. See Fuss, 'Interior Colonies', p. 20.

8 Timothy Mitchell, 'Orientalism and the Exhibitionary Order', in *The Art of Art History: A Critical Anthology*, ed. Donald Preziosi (Oxford and New York: Oxford University Press, 1998).

9 Mitchell, 'Orientalism', p. 472.

10 See Krzysztof Pomian, *Curiosities: Paris and Venice, 1500–1800* (Cambridge: Polity Press, 1990), p. 64. Imaginary wonderment appeared at a time when 'optics remained a science of miracles, exuberant, incoherent, muddled assailed by contradictions' which is the way Pomian describes the brief epistemological space that existed between theology and science in seventeenth-century Europe.

11 See Chapter 14, 'The Theatrical Art of the Panorama', in Richard D. Altick, *The Shows of London* (Cambridge and London: Belknap and Harvard University Press, 1978).

12 See Altick, *The Shows of London*, p. 177. For individual descriptions and drawings of individual panoramas, including the subjects of Canton, Hong Kong and Macao, see Robert Burford, *Some Famous Panoramas 1830–60* (London: R. Burford, 1840).

13 *London Times*, 7 April 1827.

14 Altick, *The Shows of London*. See Chapter 18, 'William Bullock and the Egyptian Hall'.

15 See Roy Thompson, 'Chang–Eng Pact Acquired', *Winston-Salem Journal*, 6 August, 1977. Although the contract states the teenagers were released under the 'free will and consent' of their parents and the king of Siam, all negotiations were translated into English and conducted by their mediator Robert Hunter. The legality of the transaction remains questionable since, at the time, Chang and Eng's father had been ten years deceased.

16 Thompson, 'Chang–Eng Pact', p. 261.

17 Thompson, 'Chang–Eng Pact', p. 268.

18 See Sander L. Gilman, 'Black Bodies, White Bodies: Toward an Iconography of Female Sexuality in Late Nineteenth-Century Art, Medicine, and Literature', in *Race, Writing, and Difference*, ed. Henry Louis Jr. Gates (Chicago and London: University of Chicago Press, 1985). According to Gilman, there were several Hottentot Venuses, and they were given the name in respect of the 'Hottentot Apron', a term used by eighteenth-century travellers such as Francois Le Vaillant and John Barrow to describe the manner of beautification of female genitalia that certain South African tribes subscribed to. The Hottentots and Bushmen were communities like those of Basutoland and Dahomey.

19 Gilman, 'Black Bodies', p. 237.

20 *Literary Gazette*, 23 February 1822. Cited in Altick, *The Shows of London*, p. 273.

21 Altick, *The Shows of London*, p. 287.

22 Charles Darwin, *On the Origin of Species By Means of Natural Selection, or the Preservation of Favoured Races in the Struggle for Life* (London: John Murray, 1859).

23 See Altick, *The Shows of London*, p. 496. Although the newly constructed Royal Panoptican, opened in 1854, continued to present ethnographic shows, the theatre closed its door two years later in 1856 when audiences declined considerably.

24 Altick, *The Shows of London*, p. 498.

25 Charles Babbage, *The Exposition of 1851 on Views of the Industry, the Science, and the Government of England*, 2nd ed. (London: John Murray, 1851), p. 42.

26 Babbage, *The Exposition of 1851*, p. 43.

27 Babbage, *The Exposition of 1851*, p. 43.

28 Smithsonian Institute, *The Books of the Fairs: Materials About World's Fairs, 1834–1916, in the Smithsonian Institution Libraries* (Chicago: American Library Association, 1992), p. 4.

29 A Century of Progress, *Official Guide, Book of the Fair 1933, Chicago, Century of Progress International Exposition* (Chicago: A Century of Progress, 1933), p. 121.

30 See Robert W. Rydell, 'Rediscovering the 1893 Chicago World's Columbian Exposition', in *Revisiting the White City: American Art at the 1893 World's Fair*, ed. Carolyn Kinder Carr (Washington, DC: Smithsonian Institution, 1993). According to Rydell, twenty million people attended the fair during the six months that it was open to the public.

31 F. W. Putnam, *Oriental and Occidental, Northern and Southern: Portrait Types of the Midway Plaisance* (St Louis: N.D. Thompson Publishing Co., 1894), Introduction.

32 Burton Benedict, *The Anthropology of World's Fairs: San Francisco's Panama Pacific International Exposition of 1915* (London and Berkeley: Scolar Press, 1983), p. 49.

33 Benedict, *The Anthropology of World's Fairs*, p. 49.

34 Putnam, *Oriental and Occidental, Northern and Southern*, Introduction.

35 Judith P. Butler, *Gender Trouble: Feminism and the Subversion of Identity* (New York and London: Routledge, 1999), p. 130.

36 Fuss, 'Interior Colonies', p. 21.

37 Fuss, 'Interior Colonies', p. 21.

38 See Julia Kristeva, *Powers of Horror: An Essay on Abjection* (New York: Columbia University Press, 1982), p. 65.

39 Jacques Lacan et al., *The Four Fundamental Concepts of Psycho-Analysis* (Harmondsworth: Penguin 1979, 1977), pp. 257, 241.

40 Homi K. Bhabha, 'The Other Question: Difference, Discrimination and the Discourse of Colonialism', in *Out There: Marginalization and Contemporary Cultures*, ed. Russell Ferguson et al. (New York and Cambridge: New Museum and MIT Press, 1990), p. 81.

41 Bhabha, 'The Other Question', p. 82.

42 Fuss, 'Interior Colonies', p. 23.

43 Georg W. F. Hegel, *Phenomenology of Spirit*, trans. J. B. Baillie, 1910 ed. (New York: Harper Row, 1967).

44 Robert Young, *White Mythologies: Writing History and the West* (New York: Routledge, 1990), p. 3.

45 Fuss, 'Interior Colonies', p. 23.

46 Karl Marx, 'Economic and Philosophical Manuscripts (1844)', in *Early Writings* (New York: Vintage, 1975), p. 327.

47 Jones, *Body Art*, p. 40.

48 Jones, *Body Art*, p. 40.

49 Maurice Merleau-Ponty, 'The Intertwining – the Chiasm', in *The Visible and the Invisible*, ed. Claude Lefort (Evanston, IL: Northwestern University Press, 1968), pp. 134–35.

50 Jones, *Body Art*, p. 41.

51 Jones, *Body Art*, p. 18.

52 Hal Foster, *The Return of the Real: The Avant Garde at the End of the Century* (Cambridge, MA: MIT Press, 1996), p. xviii.

53 Butler, *Gender Trouble*, p. 142.

54 Jones, *Body Art*, p. 46 (my emphasis).

55 Michel Foucault, 'Nietzsche, Genealogy, History', in *Language, Counter-Memory, Practice: Selected Essays and Interviews* (Ithaca, NY: Cornell University Press, 1977), p. 153.

56 Butler, *Gender Trouble*, p. 93.

8

'Do-it-yourself Artworks'
A User's Guide

ANNA DEZEUZE

Product Description

In 1966 Lygia Clark created her *Air and Stone*, a work which invites each viewer to take a plastic bag, fill it with air, close it with an elastic band, place a small stone on one of its corners and hold it in his or her hands. That same year, Yoko Ono invited visitors to the Indica Gallery to help themselves to one of the nails contained in a small box on a chair and to hammer it into a white wooden board placed on the wall above (the hammer to be used was attached to the board by a chain). This *Painting to Hammer a Nail* was based on a 1961 instruction, first published in 1964, which reads:

> Hammer a nail into a mirror, a piece of glass, canvas, wood or metal every morning. Also, pick up a hair that came off when you combed in the morning and tie it around the hammered nail. The painting ends when the surface is covered with hair.

'I think painting can be instructionalized', Ono had written in 1965. '[The a]rtist, in this case, will only give instructions or diagrams for painting – and the painting will be more or less a do-it-yourself kit according to the instructions.'[1] In a letter to a friend, Clark would later echo Ono, simply stating *à propos* of one of her works: 'I want people to do it themselves'.[2] Following these statements, I have defined as 'do-it-yourself artworks' artistic practices which, like Ono's and Clark's, require the spectator's active participation. The very term 'do-it-yourself' embodies some of the crucial characteristics of these works. The imperative form 'do' and the indexical pronouns 'it' and 'yourself' are,

1 Lygia Clark, *Air and Stone*, 1966 Lygia Clark Collection/Museu de Arte Moderna do Rio de Janeiro

grammatically speaking, performative: they are contingent on the specific situation in which they are used. 'Hammer a nail ... pick up a hair ... tie it around the hammered nail': in the same way as any reader of Yoko Ono's instructions can slip into the text through the imperatives, the hands visible in photographs of Clark's *Air and Stone* could be yours or mine. The verb 'do' emphasizes process; the pronoun 'yourself' underlines that the performance is the participant's, rather than the artist's. And, since the result of this process will be determined by each individual's unique personal experience, the pronoun 'it' will always remain open.

Warning

Do-it-yourself artworks are not related formally. Yoko Ono's *Painting to Hammer a Nail* is a text, which may be performed in a gallery, at home or in one's mind. Lygia Clark's *Air and Stone* consists of everyday objects (a found stone, a plastic bag and elastic band which can be purchased at low prices) to be apprehended through touch – a kind of extension of the haptic dimension of sculpture into the tactile realm of object use. Do-it-yourself artworks are formally similar to types of language-based conceptual art, but use texts to give instructions rather than utter statements; do-it-yourself artworks are performative, but, unlike body art and other audience-oriented performances, they require the presence of the spectator's body, rather than the artist's. Do-it-yourself artworks, finally, evoke forms of sculpture in which process is emphasized over the final result – indeed, Clark's *Air and Stone* shares organic, material qualities with Eva Hesse's sculptures and 1960s forms of so-called 'process art'. Yet, whereas viewers of Hesse's works must content themselves with imagining the textures and sensations of lightness, weight and fragility encountered by the artist, participants of do-it-yourself artworks discover these qualities directly, through touch.

Do-it-yourself artworks were developed independently from each other, in different parts of the world, in the period between 1959 and 1967. Yoko Ono, a Japanese artist who lived in the United States and Great Britain as well as Japan, was affiliated to Fluxus, a loose group of international artists who came together in the early 1960s. Brazilian

artist Lygia Clark, for her part, was one of the key figures of the Neoconcrete group which was active in Rio de Janeiro between 1959 and 1962, before moving away from the group's geometric abstraction to participatory works made out of materials of little or no intrinsic value such as *Air and Stone*.

The present user's manual for do-it-yourself artworks will provide neither an account of these two groups' works nor a systematic history of the emergence and development of art practices requiring spectator participation in the 1960s. Rather, this manual will explore the characteristics of a category of works that has seldom been studied, and situate them within their historical and socio-political contexts. The following two sections will provide descriptive analyses of the nature of spectator participation in each type of do-it-yourself artwork, in a step-by-step account of some of the aesthetic experiences that they trigger. This brief overview will then serve as a platform to address, in subsequent sections, the ways do-it-yourself artworks relate to broader social and political issues. Following an implicit set of instructions contained in these works, this basic user's guide will focus in particular on the status of do-it-yourself artworks as objects to be used, on the kind of contract which they establish with spectators, and on their political potential.

Always Read the Instructions

Text-based instructions or 'event scores' such as Ono's lay at the heart of Fluxus from the very birth of the group. On the one hand, these scores were performed during public collective Fluxus events first organized in Europe from 1962 onwards. On the other hand, they formed the core of collective Fluxus publications designed by Fluxus leader and impresario George Maciunas who assembled, packaged, advertised and sold them via mail order. The Fluxus event score emerged directly from the context of American experimental music, in particular that of John Cage, Earle Brown and Christian Wolff. Fluxus artists such as George Brecht and Dick Higgins studied with Cage at the New School for Social Research in New York in the late 1950s, while others, like Ono, became aware of Cage's work in the context of their interest in musical composition

and performance. Fluxus extended Cage's introduction of everyday
noises into musical composition by creating scores that no longer
contain any form of traditional musical sound. Fluxus artists also
followed Cage's redefinition of music as a sequence or simultaneity of
sounds which occur like 'events' within the structure of a given duration.
In Fluxus scores, these 'events' take the forms of actions, which may or
may not produce noise at all. Consequently, Fluxus disposed of musical
notation altogether and instead used texts to describe the 'event' actions,
thus allowing anyone to read and perform them, including people with
no musical background. Duration in Fluxus scores is also perceived
much more loosely than in Cage's. Some Fluxus instructions imply
durations which exceed the traditional framework of concert
performances (Ono's *Cough Piece* requires us to 'keep coughing for a
year'), while others state duration in an ambiguous way ('Put out a hand
from a window for a long time', instructs Takehisa Kosugi's *Chironomy
I*). Yet others refrain from specifying a duration altogether: George
Brecht's concise event scores typically withhold this kind of information,
as in his score for *Drip Music*, which consists of the single word
'dripping'. Typically, Fluxus scores invite readers to perform an activity –
either concretely or through the imagination, either in the context of
Fluxus concerts or in everyday life. What the activity results in is
secondary, and no one, including the artist, can in fact judge precisely
whether a score is performed in the 'right' or 'wrong' way.[3]

Yoko Ono and George Brecht were the first artists to extend the
implications of Fluxus event scores to the production of art objects.
In his first solo exhibition, *Toward Events*, at the Reuben Gallery in
New York in 1959, Brecht showed works such as *The Case*, a suitcase
placed on a table which contained objects such as a skipping rope,
a rubber ball, confetti, a ball of string and a bell. *The Case*, explained
Brecht in the invitation to the exhibition, 'is approached by one to
several people and opened. The contents are removed, and used in
ways appropriate to their nature. The case is repacked and closed.'
The invitation further specifies that the 'event (which lasts possibly
10–30 minutes) comprises all occurrences between the approach and
the abandonment of the case'.[4] It is thus because they can be arranged

2 George Brecht,
Suitcase, 1959,
photograph: Lothar
Schnepf, Cologne, by
courtesy of the artist and
Gagosian Gallery

and manipulated by the viewers that Brecht's objects can be conceived in terms of duration and hence are 'more in the nature of a performance (music and dance) than of an object'.[5]

In 1961 Yoko Ono exhibited her *Instruction Paintings* at the AG Gallery in New York. Thirteen different-shaped canvases stained with sumi ink and dripped wax were hung on the walls, spread on a table or placed on the floor of the gallery. During the exhibition, Ono guided visitors around the works, giving them instructions for each one verbally, at times demonstrating how to interact with the works.[6] Some works invited the viewer's direct actions, as in *Painting to Be Stepped on* – its title, written on a label next to a piece of canvas on the floor, was self-explanatory. In others, the result of the process needed to be imagined by viewers according to the instructions. One year later, Ono decided to dispense with the object altogether, exhibiting only the instructions without the pieces of canvas at the Sogetsu Art Centre in Tokyo. From that moment onwards, her work would include both scores and objects to be transformed by participants, either literally, or in their minds.

The *Fluxboxes* assembled by Maciunas according to the ideas of Fluxus artists from 1963 emerged at the crossroads between scores and objects in a manner similar to Ono's and Brecht's earlier experiments. Maciunas, however, stressed the object-like nature of the works by designing elaborate offset paper labels bearing the titles and names of artists that he glued onto small bottles, tins and, most frequently, the lids of small hinged plastic boxes. Sometimes the objects in those boxes simply complement an event score, as in Benjamin Patterson's *Instruction no. 2* where the instruction to 'wash your face' is printed on a paper towel and presented in a box with a piece of soap. In others, such as Yoshimasa Wada's *Smoke Fluxkit*, objects replace the text of the score altogether; a creative tension is established between the title of the work printed on the label and the objects contained in the box (such as incense cones and sticks, orange peel and leather). As one reads the labels, opens the boxes, prods, smells and handles the objects, one's experience oscillates between playful, sensory discovery and a reflection on the relations between

object and text. The *Fluxboxes* exist as material objects which suggest
activities, be they prosaic, enigmatic, humorous or poetic.

Please Touch

Fluxus explored the possibilities of creating score-like objects, but it
can be argued conversely that all objects to be handled contain a set of
implicit instructions for use. Sometimes these consist in the simple
invitation to 'please touch' that can be suggested by the structure and
display of the work. These manipulable objects, which constitute
another type of do-it-yourself artwork, can take different forms.
Whereas the objects in Clark's *Air and Stone* need to be put together
by the participant, her earlier Neoconcrete *Bichos* (*Animals*), started in
1960, were gleaming aluminium sculptures made out of slim, hinged
geometric planes which could be folded and unfolded by spectators
into various configurations. Another Neoconcrete work involving
spectator participation was Lygia Pape's 1959 *Livro da criação* (*Book of
Creation*), in which each page or unit is a painted cardboard panel
thirty centimetres square that can be taken out of a box and viewed
individually. Following an underlying narrative, each unit evokes,
without any words, a stage in the 'creation' of the world: from light,
water and fire to the invention of the ship keel and the discovery of the
planetary system. In some, simple gestures are required from the
viewer such as rotating a red disk to 'measure' the passing of time, or
unfolding the triangular sections glued to a red and white square to
suggest the flames of a fire.

Pape would retrospectively explain that while the 'concept of
participation can be seen, *a posteriori*, as a characteristic specific to the
Neoconcrete movement', it did not, in fact, originate from the artists'
declaring at some point 'we are going to do this'.[7] Neoconcrete works
such as her *Livro da criação* or Clark's *Bichos* evolved instead from a very
specific exploration of geometric abstraction in Rio de Janeiro.
Neoconcrete artists were united in opposition to the Concrete artists
active in São Paulo since the mid-1950s, whom they criticized for
dogmatically applying mathematical principles to create rigorous
geometric paintings and sculptures based on modular repetitions and

3 Lygia Clark, *Bicho (máquina)* [Critter (device)], 1962. Gilt finish on metal, 55 x 65 cm © Clark Family Collection. Photo by Eduardo Clark

symmetries. In 1958 Clark explained in an interview that in the 'serial forms' encountered in Concrete art the spectator 'is only someone who watches (*um assistente*), reading space in a purely optical manner in which time is expressed in a merely mechanical way'.[8] Instead, Clark wanted spectators to 'participate actively' in her works, 'to enter space organically'. Neoconcrete artists often used the terms 'organic' and 'expressive' to distance themselves from a 'mechanical' Concretism. The viewers' gestures in Clark's *Bichos* and Pape's *Livro* naturally introduce these 'expressive' elements within the language of geometric abstraction, literally giving the impression that they are alive, 'organic' structures, ceaselessly transformed and reconfigured.

The dialogue between the spectator and the *Bicho*, according to Clark, is an embrace, a '*corpo-a-corpo*' which in Portuguese literally means 'body-to-body'.[9] The physical intimacy suggested by this image runs through many Neoconcrete works. Small-scale, disposed directly on the floor or on low horizontal plinths, easily accessible to the hand, they urge us to come closer to inspect, interact and discover them. Some Neoconcrete works are closer to the model of the box, as in Hélio Oiticica's later *Box Bólides*. These brightly painted wooden boxes include hinged doors, sliding panels or drawers to be opened by viewers in order

to discover other hues of colours or loose pigment. Neoconcrete participatory works play on the contrasts between visible and invisible, the given and the concealed. Intimacy can thus become associated not only with 'expression' and the 'organic', but also desired, secret and affective spaces.

The exploration of intimate relations between spectator and objects which had emerged from formal preoccupations with space, line and colour would remain crucial for Clark, Pape and Oiticica long after they had abandoned Neoconcretism and the language of geometric abstraction. Clark arrived at her 1966 series of *Sensory Objects* such as *Air and Stone* through experiments with new forms and materials better suited to her continued concern with spectator participation. Though simpler in structure, *Air and Stone* conjures a greater variety of bodily sensations than the *Bichos*: the plastic bag operates both as a transparent container and a smooth, skin-like membrane, becoming an external

4 Hélio Oiticica, *B 13 Bólide caixa 10* [B 13 Box Bólide 10], 1964. Courtesy Projeto Hélio Oiticica, Rio de Janeiro

organ, while the rhythmic rise and fall of the small round pebble sinking into the soft, light mass evokes a sexual act as much as a 'very unsettling birth', as Clark put it.[10] The other title given by Clark to the *Sensory Objects* highlights their close connection to the viewer's body: *Nostalgia do corpo* (*Nostalgia* or *Longing for the Body*). 'When you touch them, it is as if you were feeling your own body', Clark simply explained in 1966.[11]

Similarly, Oiticica extended the manual exploration of the object to the spectator's body as a whole in his series of *Parangolés*, colourful capes made out of sewn cotton and jute fabrics which envelop one's torso, arms and upper legs. The participatory dimension of the *Parangolé* is two-fold. Standing on one's own in a *Parangolé*, one can explore, on the one hand, the complex layering of light, semi-transparent textiles serving as veils and shrouds, combined with brightly coloured shiny fabrics or striped cotton textiles of contrasting textures and shades. On the other hand, the *Parangolé* also invites one to reveal these hidden elements to others through walking, turning, dancing movements in which limp textiles become swirling shapes and blurs of colour, while the texts included in some of the *Parangolés* can be held up like banners or public statements. Oiticica called this double experience of the individual, private and intimate and the collective, spectacular aspect, '*o ciclo "vestir-assistir"*'(the '"wearing-watching" cycle') of the *Parangolé*, which includes the experience of wearing, the experience of looking, and the experience of looking and being looked at.[12]

Use (in Appropriate Ways)

In 1963 Oiticica wrote a text in which he compared his *Bólides* to Robert Rauschenberg's *Combines*. He took as an example Rauschenberg's 1960 *Pilgrim* in which a real painted chair is attached to the canvas. Although the chair is recognizable as an everyday object and its formal structure becomes a part of the painting, Oiticica argues, it is 'an *a posteriori* incorporation' (*incorporação a posteriori*) so that the terms 'structure of the work' (*estrutura da obra*) and 'structure of the object' (*estrutura do objeto*) remain contradictory.[13] While in *Pilgrim* the chair operates as part of the composition, an element among others painted over in the

5 Hélio Oiticica, *Parangolé P 15 Capa 11 'Incorporo a revolta'* (I embody revolt), 1967, worn by Nildo of Mangueira. Photograph: Claudio Oiticica Courtesy Projeto Hélio Oiticica, Rio de Janeiro

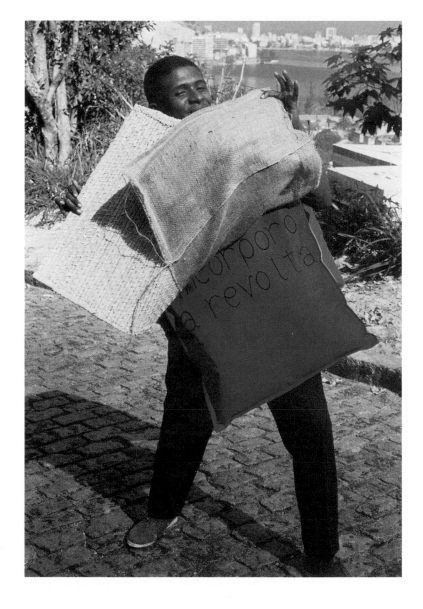

same way as the canvas, Oiticica's use of objects in the *Bólides*, as in the *Parangolés*, does not deprive them from their original function: containers remain containers, fabrics are used to clothe the body.

'Years ago, in '61 or '62, I ... saw a piece by Rauschenberg in which he had attached a chair to a canvas.'[14] The piece recalled by George Brecht in this 1967 interview was none other than Rauschenberg's *Pilgrim*, similarly singled out by Oiticica. Brecht recalls:

> Just as I was about to sit in it, I was told, 'No, no! It's attached and you can't sit in it.' I, on the other hand, make chairs that are supposed to be sat in. After all, if it's a chair why shouldn't you sit in it?

When Brecht exhibited three chairs in his contribution to the exhibition *Environment, Situations, Spaces (Six Artists)* at the Martha Jackson Gallery in 1961, viewers were not made aware that they were all part of Brecht's work. Visitors naturally sat on some of them, much to Brecht's satisfaction.

Do-it-yourself artworks are characterized by their emphasis on use. The invitation to perform activities rather than to contemplate a finished product allows the works to exist in an ambiguous, dynamic relation to the world of activities and objects. The readymade, found, assembled objects that constitute do-it-yourself artworks are always on the brink of reverting to their initial function and become part of the unnoticed, unremarkable realm of the everyday. '[F]or me', explained Brecht, 'an object does not exist outside people's contact with it.'[15] This simple statement is developed by Clark when she concluded: 'What, then, is the role of the artist? To give the participant an object which has no importance in itself and which will only take on such to the extent that the participant will act.'[16]

The emphasis on use in the do-it-yourself artwork was conceived as a means to separate it from the artwork produced and exchanged as a commodity object. According to Marx, an object becomes a fetishized commodity when it is produced in order to be exchanged for money rather than to be used, when its 'exchange value' becomes more important than its 'use value'. Artworks in the modern era are inherently useless; it has even been suggested that the artwork may have served as a model of the ultimate commodity fetish described by Marx, since its

exchange value is measurable neither by the number of hours spent in its fabrication nor in the cost of materials. Artworks, as Yve-Alain Bois put it, emerged as 'absolute fetishes' whose value 'is determined by the "psychological" mechanisms that are at the core of any monopoly system: rarity, authenticity, uniqueness, and the law of supply and demand'.[17] When Clark, Oiticica, Brecht and other Fluxus artists refused to give any material value to the objects they had created, they were thus simultaneously questioning the commodity fetish in general and the art object as an amplified version of this order. Duchamp's readymades, they realized, exemplify the commodification of art precisely because they isolate everyday objects from their functions in order to inscribe them within this 'monopoly system'. Refusing the symbolic act at the root of Duchamp's and Rauschenberg's works, 'do-it-yourself' artists sought to explore what the artwork can be *before* it becomes a commodity fetish.

Privileging performance over the artwork also served to dramatize the relations between subject and object in more philosophical terms. Like Clark and Oiticica, both Brecht and Ono seemed concerned with investigating the ways in which human beings inhabit the world. In their texts and statements, they suggest that the world of things is problematic, it is characterized by a 'closed and enigmatic ... condition', an 'absurd, opaque, presence' and a 'stickiness' which subjects struggle to access.[18] The perception of objects, and the thought processes such as symbolization and imagination that accompany it, lie at the heart of many 'do-it-yourself' practices.

By inviting viewers to directly encounter, handle, engage with objects, these works introduce us to these complex philosophical issues, making us aware of our bodies and our modes of interacting with the 'sticky' reality of the unknown.

For Clark, the work was a 'springboard' for the viewer's experiences; for Ono, it was 'a wish' or 'a hope'.[19] Rather than finished objects, do-it-yourself artworks are starting points, triggers, a first stage towards future actions and experiences. In this sense, do-it-yourself artworks act as tools, objects which always imply an activity, a process. Like tools, Clark's *Sensory Objects* and Oiticica's *Parangolés* can be seen as temporary extensions of the participant's body, as the plastic bag in

Air and Stone becomes an unidentifiable organ, or man-made fabrics are metaphorically grafted onto biological tissues to create a new skin for the wearer of the capes. If they are tools, these objects are tools to help explore one's own body – in terms of subconscious associations, in Clark's *Nostalgia of the Body*, or in terms of performative identities, in the case of Oiticica's *Parangolés*.

Many *Fluxboxes* seem to deliberately parody the usefulness of toolboxes, in their promise to provide sets of objects to make light or eggs (Bob Watts) or even commit suicide (Ben Vautier). Though removed from the 'kit' format, Fluxus scores also serve as tools of different kinds. Alison Knowles's *Proposition*, which instructs us to 'make a salad', evokes the world of cooking recipes.[20] While George Brecht's *Games and Puzzles* series of boxes imitate game rules by instructing us for example to 'spell our name' using a random set of dice (only two of which actually bear letters), some of his scores evoke the practice of Zen meditation exercises. One of his 1961 *Exercises*, for example, asks us to:

> Determine the centre of an object or event.
> Determine the centre more accurately.
> Repeat, until further inaccuracy is impossible.

Freed from the objective of producing a given 'music', Fluxus scores become, like Oiticica's and Clark's 'tools', vehicles for a reflection on our daily activities and gestures, our bodies and our situation in the world.

Get Together

Reflecting on one's body, gestures and individual activities has often been perceived as the concern of a range of practices, developed in the 1960s and 1970s, known as performance art. In 1975 Lygia Clark criticized performance artists for having replaced the artwork as commodity fetish with their own bodies, which had in turn become new objects of spectacle and fetishization.[21] Clark claimed that she renounced authorship so that the participants themselves could experience works directly, without the mediation of the artist. Although they are also performative, the 'body art' performances referred to by Clark set up a relation between audience and performer very different from that of

do-it-yourself artworks. Viewers of more extreme forms of 'body art' by Gina Pane, Chris Burden, Vito Acconci or Abramovic/Ulay usually have three choices: to leave, to be forced into complicity by watching actions from which they may feel alienated, or to submit to a masochistic identification with the performer. In contrast, the do-it-yourself artwork exists *only* through the consensus and willingness of the participants to interact with the object, and with each other, without renouncing their individual positions. Whereas body art sets up a 'masochistic contract' with their audiences, as Kathy O'Dell has pointed out, do-it-yourself artworks rely on a tacit contract of trust between the artist and the viewer, and between the participants themselves.[22]

Trust lay at the heart of Fluxus scores and objects from the start. As the traditional relations between composer and performer were subverted by event scores which no longer contain inherent criteria to judge their success or failure, as Brecht and Ono invited gallery-goers to touch their works instead of just watching them, a new type of tacit contract emerged between the artist and the participant. This contract presupposed the goodwill of the participant, and some came to observe that this trust was sometimes misplaced. Brecht for example 'hoped', at the time of his 1959 exhibition, 'that people would enter the game with a certain gentleness', but was unfortunately led to realize that 'that didn't work, that people would take the things [he] loved most and leave nothing in exchange'.[23] What the failure of such an experiment reveals is the fruitful tension, inherent to all do-it-yourself artworks, between the openness of instructions and objects allowing a new freedom to the participant on the one hand, and, on the other, the limits which they implicitly require as conditions for participation. Like games, do-it-yourself artworks can only preserve their identity as long as at least a majority of players follow the rules. This relation of trust implied in games is nowhere clearer than in Ono's *Chess Set* which was first exhibited at the Indica Gallery in 1966 as a chess set and board entirely painted white, accompanied by the invitation to play. The white chess pieces required players to remember their positions throughout the game and to trust each other not to take advantage of

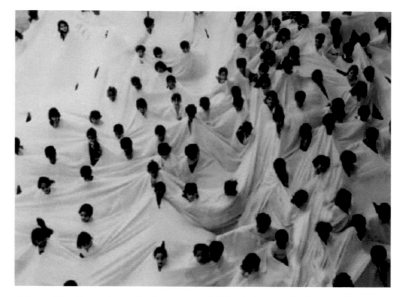

6 Lygia Pape, *Divisor*, 1968. Photograph: Paula Pape © Paula Pape, Rio de Janeiro

this ambiguity: when she later re-exhibited the work, Ono aptly renamed it *Play it by Trust*.

If body art, in its dramatization of the 'breakdown' of the consensual contract, emerged in the context of a late 1960s feeling of helplessness and disillusionment with authority, do-it-yourself artworks were part of an earlier, more optimistic, revolutionary moment in the decade. Abdicating one's authority as an artist, for Fluxus as well as Clark and Oiticica, was conceived not only as a means to question all forms of hierarchy and inequality, but also as a way to free the viewer, thus echoing the widespread discourse of individual self-enfranchisement and liberation which characterized the 1960s. As such, do-it-yourself artworks share this optimistic outlook with dominant forms of collective political actions as well as with the improvised communes which sprang up across Europe and the United States during that decade. The fact that do-it-yourself artworks can no longer function if the rules break down specifically dramatized the 1960s belief in the power of communities based on solidarity and trust. Lygia Pape's 1968 *Divisor* (*Divider*), which consisted of a huge thirty-by-thirty-square-metre piece of cotton with evenly spaced holes through which people can put their heads, encapsulates the aspirations of many communes and collective demonstrations. As the simple plane of cloth comes alive through the energy of the moving individuals sharing this space of play and festivity, it acts like the skin of a collective body. In the Brazilian climate of the time – an increasingly policed society under dictatorship – street

agitation of a collective nature could easily become a subversive action. The idea that groupings of people could act as 'insurrectional cells', articulated by one of the leaders of the May 1968 uprisings in Paris, Daniel Cohn-Bendit, was crucial for New Left movements and hippie communes in Europe, North and South America.[24] These cells, it was believed, had a double function: to experiment with models of community other than the contested dominant society, and to serve as the starting points for organized political protest and demonstrations.

The politics of the do-it-yourself artwork thus span both the personal and the collective as they encourage participants to reflect on their bodies and on their everyday activities and to work with others, whether it is the artist or other participants. Self-discovery and solidarity, freedom and trust are thus brought together within an ideal of transformation. Indeed, Maciunas believed that Fluxus actually prepared the way to the disappearance of the artist altogether, once people understood 'the needlessness [sic] of art'.[25] While few artists shared Maciunas's conviction, the possibility of this disappearance is contained within the conception of the do-it-yourself artwork as a tool.

Tell Your Friends About It

Like political tactics, practical tips, recipes and games, do-it-yourself artworks can be transmitted orally. Like tools, they ask to be borrowed and used. Copying down a Fluxus instruction in your notebook and performing it at home, remembering how to make Clark's *Air and Stone* and explaining it to others, looking at a picture of Pape's *Divisor* in order to recreate it are all ways in which you can take possession of these works and make them your own. Ono called some of her works 'word-of-mouth pieces',[26] and Fluxus artist and folklorist Bengt af Kintberg highlighted the analogy between Fluxus scores and orally transmitted folklore such as 'games, jokes and rituals'.[27] Since they are not dependent on unique objects, and are not linked to a unique author, these folkloric works allowed Fluxus, according to Klintberg, to attack 'the pompous image of the artist as a genius with a unique, personal style', so necessary to the art market.

In a 1969 article, Roger Abrahams described folklore as 'an artistic expression in which there is a certain degree of personal interrelationship between performer and audience'.[28] The 'face-to-face' relation which defines folklore stands as an ideal towards which 'do-it-yourself' artists were striving in their desire to establish a more important role for the spectator in their works. Although they do not necessarily recapture the literal, physical face-to-face relation between participants, the structure of do-it-yourself artworks contains a possibility of oral transmission and a need for enactment which are both fundamental characteristics of folklore. Even object-based works such as *Fluxboxes* or Oiticica's *Parangolés* privilege the performative to such an extent that they ask to be passed around, copied, shared among as many participants as possible. Though the *Parangolés* are unique objects, Oiticica did create in 1968 a 'do-it-yourself' *Parangolé* which provides viewers with instructions for making their own.[29]

The kinship between folklore and do-it-yourself artworks has major implications for their distribution and display. By being transmitted like games and folklore, do-it-yourself works escaped from the market economy of the art world, and effectively suggested alternative spaces for production and exchange. Although many artists in the 1960s shared this desire to question the status of the artwork as a commodity, do-it-yourself artworks seem to have been more successful than other forms of so-called conceptual art, which quickly found their ways into galleries and institutions. Fluxus artists deliberately conceived of alternative means of producing and distributing Fluxus publications. Though sharing Fluxus's questioning of the artist's role, Clark and Oiticica did not systematically elaborate new means of production and distribution for their works. They participated in selected shows in Brazil, Europe and the United States, but seemed to have increasingly lost interest in showing their works in galleries. It was perhaps the realization that the climate of trust and the ideal face-to-face relations implied by do-it-yourself artworks could only be achieved under specific circumstances that led Oiticica, Clark and Fluxus artists to seek new kinds of sites and audiences for their works. The fact that performers of Fluxus scores have tended to be predominantly other Fluxus artists, and that the wearers of

the *Parangolés* seen in most photographs were Oiticica's friends, raises the issue of whether 'do-it-yourself' artists truly achieved such hopes. Maybe a close-knit community of artists and friends was the only readily available 'play-community', as Johann Huizinga called it, within which participants' willingness to play the game according to the rules could be taken for granted.[30] Maybe the art world was not ready to open its doors to alternative modes of participation. Maybe the belief in the revolutionary potential of play and spontaneous groupings based on trust could only be a short-lived phenomenon in the specific context of the 1960s. To start answering these questions, one would need to look at contemporary forms of spectator participation which artists have been developing since the 1990s, investigating, in a new context, some of the themes explored by 1960s do-it-yourself artworks. Another possible way of thinking about the success, or failure, of the do-it-yourself artwork is of course more immediate: it would simply involve you picking one of them and doing it yourself.

NOTES

1 Yoko Ono, 'Letter to Ivan Karp, January 4, 1965', reprinted in *Grapefruit: Works by Yoko Ono*, 3rd edn (New York: Simon and Schuster, 2000), n. p.

2 Lygia Clark, 'Letter to Guy Brett, November 10, 1968', quoted by Guy Brett, 'Lygia Clark: Six Cells', in Guy Brett et al., *Lygia Clark*, exh. cat. (Barcelona: Fundació Antoni Tàpies), p. 23.

3 For more on Fluxus scores, see my article 'Origins of the Fluxus Scores: from Indeterminacy to the "Do-it-yourself Artwork"', *Performance Research*, vol. 7, no. 3 (2002), pp. 78–94.

4 George Brecht, 'Invitation to *Towards Events*, New York, Reuben Gallery, 1959', n. p.

5 George Brecht, 'Notes on the shipping and exhibiting MEDICINE CABINET (alternative titles: MEDICINE CHEST, CABINET), 1960', unpublished document dated 11.16.61, New York, Museum of Modern Art Library, n. p. I have discussed Brecht's objects at greater length in 'Unpacking Cornell: Consumption and Play in the works of Rauschenberg, Warhol and George Brecht', in Jason Edwards and Stephanie Taylor (eds), *Joseph Cornell: Opening the Box* (Frankfurt and Oxford, forthcoming).

6 Cf. Jon Hendricks, *Yoko Ono: Paintings and Drawings, New York, AG Gallery, July 17–30 1961*, exh. cat. (Budapest: Gallery 56, 1993).

7 Lygia Pape, 'Depoimento a Glória Ferreira', in Paul Sergio Duarte (ed.), *Lygia Clark e Hélio Oiticica: Sala especial do 9° Salão Nacional de artes plásticas*, exh. cat. (Rio de Janeiro: Paço Imperial, 1986), p. 71 (my translation).

8 Lygia Clark, 'Ligia [*sic*] Clark busca na pintura a expressão do proprio espaço', *Folha da manhã*, 27 September 1958 [Lygia Clark Archives, Rio de Janeiro, Museu de Arte Moderna, MFN 1125] (my translation).

9 Cf. Lygia Clark, 'Bichos', in Brett et al., *Lygia Clark*, p. 121.

10 Lygia Clark, 'L'Art, c'est le corps' (1973), extract translated in Duarte (ed.), *Lygia Clark*, p. 188.

11 Lygia Clark, quoted in Anon., 'Entreges prêmios aos vencedores da Bienal baiana: "linha orgânica" decide de carreira de Lygia Clark', supplement of the *Diário de notícias*, 30 December 1966, p. 7.

12 Cf. Hélio Oiticica, 'Notes on the *Parangolé*' (1965), in Guy Brett et al., *Hélio Oiticica*, exh. cat. (Rotterdam: Witte de With, center for contemporary art), pp. 93, 96. For more on the *Parangolés*, cf. Guy Brett, 'Fait sur le corps: le *Parangolé* d'Hélio Oiticica', *Cahiers du Musée national d'art moderne*, 51, (spring 1995), pp. 33–45, and my 'Tactile Dematerialization, Sensory Politics: Hélio Oiticica's *Parangolés*', *Art Journal* (summer 2004), pp. 58–71.

13 '*Bólides*' (1963), in Brett et al., *Hélio Oiticica*, p. 66.

14 George Brecht, 'Interview with Henry Martin' (1967), reprinted in Henry Martin (ed.), *An Introduction to George Brecht's Book of the Tumbler on Fire* (Milan: Multhipla edizioni, 1978), p. 80.

15 Brecht, 'Interview with Henry Martin', p. 78.

16 Lygia Clark, 'On the Magic of the Object' (1965), in Brett et al., *Lygia Clark*, p. 152 (slightly modified translation).

17 Yve-Alain Bois, 'Painting: the Task of Mourning' (1986), in *Painting as Model* (Cambridge, MA: MIT Press, 1990), p. 237.

18 'Closed and enigmatic', 'condition of "thing".' Oiticica, *'Bólides'*, p. 66; the 'absurd, opaque, presence' of the object is mentioned by Ferreira Gullar, 'Diálogo sobre o não-objeto' (1960), reprinted in Aracy Amaral (ed.), *Projeto construtivo brasileiro na arte (1950–1962)*, exh. cat. (Rio de Janeiro: Museu de Arte Moderna, 1977), p. 90. 'I am still groping in the world of stickiness.' Yoko Ono, 'The Word of a Fabricator' (1962), translated in Jon Hendricks and Alexandra Munroe (eds), *Yes Yoko Ono*, exh. cat. (New York: Japan Society, 2000), p. 28.

19 'Concerning the Magic of the Object', in Brett et al., *Lygia Clark*, p. 101; Yoko Ono, 'To the Wesleyan People Who Attended the Meeting, a Footnote to my Lecture of January 13, 1966', in *Grapefruit*, n. p.

20 I have developed this comparison in 'Everyday Life, "Relational Aesthetics", and the Transfiguration of the Commonplace', *Journal of Visual Art Practice*, vol. 5, no. 3 (2006), pp. 143–52.

21 Cf. Lygia Clark, 'On the Suppression of the Object (Notes)' (1975), in Brett et al, *Lygia Clark*, pp. 264–65.

22 Cf. Kathy O'Dell, *Contract with the Skin: Masochism, Performance Art and the 1970s* (Minneapolis, MN, and London: University of Minnesota Press, 1998).

23 George Brecht, 'Interview with Irmeline Lebeer' (1973), in Martin (ed.), *An Introduction*, p. 88.

24 Daniel Cohn-Bendit and Gabriel Cohn-Bendit, *Obsolete Communism: The Left Wing Alternative* (1968), quoted by Julie Stephens, *Anti-Disciplinary Protest: Sixties Radicalism and Postmodernism* (Cambridge: Cambridge University Press, 1998), p. 29.

25 Cf. George Maciunas, 'Letter to Tomas Schmit, January 1964', reprinted in Emmett Williams and Ann Nöel (eds), *Mr. Fluxus: a Collective Portrait of George Maciunas, 1931–1978* (London: Thames and Hudson, 1997), p. 104.

26 Yoko Ono, 'On Insound and on Instructure', programme for Contemporary American Avant-garde Music Concert, Kyoto, Yamaichi Hall, 1964, reprinted in Hendricks and Munroe (eds), *Yes Yoko Ono*, p. 12.

27 Jean Sellem, 'The Fluxus Outpost in Sweden: an Interview with Bengt af Klintberg', in Jean Sellem (ed.), *Fluxus Research*, special issue of *Lund Art Press*, vol. 2, no. 2 (1991), p. 69.

28 Roger D. Abrahams, 'The Complex Relations of Simple Forms', *Genre*, 2 (June 1969), p. 126.

29 Cf. Hélio Oiticica, *'Made-on-the-body Cape, 1968'*, in Janet Daley et al., *Three Towards Infinity: New Multiple Art*, exh. cat. (London: Arts Council, 1970), p. 78.

30 Johan Huizinga, *Homo Ludens* (1944), trans. Richard Francis Carrington Hull (London, Henley and Boston: Routledge and Kegan, 1949), p. 12.

Martha Rosler's Fighting Legions
Semiotics of the Kitchen (1975/2003) – Performance and the (Video) Document

AUGUST JORDAN DAVIS

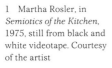

1 Martha Rosler, in *Semiotics of the Kitchen*, 1975, still from black and white videotape. Courtesy of the artist

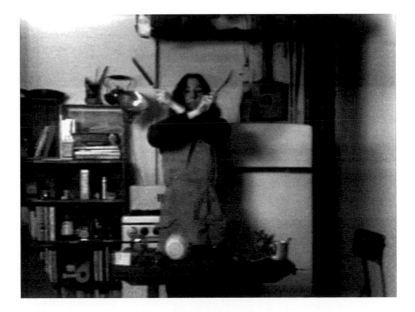

Peggy Phelan insists that performance ontologically resists reproduction; it is a one-time only event, 'a maniacally charged present'.[1] Maria Troy disagrees: 'Through video, the performance could become endlessly present, always enacted for the first time'.[2] In November 2003 Martha Rosler restaged her 1975 *video* performance *Semiotics of the Kitchen* as a live event at the behest of the Whitechapel Gallery, London, as part of their series *A Short History of Performance, Part II*. It coincided with one of this book's foundational contexts: Tate Liverpool's exhibition and related events, *Art, Lies and Videotape: Exposing Performance*.

Semiotics 1975 and 2003 are works about mediation: the mediation of language and televisual representations and the mediation of concepts of gender and its 'natural' roles. They are equally works about performance: from speech acts to cookery lessons to the masquerade of the housewife. Though it was unusual for Rosler to return to a piece of such an age,[3] the issues performed in *Semiotics* have remained current in her work, such as 1985's *Global Taste: A Meal in Three Courses* which is 'a video installation about food, language learning and subjectivity, children, and advertising',[4] and recent performances on the world of coffee.[5]

Returning to *Semiotics* also pushed further its performativity in relation to the themes of both the repetition of maintenance labour and the sustenance of 'naturalised' gender roles.[6] The work serves to make conscious the

> view that gender is performative, that what we take to be an internal essence of gender is manufactured through a sustained set of acts, posited through the gendered stylization of the body. In this way, it showed that what we take to be an 'internal' feature of ourselves is one that we anticipate and produce through certain bodily acts, at an extreme, *an hallucinatory effect of naturalized gestures*.[7]

Semiotics is a performance about the performativity of gender constructed through the sign-system of maintenance labour, and suggests that through such repetitive performance woman self-inflicts her oppression through her lack of counter-performative actions. However, *Semiotics* implies that such a counter is possible. This essay explores the performances at play within *Semiotics of the Kitchen* 1975

2 Martha Rosler, *Untitled (Kitchen I)* from 'Beauty Knows No Pain, or Body Beautiful', photomontage series, 1967/1972. Courtesy of the artist

and 2003. In doing so, it navigates the complexities inherent to the concerns of *Art, Lies and Videotape* and Tate Liverpool's conference 'Caught in the Act...': questions of (video) performance and (video) documentation, as well as the complexities specific to Rosler's domestic 'fixation' and the case of her doubles, *Semiotics '75* and *Semiotics '03*.

The Domestic(,) Martha Rosler

In the late '60s, Martha Rosler decided to stop painting. She has stated that it no longer seemed relevant;[8] this marked her turn to something of a pop art idiom with the incorporation of everyday objects and images in an 'intermedia' *oeuvre*. Rosler had taken 'street photographs' since the early 1960s, but regarded photography as without a tradition and not a precious practice, unlike painting.[9]

In 1965 she had begun constructing large (4 feet x 8 feet) collages using print media photographs.[10] By 1966 she had commenced the photomontages which would become the series 'Beauty Knows No Pain, or Body Beautiful', exploring the uses of the female model in print advertising and pornographic magazines, creating convergence where there was strict segregation. These *détourné* ads were soon joined by the concurrent photomontage series 'Bringing the War Home: House Beautiful' and 'In Vietnam'.[11]

Having completed her bachelor's degree in English studies in 1965,[12] and helped to set up poetry magazine *Pogamoggan* in 1966,[13] she moved with Lenny Neufeld and David and Eleanor Antin from New York to San Diego, California.[14] As she writes in 'Immigrating, 1975', while Lenny was in grad school she had their son Joshua Neufeld and spent time at home, planting and learning about health food.[15]

She eventually enrolled herself at the University of California, San Diego 'in the fall of 1971'[16] where she obtained her MFA in 1974.[17] Rosler performed and 'exhibited' in alternative spaces, only recently having 'entered the gallery system' due to 'the virtual collapse of the "alternative space" movement in the United States'.[18] By the end of her MFA she was a single mother and had started contract teaching,[19] having previously worked in magazine publishing, both in New York and in Del Mar, California.[20] Rosler had also engaged with other feminist artists in

California, collaborating on performances.[21] She had explored by now the history of photographic practice and was engaged with the politics of documentary photography.[22]

Rosler had also begun to develop her own feminist performance, staging a live event in 1973 entitled *Vital Statistics of a Citizen Simply Obtained.* In 1974 Rosler began several series of postcard novels and holiday postcards based around the kitchen as hearth of the home, which she mailed to several hundred people both 'in and out of the art world'.[23] One of these postcard novels was entitled *A budding gourmet* and charted the progress of an aspiring middle-class wife to accrue greater cultural capital for her family through the cultivation of cooking as an art form. The narrative interpolated issues about Third World food production and the exploitative tourism of 'exotic cuisine' implicit in gourmetism. This work was then developed further as a video performance, also in 1974, under the same title. It was Rosler's first foray into video production.[24]

That same year she produced an installation/performance entitled *A Gourmet Experience* using the postcard novel in its material which included a dining table, set for dinner with photographs of food in lieu of a meal and Rosler reciting from the budding gourmet's monologue. Rosler has said about this work:

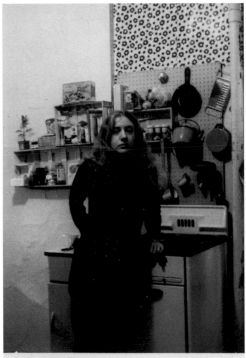

3 Martha Rosler, *Holiday Card # 2*, from the series 'From Our House to Your House', mailed annually from 1974 to 1978. Courtesy of the artist

I see something of an analogy between, on the one hand, women in our society who are food producers – cooks, not growers – but who are expected to drastically limit their food consumption and, on the other hand, farmworkers and even many countries who must produce agriculturally but who have inadequate food consumption – not because there is a cultural proscription, but because they can't afford it.[25]

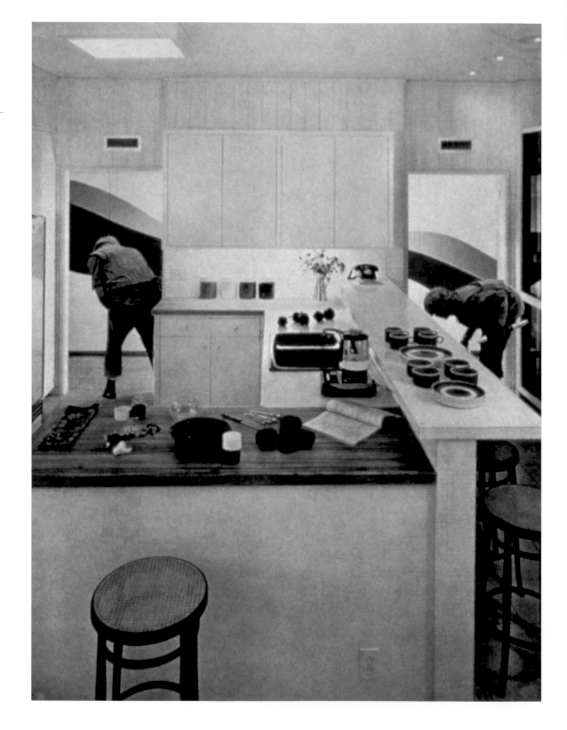

4 Martha Rosler, *Red Stripe Kitchen*, from 'Bringing the War Home: House Beautiful', photomontage series, 1967–72. Courtesy of the artist

Semiotics is part of what Annette Michelson calls Martha Rosler's 'Food Chain', together with *A budding gourmet* (1974) and *Losing* (1977).[26] Along with works such as *The East is Red, the West is Bending* (1977) and *The Art of Cooking: A Mock Dialogue Between Julia Child and Craig Claiborne*[27] (1974), these 'Food Chain' pieces explore the international and domestic (i.e., American) oppressions of capital / class / race / gender / sex imbricated in the productions (and reproductions) of food and the 'art' thereof.[28] For with Rosler's praxis comes a performative (art) activism: Rosler's feminism and anti-war activism are performed through the 'utterance' of her works as much as the works are uttered from the position of the artist *engagé*.[29]

In her turn to the 'everyday', Rosler has been drawn again and again to considerations of the 'domestic'. From the early photomontages such as 'Bringing the War Home', of which *Red Stripe Kitchen* is but one example, Rosler has performed the dialectic that 'the personal leads to the political and the political to the personal'.[30] Not only does a work like *Red Stripe Kitchen* literally domesticate the 'in country' action of fighting in Vietnam – and, in other images, its attendant atrocities – but it truly gives 'the war at home' new dimensions. It suggests both the domestic American division over support for the war with Vietnam *and* the increasing number of domestic wars for various civil rights liberation movements.

Red Stripe Kitchen is wonderfully emblematic of this duality in Rosler's *oeuvre*: the kitchen is literally a minefield. But this is not a clear-cut gender war. Class and 'race' are implicated too as the example of Julia Child or Elizabeth David makes clear. These are women who both turned to the culinary after work in the OSS (Office of Strategic Services)[31] and the Ministry of Information, respectively, having no background in cookery, growing up with 'domestic help' who did the cooking: notably, both citing the 'poor quality' of the food produced by the servants as part of their incentive to do it themselves.[32] Rosler, interviewed by Linda Montano on 'Food', comments:

> People who live in the grand manner have cooks and other servants, and historically it has only recently become part of the bourgeois housewife's role actually to cook the household's food. The modern bourgeois wife, then, has

> an extra demand placed upon her – to produce artfully created dishes while
> still being expected to sit at the table as a consumer, eating.[33]

Furthermore, as Rosler eloquently discusses in 'For an Art Against the
Mythology of Everyday Life' (first printed in 1979 and reprinted most
recently in her new collection of selected essays, *Decoys and
Disruptions*), commodity fetishism mediates our relation to the 'domestic
arts', a mediation of which Julia Child was at the forefront:

> This fetishism of commodities, as Marx termed it, is not a universal mental
> habit; it has its origins in a productive system in which we are split off from
> our own productive capacities, our ability to make or to do things, which is
> transformed into a commodity itself... 'labor power'... Those who aspire to
> move upward socially are led to develop superfluous skills – gourmet cooking,
> small-boat navigation – whose real cultural significance is extravagant, well-
> rationalized consumerism and the cultivation of the self.[34]

Rosler has said about these works that 'I was interested in the
commodification of food, taste, and tourism... and the idea of women
having to develop the art of cooking as they might have had, for example,
to play the clavichord in previous times'.[35]

Works such as the postcard novel *Tijuana Maid* engage directly
with these questions of who does the maintenance labour and to
what end, with what sort (or lack) of attendant cultural cachet.
If feminism seeks to liberate women from this arbitrarily allocated
reproductive and repetitive siphoning off of their time and creativity,
there still remains the question of how will that maintenance get
done? Labour-saving devices may abound but there still remain
hours of work to be undertaken by *someone*. Furthermore, financial
and geographical, not to mention electrification, access is necessary
to derive benefit from such devices. *Semiotics of the Kitchen*, it is
interesting to note, displays what in 1975 were largely recently
obsolete hand-held kitchen tools,[36] which had been replaced by
electric blenders, mixers and food processors such as the Cuisanart,
but only for those who could afford them. This is an issue still
unanswered.[37] Of course the assignment of maintenance labour to
women, both within the workplace and at home, has been a sexist
component of the capitalist division of labour as thoroughly explored

5 Martha Rosler, *Tijuana Maid*, instalment # 4 from serial postcard novel, 1975. Courtesy of the artist

PEANUT BUTTER & JELLY SANDWICH

Butter 2 slices of bread. Spread one slice generously with peanut butter and top with a layer of jelly. Cover with remaining slice of bread; cut in half. Serve with a large glass of milk for a hearty lunch.

EMPAREDADO DE JALEA Y MANTE-
QUILLA DE CACAHUATE

Unte de mantequilla 2 reba-
nadas de pan. Unte generosa-
mente 1 rebanada con mante-
quilla de cacahuate y luego
con la jalea. Cúbrala con la
otra rebanada de pan y corte
a la mitad (diagonal). Sirva
con un vaso grande de leche.

El libro contiene una lista de frases en inglés y en español:

Sweep the kitchen floor.
scrub
wax and polish
We like breakfast served at----.

Have you ever shopped in a
supermarket?

Barra el piso de la cocina.
Estregue
Encere y saque brillo
Nos gusta que nos sirva el
desayuno a las-----.

Ha ido usted al super-mercado?

etcetera, etcetera, y contiene una frase que oía siempre:
Will you cook a Mexican dinner for us sometime?
Nos cocina una comida mexicana para nosotros alguna vez?

4

by Margaret Harrison, Kay Hunt and Mary Kelly in their 1975 work *Women and work: a document on the division of labour in industry*.[38]

In works such as *A Budding Gourmet*, *A Gourmet Experience*, *Tijuana Maid* and *Losing*, to name but four, Rosler explores the ways a (white, bourgeois or upward-aspiring working-class, straight) woman can dominate and be implicated in the oppressions of others whom she tours and co-opts to attain cultural capital.[39] A work such as *First Lady* from 'Bringing the War Home' presses such questions further. Depicting Pat Nixon in a ball gown posing in the White House, the photomontage substitutes the over-mantel painting for a still from the film *Bonnie & Clyde* showing Faye Dunaway's inert bullet-riddled body.[40] Rosler has mentioned her understanding of this film as a cipher for issues about Vietnam.[41] We ask of the wife/partner: how culpable is she? What is her punishment? Or does she elude implication through division of the man into the office-worker and the lady into the 'household angel'? But what about the woman as partner in crime? How much is she just a beneficiary, a dupe, a moll, and how much an agent?

6 Martha Rosler, *First Lady*, from 'Bringing the War Home: House Beautiful', photomontage series, 1967–72. Courtesy of the artist

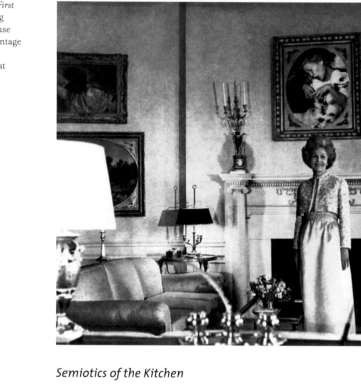

Semiotics of the Kitchen

'My art is a communicative act, a form of an utterance, a way to open a conversation'[42]

Language had been seen, before semiotic structuralist analysis, as a rational naming process, exploration of whose (pre-)history would reveal its 'meaning'. Saussure's study of Sanskrit led him to determine that there was, in fact, no such rational logic underpinning language. It was, instead, an arbitrary system of difference enshrining significance.[43] The work of C. S. Peirce and Ferdinand de Saussure established semiotics as the study of how signs function as signs. With *The Bowery in two inadequate descriptive systems* and *Semiotics of the Kitchen*, Martha Rosler explores the adequacy of such sign systems.

In late 1974/early 1975, while visiting friends in New York (Rosler lived on the West Coast from 1968 till 1980),[44] Martha Rosler, within a space of a few weeks, produced *The Bowery in two inadequate descriptive systems* and *Semiotics of the Kitchen*, a video shot in a friend's loft-space. Rosler specifically wanted to use a loft space so the video was not in a suburban setting, but more like a TV studio: she wanted it to be obviously 'a sign for a kitchen'.[45] This was a performance direct to video,[46] video as the appropriate medium for comment on broadcast television.[47] And the PBS Julia Child cookery show was the target.[48] Bringing the notion of 'France' to America with her Cordon Bleu background, Julia Child popularized the notion of the TV cookery lesson. This was very much the act of the female dilettante mediating *haute* (read male, professional) *cuisine* for the 'upwardly-mobile' American housewife.[49]

Semiotics was to be part of Rosler's project 'to break the fetishism of the sign/image/commodity'.[50] In her article, 'The Figure of the Artist, The Figure of the Woman', Rosler writes about the 'female... as a sign'.[51] In relation to pop art, Rosler states in the article: 'The ambiguity is whether the artist has positioned himself as the *speaker* or the *spoken* of these "languages" of domination'.[52] With the complication of a feminist employing pop art tactics, Rosler creates a work that, rather than synthesizing such complications, capitalizes precisely on them.

The work lasts approximately six minutes with Rosler shot in black and white in a kitchen. She stands behind a table laid with nineteen hand-held kitchen implements (and an apron), which she proceeds to name, alphabetically, and then demonstrate.[53] There exist many fair descriptions of this performance.[54] Several commentators note her deadpan humour.[55] This largely manifests through the discordance of her straightforward naming of each device, followed by her hyperbolic gesturing of the item's use. In terms of implements such as the butcher's knife or ice pick, the gestural display is a homicidal mime.

When she comes to the final six letters of the alphabet, Rosler no longer introduces tools, but brandishing the knife and BBQ fork, like a psychotic half-time cheerleader spelling out the team's name with

7 Martha Rosler,
*The Bowery in Two
Inadequate Descriptive
Systems*, 1974/75. One
photo-text couple from the
grid of such combinations
that constitutes this piece.
Courtesy of the artist

muddled

fuddled

flustered

lushy

sottish

maudlin

her limbs, raises her arms to form the letters U, V, W, X and, penultimately, Y.[56] At Z, Rosler performs the mark of Zorro with her knife as (phallic) sword.[57]

Rosler has become both the speaker and the spoken of the signs within the *Semiotics of the Kitchen*. It is this duality that is the key to the performance. An unattributed blurb on the Electronic Arts Intermix website regarding *Semiotics* claims, 'In this alphabet of kitchen implements, states Rosler, "when the woman speaks, she names her own oppression"'.[58] The *Semiotics* performance is in fact an exploration of women's domestic performativity. Within this work, Rosler embodies not merely the oppressed domestic sign but the 'utterance-*origin*' of that oppression.[59] Such schizophrenic embodied performance is revolutionary. In staging a *Semiotics of the Kitchen* it exhibits the arbitrary construction of its semiology, denoting the absence of a *positive term*[60] and thus denying the dominance of a masculine over a feminine position. This further offers the liberating realization of the self-infliction of the performative *Semiotics*: and if woman is the promissory party, surely she can concoct a happy counter-performative.[61]

As Peggy Phelan points out in *Unmarked*, such a performance is 'especially intense because women are not assured the luxury of making linguistic promises within phallogocentrism, since all too often she *is* what is promised'.[62] Precisely, says Rosler's performance. Seen as the castrated body, woman is the mute body,[63] unable to inscribe the law of the father, with its naming and codification – with its erection of semiotic structures that 'name one's oppression'.

Rosler has stated that she was also motivated by a further quiescence: the perverse relationship women have domestically with food. She is traditionally its producer ('cooks, not growers')[64] while also being one of its (curtailed) consumers, engaged in 'self-abnegation'.[65]

But Rosler sees all of these positions as merely socially constructed and not at all natural or insurmountable. Adopting the oppositional masquerade of Zorro, Rosler brandishes the (phallic) knife/sword and names away. This is Rosler challenging previous constructions of the *Lebenswelt* (Husserl's 'life-world')[66] with new feminist '"we"-thoughts' regarding 'the meaning of objects' and subjects 'created and made

8 Martha Rosler,
Semiotics of the Kitchen,
1975, still from black and
white videotape. Courtesy
of the artist

public'.[67] These new 'we'-thoughts are performed as Rosler's gestures of
'rage and frustration'.[68] They belie the notion of the culinary hostess
with the mostest. She is 1972's 'novel' creation, the Stepford wife,
short-circuited.[69]

Performative gestures were discussed by Austin, who said that they
'may sometimes serve without the utterance of any word, and their
importance is very obvious'.[70] In *Semiotics* the gestures constitute
Rosler's counter-performative. They establish the woman in action,
they perform her challenge to the tyranny of inscription – of
incantation. The gestures should be read as a separate, though
interconnected, performance to that of the incantation of names.
It is a dialogic[71] performance of two conflictual positions, the named
domestic woman and the (un)masked woman 'acting out'.[72] Though the
U,V,W,X,Y,Z is a synthetic moment where the woman becomes the sign
utterly, it is also when, at last, she proclaims her mark of Zorro – her
calling card of challenge to oppression. It is the schizophrenic moment
of proclamation that she is both Don Diego, the bookish, and Zorro,
the challenger of tyrannical 'law'. She is performing her calling card

unmasked and it is this which confuses the separation of identities which the masquerade erects: this is her acknowledgement of the self-infliction of the domestic *Semiotics* which confines woman's significance. What of Zorro's *sign*ificance? The sign of Zorro is the mark of Zorro – it is his calling card – it is integral to the performance of his (*sic*) masked identity – it is a part of his superhero armature – it is his phallic inscription of his vigilante law – the masked swordsman.[73] This Spanish Los Angelino Scarlet Pimpernel marks his emblem rather than merely wearing it.[74]

The Zorro legend has been constructed from numerous film and television versions, as well as the inaugural book of 1919 by Johnston McCulley, and the further 65 books and short stories of Zorro he wrote.[75] Two versions of the legend which have posited alternative Zorros need mention. One is the 1944 film *Zorro's Black Whip*, where the character of the masquerading vigilante Black Whip is taken over and performed by a woman, and 1981's comedic revision, *Zorro – The Gay Blade*, where George Hamilton is both Don Diego/Zorro and his gay brother Bunny Wigglesworth/Zorro – The Gay Blade.

In both of these films the alternative Zorro (the female Black Whip and Zorro – The Gay Blade) do not adopt the sword but a whip as their emblematic weapon. This denies them the performative inscription of the 'true' Zorro. In *Zorro – The Gay Blade*, it is noteworthy that, aside from the farcical costuming differences (with Don Diego's Zorro in the traditional all black and Bunny's Zorro in a variety of camp and garish theatrical variations on the Zorro costume, including one truly inspired Carmen Miranda gold lamé version, complete with turban and fruit) the two Zorros are differentiated by Don Diego's use of the traditional sword versus his brother's whip.[76]

So this is a cookery lesson like no other you've seen before. And it's funny, it's very funny. Everyone remarks on her deadpan delivery.[77] This deadpan humour derives from her interest in anti-Friedian literalness and Andy Warhol's blunted affect persona, with the theatricality implicit in that kind of pop performativity.[78] Maria Troy notes that Rosler performs with gestures 'more samurai-like than suburban'.[79] This, together with *Semiotics*' implicit reference to Julia Child, though not as

direct as a work such as Suzanne Lacy's 1978 14-minute video, *Learn Where the Meat Comes From*,[80] places Rosler's humorous take-off of televisual spectacle[81] and its 'messages' as a precursor to 1975's 'Not Ready for Primetime Players', a.k.a. the first cast of now institutional *Saturday Night Live*, NBC's weekly late-night comedy sketch show.[82]

Like *SCTV* which was the similar faux-tele TV programme of comedy troupe *Second City*, the Chicago group whence most of the 'Not for Primetime' cast came,[83] *SNL* spoofed the concept of primetime television: from the Nightly News Update ('Weekend Update' – a simple precursor to the British Chris Morris ensemble effort *The Day Today*) to chat shows, presidential addresses to 'fellow Americans', absurd commercials and sit-coms, to cookery shows. Troy's 'more samurai-like than suburban' brings to mind John Belushi's manic Harpo-esque Futaba, the Samurai who was featured each week in a different profession with Don Pardo's unmistakable voice-over,[84] 'And Now For Another Episode of "Samurai Psychiatrist"', or Samurai B.M.O.C., or Samurai TV Repair Man, or, most appropriate for *Semiotics*, Samurai Delicatessen.

In Samurai Delicatessen (which aired on 17 January 1976, *SNL*'s 10th episode), Buck Henry, the usual foil to Belushi's violent mime, playing a character named Mr Dantley, asks for a sandwich which Belushi maniacally hacks into existence, famously throwing the tomato and slicing it with his sword mid-air. At the end of the sketch, after nearly committing hari-kari over Henry's protest at the amount of fat left on the corned beef he requested be 'very lean', Henry's final request is that Belushi cut the sandwich in half. Given that most sketches ended with Belushi demolishing furniture with his sword, it defies expectations when 'Samurai screams, pulls out his sword, then carefully cuts the sandwich in half' (script description). The gag is reinstated when Henry, paying for his sandwich, asks if the Samurai could 'break a twenty [Samurai shouts, and slams his sword on the $20 bill, smashing the counter to bits]'.[85]

On 9 December 1978 *SNL* was hosted by Monty Python member Eric Idle. This episode is notable for the first sketch of the night, after Idle's opening monologue, 'The French Chef'. In true Python style, Dan Ackroyd is in drag as Julia Child demonstrating a recipe with

chicken. The lesson goes horribly wrong when, after strongly insisting on not throwing away the liver but keeping it for various applications, Ackroyd/Child gruesomely cuts 'her' finger while deboning the chicken. Absurdist extremes of now familiar horror-film-style blood gushing ensue with Child attempting to weather this unforeseen 'interruption' and continue with the lecture. The laughs are derived from the nervous chuckles of the traumatized together with the mounting hyperbolic responses by Ackroyd which have Child try to ring for emergency help on the stage prop phone, all the while filmed by a non-interventionist crew. Finally falling against the counter, in true combat style of 'leave me, I'm done for, but save the children', 'she' calls out: 'Save the liver!'[86]

Though comparatively restrained, *Semiotics* is engaged with this same visual culture and critique of the everyday through absurdist humour, especially that which challenges the viewer's 'horizon of expectations'.[87] This disjunction, between the expected demonstrative gestures and the gestures Rosler performs, produces a Brechtian alienation effect, which makes conspicuous a quote favoured by Martha Rosler: 'that 'the familiar is not necessarily the known'.[88] This making strange is part of Rosler's overall praxis which she describes as her project of performing decoys whose lure is the façade of the known, whose then revealed 'otherness unsettles certainty and disrupts expectations'. Rosler hopes that her work therefore can be 'the first step toward change'.[89]

Recognizing this strategy of decoys (one of which is parody) at work in the gestural disjunction of *Semiotics* enables one to understand further how Rosler makes her counter-performative 'happy'.[90] What she is actually doing is performing an unhappy performative – that is, circumventing the happy performative of the oppressive *Semiotics of the Kitchen*, which was only ever a decoy, via her counter-performative gestural acting out. It is this comedic acting out which *détournes* 'The circumstances of the utterance'.[91]

Austin speaks of the need for the presumption of seriousness on the part of the utterance-*origin* to establish appropriate circumstances for a happy performative.[92] Joking undermines the performative quality of the

utterance – humour literally can kill the performative, can create a misfire. This is the dialectical quality of Rosler's performance: she is both deadly serious in her performative exploration of the *sign*ificance of the woman's place in the kitchen and yet she is having a laugh. Her deadpan humour is a liberation from the *Semiotics of the Kitchen* – it is a deconstruction of the structure of a woman's place.

Second Helpings

'Instead of pursuing mastery and completion, for Rosler art is a continuous and on-going practice, a conversation in which images, text, and fragments all take part.'[93]

'My tendency has been to return in cycles to matters I'd dealt with earlier.'[94]

'So I come and go, but I'm always the same. As a mother, food and nurturing have been a constant concern.'[95]

It's odd to hear you talk about these works as heterodox, since they seem so all-of-a-piece to me... At a work's inception, I would try to figure out what was the best mode of production for its idea. But then I might use the text of a postcard novel or a performance of a written piece as a videotape, not simply let it rest.[96]

Q: Understandably, as Whitechapel's programme was a second part of their A Short *History* of Performance, returning to earlier work was logical – but why specifically select *Semiotics*?

A: I didn't – they did. I said it was never a live performance and that I didn't believe in redoing things that were so old but that I would come up with a different idea. I suggested doing the performance as a kind of audition, which would leave room for many women to interpret the work as they chose, at least for their parts in it.[97]

20 November 2003, Whitechapel Gallery, London: approximately 26 (young) women met Martha Rosler 'an hour or so before the performance'.[98] They collaborated on a restaging of *Semiotics of the Kitchen*:

Three cooking-show / home-ec kitchen stations were set up throughout the Whitechapel Gallery. The performance was framed as an audition, a 'manned' video camera feeding to a monitor placed high on a shelf completing each station as a 'set.' A line of six or seven young women – those who would

season's greetings from
our house to your house

GRATER

9 Martha Rosler, *Grater*,
from the series 'From Our
House to Your House',
mailed annually from
1974 to 1978.
Courtesy of the artist

'audition' – stood to the side of each kitchen, waiting as Rosler's 1975 original played on a monitor at the far end of the gallery... When the video ended, a woman at the first kitchen said, 'A is for apron' and continued with several letters before returning to the end of the line, where she was replaced by the next performer. The second and third stations had joined in, each at a delay of several letters, such that a 'round' was effected. Each group cycled through the alphabet three times, their expressions ranging from deadpan and boredom to irritation, aggression and maliciousness. The performers chopped, grated and sliced their way through the audition for the cooking show to end all cooking shows. All of the performers gathered at the far kitchen for the finale 'V,W,X,Y,Z.' [*sic*] Here they no longer referenced utensils or techniques but became the linguistic signs, simultaneously embodying and activating the letters with their arms outstretched and closing with a Zorro-like flourish.[99]

Q: Was *Semiotics* material which you had wanted to revisit for some time?

A: It never occurred to me and struck me as a bizarre and therefore intriguing chance.

Q: You've stated elsewhere that... you... chose a friend's loft's kitchen space as you wanted to achieve a TV studio set feel, *à la* Julia Child. Bearing in mind the use of the '75 video in the background at the Whitechapel show and the 'auditioning' of women in the performance's round-robin, how well do you

think the work's original logic / premise translated or was transcended by the 2003 restaging?

A: It is of course a revisiting of a period piece. The gallery setting was a good approximation of the original idea of a set.

Q: In conceiving the structure of this restaging what considerations were at the fore in converting a taped piece into a public, *live*, gallery-space performance?

A: The chance for an array of young women to get hands on with a work of a previous generation and make it theirs, and then ours.[100]

Anna Dezeuze wrote of *Semiotics of the Kitchen* for *Art Monthly* that she felt in restaging the 'original feminist bite was lost in a live event involving three groups of women re-enacting, with varying degrees of success'.[101] Philip Stanier, reviewing the restaging for *liveartmagazine. com*, felt that 'In its time, the piece was seminal, but it has dated somewhat because of the changes in gender relations over the past decades, which have progressed from broad and visible forms of cultural discrimination, to far more complex and subtle forms of manipulation, disempowerment and exploitation'.[102] This 'post-feminist' response is echoed by Paul Edmunds, who, writing of an exhibition in South Africa which included *Semiotics* a few years ago, held: 'It looks really dated to me... Perhaps it's just the politics which are dated and have long been assimilated into the mainstream that make the work seems [*sic*] so laboured.'[103] But Heather Anderson, whose description of the restaging is quoted above, found in 'the 2003 version of the work, the group of young women simultaneously performed its role like so many women across the city and around the world, highlighting the continued relevance of Rosler's critique to feminism's third wave'.[104]

With the restaging, *Semiotics* multiplies its point: now there are as many (or more) participants as letters, women volunteers arbitrarily linked to this work. Women who give life to Rosler's 1983 assertion that there 'may be few women's shows now, but there are many feminist artists of all ages'.[105] The questions of maintenance labour and women's social de*sign*ations have not gone away – if anything they've grown more complex; by no means boring (or passé), they continue to challenge us.

According to the Zorro Legend website, the Zorro films have broken into two types: those which tell of the 'original' Zorro, like Douglas Fairbanks Sr.'s 1920 and Tyrone Power's 1940 (remake) *The Mark of Zorro*, and those which cast a 'descendant' of Zorro who now dons the *mask* to take up the legend and fight anew. 'It is interesting to note that in general, the better, higher quality, and more memorable versions of Zorro are the ones that retell the original legend of Zorro.'

'In the original story Zorro has a band of caballeros who help him fight against injustice. The band of caballeros is ignored in all versions of Zorro except *Zorro's Fighting Legion*, in which it is of primary importance to the plot.'[106] Reception of the *Semiotics* restaging follows a similar path of preference for the original, which spawned its own *Zorro – The Gay Blade* in the queer restaging *Semiotics of the Bitchin'* (K8 Hardy and Therine Youngblood, 2001, USA, video, colour, sound, 10 min.).[107] And in Martha's Fighting Legion of 2003, we have a further expanded field of signs: women revealing their continued dialectical auditioning and subverting of their *sign*ificant masquerade.

Performance and the (Video) Document

So what difference is performed by the making live, for the first time, of a performance previously done only to camera? Can video performance ever count as performance if we take Phelan's ontological point, cited at the opening of this essay? For surely Phelan is right when she says that it is this very lack of reproduction which gives performance its politics, its inability to be co-opted, its anti-commodification, its irreproducibility, its evanescence.

With video performance, the document and the event are inseparable. We are left with the little lady in a box we can play again and again – electrotrickery performance.[108] Or, as Troy asserts, do we have an ever-live, ever-present performance which can time travel? The restaging of *Semiotics* opened with the 1975 video playing in full: the video was incorporated into the live performance as a *document* of the '75 version.

Rosler has spoken about the transactional nature of her works, such as the postcard novels or the photomontages, which were not shown in

gallery contexts but published in alternative publications such as *Goodbye to All That*. When the works are shown in galleries Rosler sees them as no longer the works she made but representations of themselves, devoid of their original performance.[109] Our question should be then: at which point does the documentation commence and the performance rupture? Surely our interaction as an audience, even the mere interaction of encoding to memory, is the first document? Naming the action 'performance art' creates the document of label.

This very act of writing about performance is an obvious documentation, one which writers such as Amelia Jones and Jane Blocker, as noted by Gavin Butt in his introduction to *After Criticism*, try to negotiate through performative writing.[110] Video performance can itself be seen in a similar light: wanting to create performative critiques, artists such as Rosler perform to camera knowing that a single object will not result but work with potential for wide dissemination (*sic*) will. The Benjaminian concept of the anti-auratic reproduction lies within the embrace of multiples that video offers.

Of course this is not a position above co-option; Rosler has written of the aura attaching to the copy in an establishment of anti-art as Art.[111] In relation to the inadequacy of representational systems that Rosler explores with *The Bowery*, Benjamin Buchloh asked her 'video work... Is that less "inadequate"? [Rosler replies]: No, but it is better in some ways because at least people move and speak and aren't fixed into icons.'[112]

Phelan, though, is emphatic and deeply cogent in her insistence on the 'no left-overs'[113] of 'real' performance art. And on restagings she says 'It can be performed again, but this repetition itself marks it as "different"'.[114] However, what if the performance one intends must convey its intimate relation to broadcast television? In the restaging this is performed with the live feed onto the monitors behind the kitchen stations showing the auditioning women perform. Alan Kaprow, in his essay about video art, writes of this use of video as the most interesting application of the medium.[115]

In 1975 Rosler used video to create a decoy of a cookery show – a point fundamental to the performativity of *Semiotics*:

video is useful in that it provides me with the opportunity to construct 'decoys', entities that engage in a natural dialectic with TV itself. A woman in a bare-bones kitchen, in black and white, demonstrating some hand tools and replacing their domesticated 'meanings' with a lexicon of rage and frustration is an antipodean Julia Child.[116]

In this sense the video *is* the performance.[117]

Of course, the issue of what is a document(ary) is also at play here, a question which Rosler explored in 'In, around and afterthoughts: on documentary photography'. *Art, Lies and Videotape: Exposing Performance* sought to explode the myth of the transparent document, mainly through the question of the fictive or fictitious recorded 'performance'. Babette Mangolte's contributions to the exhibition, specifically her 'in conversation' with RoseLee Goldberg on 15 November 2003, added to this question of the construction of documents via the notion of multiple photographers' versions of the same performance. This conversation was a terrific consideration of the myriad positionalities and temporalities involved in the production of 'documentation', enlivened by contributions from the audience by relatives of Yves Klein and Oscar Schlemmer. The event became an engaging performance of the exhibition's embodied concerns.

Yet *Semiotics*, as a video, is equally Rosler's own documentation of the performance, thus confronting these very issues of *how* the performance will be seen, since it will be seen through its documentation. And what of the performance unseen: either not documented or only in a few, often hard-to-get-hold-of photos, where word of mouth and the inscription of such oral histories is the 'only'/main document?

Writings about performances – articles, reviews, reminiscences, reconstructions, postulations, speculations, inquiries, suppositions, projections and the like – are, perhaps, the most disseminated document(ary)s of performance art. The restaging of *Semiotics* suffers from this. Having not attended it myself, I have to rely on proxy accounts and their varying responses.

Tidying Up

In my introduction I stated that *Semiotics* is a performance about the performativity of gender constructed through the sign-system of maintenance labour, and that through such repetitive performance woman self-inflicts her oppression through her lack of counter-performative, adding, however, that such a counter is possible. We still need these 'declarations' where consumerist irony can devour our 'acting out' while keeping us in our place: see for instance the numerous novelty tea towels and ironing board covers which aim to jolly along our chores. But does a 'Hey, guys, iron away Jordan's bikini!' ironing board cover aid the cause of feminism even if it prompts a man to do his own ironing?[118]

Most interesting for *Semiotics* are the tea towels of the English designer Julie Haslam where the towel has a black and white photo of a butcher's knife screen-printed in isolation and at life-size onto the 'neutral' towel. Another depicts a whisk. It is Rosler's 'lexicon of rage and frustration' as defused joke, decorative and handy, amusing but not titled

NOTES

1 Peggy Phelan, *Unmarked: The Politics of Performance* (London: Routledge, 1996), p. 148.

2 Maria Troy, 'I Say I Am: Women's Performance Video from the 1970s', Video Data Bank website http://www.vdb.org/resources/isayiamessay.html.

3 Though she has continued to re-perform variations on *Garage Sale* since 1973 and as recently as 2003 in Sweden and with 2005's *London Garage Sale* at the ICA.

4 Linda M. Montano, 'Food: Martha Rosler', in *Performance Artists Talking in the Eighties* (Berkeley, Los Angeles and London: University of California Press, 2000) p. 205.

5 As discussed at her talk at Tate Liverpool in conjunction with the *Shopping* exhibition in March 2003.

6 'Performativity is not a singular act, but a repetition and a ritual, which achieves its effects through its naturalization in the context of a body, understood, in part, as a culturally sustained temporal duration.' Judith Butler, 'Preface, 1999', in *Gender Trouble: Feminism and the Subversion of Identity* (New York and London: Routledge, 1990, 2nd edn 1999), p. xv.

7 Butler, *Gender Trouble*, p. xv, emphasis added.

8 Alexander Alberro, 'The Dialectics of Everyday Life: Martha Rosler and the Strategy of the Decoy', in *Martha Rosler: Positions in the Life World*, ed. Catherine de Zegher (Birmingham: Ikon Gallery, 1998), p. 75. Benjamin Buchloh, 'A Conversation with Martha Rosler', in de Zegher (ed.), *Martha Rosler*, p. 29. Both Alberro and Buchloh provide most of the citations for this section. See also Alberro, 'Dialectics', p. 77, in relation to Rosler having 'exhibited paintings in New York at a couple of small galleries in the 1960s'.

9 Buchloh, 'Conversation', p. 24.

10 Alberro, 'Dialectics', pp. 76–77. Buchloh, 'Conversation', p. 50.

11 Alberro, 'Dialectics', pp. 79–80. Buchloh, 'Conversation', p. 47.

12 Alberro, 'Dialectics', pp. 75 and 76, footnote 7.

13 Buchloh, 'Conversation', p. 39. Alberro, 'Dialectics', p. 75.

14 Buchloh, 'Conversation', p. 25.

15 Martha Rosler, 'Immigrating, 1975', reprinted in de Zegher (ed.), *Martha Rosler*, p. 285.

16 Alberro, 'Dialectics', p. 77.

17 'Biography/Bibliography', in de Zegher (ed.), *Martha Rosler*, p. 287.

18 Alberro, 'Dialectics', p. 79, footnote 12.

19 'I was teaching and figured I would continue to get casual or regular labor teaching.' Interview with author, via email, 25–26 October 2004.

20 Alberro, 'Dialectics', pp. 78 and 76, footnote 7.

21 Alberro, 'Dialectics', pp. 77–78.

22 Buchloh, 'Conversation', pp. 32–33, 36–39 and 42–44.

23 Montano, 'Food', p. 205. 'My basic list came from Ellie [sic] Antin, who was much more involved in the mail art network than I was at the time. When the *Village Voice* wrote it up, people asked to be put on the mailing-list.'

24 Alberro, 'Dialectics', pp. 73–74.

25 Montano, 'Food', p. 203.

26 Annette Michelson, 'Solving the Puzzle', in de Zegher (ed.), *Martha Rosler*, p. 184.

27 New York Times food critic, died in 2000 at the age of 79.

28 See Alberro, 'Dialectics', p. 74.

29 See note 61 regarding, via Judith Butler's doer and the deed, my understanding of this performative activism.

30 Montano, 'Food', p. 203. Francis Frascina also comments on this aspect of Rosler's praxis, specifically as developed from/constituting her activisms; see Francis Frascina, *Art, Politics and Dissent: Aspects of the Art Left in Sixties America* (Manchester and New York: Manchester University Press, 1999), p. 172. Rosler returned in November 2004 to her photomontage series 'Bringing the War Home', creating a new series of images relating to the US/UK invasions of Afghanistan and Iraq.

31 The OSS: Second World War departmental forerunner of the CIA.

32 This information is widely available in all the biographical sources for Julia Child (b. 15 August 1912, d. 12 August 2004) and Elizabeth David (b. 1913, d. 1992). Googling them will provide an array of such sources. See, for instance, Child: Starchefs. com website http://starchefs.com/JChild/ html/biography.shtml and CNN website http://www.cnn.com/2004/SHOWBIZ/ TV/08/13/obit.child/. David: The New York Review of Books website http://www. nybooks.com/nyrb/authors/8498; Penguin UK website http://www.penguin.co.uk/nf/ Author/AuthorPage/0,,0_1000008540,00. html.

33 Montano, 'Food', p. 203.

34 Martha Rosler, 'For An Art Against The Mythology of Everyday Life', in *Decoys & Disruptions: Selected Writings, 1975–2001* (Cambridge, MA, and London: The MIT Press, 2004), p. 5.

35 Interview with author, via email, 25–26 October 2004.

36 As noted by Rosler at her artist's talk/ bus tour for the Liverpool 2004 Biennial, 21 September 2004.

37 Several interesting works that deal with these complex issues include: Lindsay Mackie and Polly Pattullo, *Women At Work* (London: Tavistock Publications, 1977); Angela Davis, *Women, Race and Class* (London: The Women's Press, 1981); Barbara Ehrenreich, *Nickel and Dimed: Undercover in Low-wage America* (London and New York: Granta Books, 2002); Polly Toynbee, *Hard Work: Life in Low-pay Britain* (London: Bloomsbury, 2003).

38 See Griselda Pollock, 'Screening the Seventies: Sexuality and Representation in Feminist Practice – A Brechtian Perspective', in *Vision and Difference* (London: Routledge Classics, 1988, 2003), pp. 227–31. Consider also Helen Molesworth, 'Clearing Up in the 1970s: The Work of Judy Chicago, Mary Kelly and Mierle Laderman Ukeles', in *Rewriting Conceptual Art*, ed. Michael Newman and Jon Bird (London: Reaktion Books, 1992), pp. 107–22.

39 See note 28.

40 See Alberro, 'Dialectics', p. 80.

41 Rosler, bus tour lecture, Liverpool, 21 September 2004; and noted by Greil Marcus, 'Column December 13th, 1999', *Salon.com* website http://www.salon. com/media/col/marc/1999/12/13/ marcus10/ [also posted on Martha Rosler's own website on http://home.earthlink. net/~navva/reviews/index.html].

42 Martha Rosler quoted Michael Rush, *Video Art* (London: Thames & Hudson, 2003), p. 86.

43 See John Lechte, 'Semiotics: Ferdinand de Saussure', in *Fifty Key Contemporary Thinkers* (London and New York: Routledge, 1994, 2003), pp. 149–50.

44 Alberro, 'Dialectics', p. 77.

45 Buchloh, 'Conversation', pp. 46–47 (especially page 46 on simultaneity of conception of *Bowery* and *Semiotics* and their points of intersection). Also see pages 34–35 and 201 in de Zegher (ed.), *Martha Rosler*, for the diary entries of the lists of words for *Bowery* and *Semiotics*, respectively.

46 Rosler stated that *Semiotics* was performed for 'the crew: camera and sound' in interview with author, via email, 25–26 October 2004. See also Christoph Grunenberg, 'Foreword', in *Art, Lies and Videotape: Exposing Performance*, ed. Adrian George (London: Tate Publishing, 2003), p. 7: 'iconic performances staged exclusively for the camera'. According to Tracey Warr, 'A substantial number of '60s and '70s "performances" are in fact hybrid performance photography, not performed for live audiences but for the camera.' 'Image as Icon: Recognising the Enigma', in George (ed.), *Art, Lies and Videotape*, p. 33.

47 See Martha Rosler, 'To Argue for a Video Representation. To Argue for a Video against the Mythology of Everyday Life [1977]', in *Conceptual Art*, ed. Peter Osborne (London and New York: Phaidon Press, 2002), pp. 263–64, esp. 264. See Osborne's footnote on this work's genesis and reprinting. It has also been reworked by Rosler as the essay cited in note 34 (see page 7).

48 Rosler, 'For an Art Against', p. 7. This American celebrity TV chef and cookery book and show author/'star' is discussed further later in the essay, together with two other notable 'spoofs' of her.

49 Of course, in the past fifteen years, Americans would think of Martha Stewart, the now convicted and imprisoned former Wall Street stockbroker turned lifestyle/cookery guru media mogul, if asked who was the pre-eminent expert on all things domestic; but in terms of popular cookery during the 1960s to 1980s it was the former OSS operative turned jet-set Cordon Bleu PBS TV cookery presenter Julia Child who reigned supreme. An interesting coincidence regarding Martha Stewart and Martha Rosler is their shared biblical nomenclature which denotes 'housewife'; a fact which is unlikely to have been lost on Rosler with her 1977 audio piece 'What's Your Name, Little Girl?'; see de Zegher (ed.), *Martha Rosler*, pp. 205–07.

50 Silvia Eiblmayr, 'Martha Rosler's Characters', in de Zegher (ed.), *Martha Rosler*, p. 157.

51 Martha Rosler, 'The Figure of the Artist, The Figure of the Woman', in *Decoys & Disruptions*, p. 100: 'In pop, the female appears as a sign... The figure of the woman was assimilated both to the desire attached to the publicized commodity form and to the figure of home.' And: 'Yet, *as sign*, the female is indeed conquered in pop, as she was in expressionism... Unlike pop, feminism – and feminist art – insisted on the importance of gender as an absolute social ordering principle and also on the *politics* of domination in all of social life, whether personal or public.'

52 Rosler, 'Figure of the Artist', p. 97.

53 See de Zegher (ed.), *Martha Rosler*, p. 201: 'Apron, Bowl, Chopper, Dish, Eggbeater, Fork, Grater, Hamburger Press, Ice pick, Juicer, Knife, Ladle, Measuring Implements, Nutcracker, Opener, Pan, Quart Bottle, Rolling Pin, Spoon, Tenderizer, UVWXYZ (W – whisk)'; Alberro, 'Dialectics', p. 76 mentions that 'poetic and incantatory lists appear throughout her [Rosler's] work'.

54 E.g., Helena Reckitt and Peggy Phelan (eds), *Art and Feminism* (London and New York: Phaidon Press, 2001, 2003), p. 87; Tony Godfrey, *Conceptual Art* (London and New York: Phaidon Press, 1998, 1999), p. 287; Paul Wood, *Conceptual Art* (London: Tate Publishing, 2002), pp. 71–72; Rush,

Video Art, p. 86; de Zegher (ed.), *Martha Rosler*, p. 296; Eiblmayr, 'Characters', 153–54. There are also many good descriptions on various websites. Additionally, *Semiotics* can be seen in its entirety on YouTube.com along with a couple of sophomoric parodies that others have posted.

55 Just two examples are Alberro, 'Dialectics', p. 76 and Eiblmayr, 'Characters', p. 155.

56 'Rosler... finally turns into a tool herself. Yet she is...personifying... the letter itself: U, V, W, X, Y, Z become written by her body, which in turns means that her body becomes written by them.' Eiblmayr, 'Characters', p. 153.

57 When asked on her bus tour lecture at the Liverpool Biennial on 21 September 2004, what she did for Z, Martha Rosler replied, gesturing the Z drawn in the air, 'Why, the mark of Zorro, of course!' '*Zorro, Zorro, who makes the sign of the Z*', from the television show's theme song which sold 'more than 1,000,000 copies... during the two year run of the series' (1957–59); 'Norman Foster (words) and George Bruns (music)' from http://www.geocities.com/thezorrolegend

58 Unattributed, from blurb on *Semiotics of the Kitchen* (1975) at the Electronic Arts Intermix website http://www.eai.org/eai/tape.jsp?itemID=1545.

59 J. L. Austin, *How to Do Things with Words* (Cambridge, MA: Harvard University Press, 1962, 2003), p. 60.

60 Lechte, 'Saussure', p. 150.

61 I have in mind here a conception of self (-inflicted) as described by Judith Butler: 'My argument is that there need not be a "doer behind the deed", but that the "doer" is variably constructed in and through the deed. This is not a return to an existential theory of the self as constituted through its acts, for the existential theory maintains a prediscursive structure for both the self and its acts. It is precisely the discursively variable construction of each in and through the other that has interested me here.' Judith Butler, 'Conclusion: From Parody to Politics', in *Gender Trouble*, p. 181.

62 Phelan, *Unmarked*, p. 150: Phelan goes on to say 'Feminist critical writing [Modleski argues] "works toward a time when the traditionally mute body, 'the mother', will be given the same access to 'the names' – language and speech – that men have enjoyed"'.

63 Phelan, *Unmarked*, p. 150: 'the "speaking bodies" of men and the "mute bodies" of women'.

64 Montano, 'Food', p. 203.

65 Montano, 'Food', p. 202.

66 Roger Scruton, *A Short History of Modern Philosophy: From Descartes to Wittgenstein* (London and New York: Routledge, 1981, 2nd edn 2002), p. 267; see also p. 268. Martha Rosler's retrospective catalogue is entitled *Martha Rosler: Positions in the Life World*. Of course, Husserl's life-world is further developed by Jürgen Habermas, who considers it in light of Austin's work on speech acts. Though English translations of such work would not have been available in 1974/75, reference to Rosler's library – via her project with e-flux – reveals her ownership of several of Habermas's works.

67 Scruton, *Modern Philosophy*, p. 269.

68 Rosler, 'For an Art', p. 7.

69 'An unsmiling woman, the antithesis of the perfect TV housewife, demonstrates some of the hand tools of the kitchen, replacing their domesticated "meaning" with an alphabetic lexicon of rage and frustration. These securely understood signs of domestic industry are redefined by the artist's gestures as vehicles of violence or instruments of mad music.' de Zegher (ed.), *Martha Rosler*, p. 296.

70 Austin, *Words*, p. 76.

71 'Peirce also argued, not only that all thinking is necessarily in signs, but that "all thinking is dialogic in form" (6.338), even if this dialogue be only with oneself.' John Lechte, 'Charles Sanders Peirce', *Fifty Key Contemporary Thinkers*, p. 148.

72 See Lynda Hart and Peggy Phelan (eds), *Acting Out: Feminist Performances* (Ann Arbor, MI: University of Michigan Press, 1993).

73 See the Zorro Legend website http://www.geocities.com/thezorrolegend

74 The Scarlet Pimpernel was the flower incised on his signet ring with which he sealed his correspondence, both a wearing and a marking (and one could say that when at ease, the sword is worn as well). I am also referencing the notion of Superman with his S pennant splayed across his chest; of course, in terms of masquerade Superman is the interesting example of the unmasked superhero who conceals his 'real' identity through the adoption of the transparent mask of spectacles as Clark Kent. In the character of the Lone Ranger we have the perpetual Zorro anglicized and transplanted from Spanish California to formerly Spanish/Mexican Texas – the man who seemingly never unmasks: 'Who is that masked man?'

75 'More than 65 Zorro books and short stories were to follow, with an estimated 500 million readers around the world following in the masked avenger's exploits in 26 languages before McCulley's death on November 22, 1958 at age 75.' http://www.geocities.com/thezorrolegend

76 This use of the whip also brings to mind Wonder Woman's lasso of truth. Furthermore there are interesting issues about drag in these two alternative Zorros as well.

77 'I read Michael Fried's essay ['Art and Objecthood']... and he spoke of the problem of art that did not follow these Modernist precepts as being "theatre". And I said "bingo, that's it, that's right." The art that is important now is a form of theatre.' Martha Rosler, interview with the author, 24 November 1991. Francis Frascina, 'Chapter 2: The Politics of Representation', in *Modernism in Dispute: Art since the Forties*, ed. Paul Wood, Francis Frascina, Jonathan Harris and Charles Harrison (New Haven, CT, and London: Yale University Press, in association with Open University, 1993), pp. 160–61. See Eiblmayr, 'Characters', p. 158: 'with streaks of a sort of hidden, sometimes malicious wit'. And see page 88 of de Zegher (ed.), *Martha Rosler*, for a reproduction of a postcard work to Martha Rosler from Ray Johnson, c. 1973: 'Dead Pan Club'.

78 Many mentions of this abound, but see, e.g., Wood, *Conceptual Art*, p. 71. Rosler, 'Figure of the Artist', pp. 97, 99.

79 Maria Troy, 'I Say'.

80 Rosler 'formed close relationships with Los Angeles feminist artists, such as Nancy Buchanan and Suzanne Lacy, and with other women at the Women's Building... an outgrowth of the Feminist Art Program at the California Institute of the Arts.' Alberro, 'Dialectics', p. 78.

81 And her stated desire to 'negate the slickness of the mass media'. Alberro, 'Dialectics', p. 88.

82 Annette Michelson says of Rosler's *Born to be Sold: Martha Rosler Reads the Strange Case of Baby $M* (1988) that its 'ebulliently satiric intensity recalls the style of American television's celebrated program *Saturday Night Live*'. Michelson, 'Solving the Puzzle', p. 191.

83 Perhaps due to geographical proximity, this Chicago-based comedy troupe had strong connections with Canada, from Canadian performers such as Dan Ackroyd and John Candy, to sketches such as the two flannel-clad, Canadian beer-drinking sports TV spectators played by John Candy and Rick Moranis, who even had their own (pre-) Wayne's World-esque spin-off film entitled *Strange Brew*.

84 See his entry on IMDb: http://www.imdb.com/name/nm0661094/

85 Taken from http://snltranscripts.jt.org/75/75jsamurai.phtml

86 Taken from http://snltranscripts.jt.org/78/78hchef.phtml

87 See Terry Eagleton, *Literary Theory: An Introduction* (Oxford: Blackwell Publishers, 1983, 1994), p. 103.

88 Martha Rosler, 'Preface', in *Decoys & Disruptions*, p. ix; it is Henri Lefebvre quoting Hegel. This quote also opens Michelson's 'Solving the Puzzle', p. 181.

89 Rosler, 'Preface', p. ix. See also Alberro 'Dialectics'.

90 Austin speaks about performative statements as not true or false but as happy or unhappy – see in particular Austin, *Words*, p. 14.

91 Austin, *Words*, p. 76.

92 Austin, *Words*, pp. 8–9, 34. And see page 27 on misfires.

93 Alberro, 'Dialectics', p. 86.

94 Montano, 'Food', p. 203.

95 Montano, 'Food', p. 205.

96 Buchloh, 'Conversation', pp. 49–50.

97 Interview with author, via email, 25–26 October 2004.

98 Interview with author, via email, 25–26 October 2004.

99 Heather Anderson, 'Happy F. O. to You! Some thoughts on performances by *Les Fermières Obsédées*', *Arts Atlantic Magazine*, Issue 78 as found at http://www.artsatlantic.ca/issue78/78_feature.html.

100 Interview with author, via email, 25–26 October 2004.

101 Anna Dezeuze, 'Art, Lies and Performance', *Art Monthly*, 273 (February 2004), p. 14.

102 Philip Stanier, 'History of Performance Art Part II. Whitechapel Art Gallery', *liveartmagazine.com* http://www.liveartmagazine.com/core/reviews.php?action=show&key=175.

103 Paul Edmunds, 'Beyond the Material: Conceptual Art from the Permanent Collection at the SANG', *Artthrob*, Reviews/ Cape http://www.artthrob.co.za/02sept/reviews/sang.html.

104 Anderson, 'Happy F. O.'.

105 Rosler, 'Figure of the Artist', p. 111.

106 See http://www.geocities.com/thezorrolegend. Also consider 1974's *The Mark of Zorro*, starring Frank Langella, which would have rekindled attention to Zorro in the year in which Rosler made *Semiotics of the Kitchen*.

107 See http://www.mixnyc.org/2001/fuck.shtml or http://www.frameline.org/festival/26th/programs/girls_by_the_bay.html.

108 I am referring here to what I consider a potent predecessor of electronically infused performance art – whether that of just filming/photographing/videoing the performance to create a document to works that intimately implicate electronics/video in their performance. This predecessor is the European salon performances of

the eighteenth century of displays of the properties of static electricity, which featured a human 'conductor' and a variety of everyday objects: cloth, glass, feathers, cats, staged with great showmanship. This included the occasion when a charged boy was hung from the ceiling and a salver of feathers presented beneath him, making them seem to levitate. Benjamin Franklin similarly conducted such spectacles in the US, once hosting a dinner on the banks of a river outside of Philadelphia where all of the turkeys were killed by electricity and some of the dinner plates were electrified. Discussed in Melvyn Bragg's programme 'In Our Time', BBC Radio 4, 4 November 2004.

109 Martha Rosler, 'Place, Position, Power, Politics', in *Decoys & Disruptions*, pp. 355–56, on photomontages, and Buchloh, 'Conversation', p. 45, on postcards.

110 Gavin Butt, 'Introduction: The Paradoxes of Criticism', in *After Criticism: New Responses to Art and Performance*, ed. Gavin Butt (Oxford: Blackwell, 2005), p. 10. See also Amelia Jones, *Body Art: Performing the Subject* (Minneapolis, MN, and London: University of Minnesota Press, 1998) and *Irrational Modernism: A Neurasthenic History of New York Dada* (Cambridge, MA, and London: The MIT Press, 2004).

111 Martha Rosler, 'Video: Shedding the Utopian Moment', in *Decoys & Disruptions*, pp. 68 and 65.

112 Buchloh, 'Conversation', p. 45. But with the video often seen only as an iconic printed still in books the spectre of 'iconic performances staged exclusively for the camera' looms (quote cited in note 46).

113 Phelan, *Unmarked*, p. 148.

114 Phelan, *Unmarked*, p. 146.

115 Allan Kaprow, 'Video Art: Old Wine, New Bottle (1974)', in *Essays on the Blurring of Art and Life, Allan Kaprow*, ed. Jeff Kelley (Berkeley, Los Angeles and London: University of California Press, 1996), pp. 148–53.

116 Rosler, 'To Argue For', p. 264.

117 Rosler, 'To Argue For', p. 264. Here my assertion is expanded and complicated by Rosler: 'How does one address these banally profound issues of everyday life? It seems to me appropriate to use the medium of television, which in its most familiar form is one of the primary conduits of ideology – through both its ostensive subject matter and its overtly commercial messages. I am trying to enlist "video", a difficult form of television, in the attempt to make explicit the connections between *ideas* and *institutions*, connections whose existence is never alluded to by corporate TV. Nevertheless, *video is not a strategy*, it is merely a mode of access.' (emphasis added).

118 See one of numerous websites where this can be found http://www.femalefirst. co.uk/celebrity/celebrity-clothes-fashion-list.php?designer=Jordan%20Ironing%20Board%20Cover

10

Interaction/Participation
Disembodied Performance in New Media Art

BERYL GRAHAM

> Question: How have recent developments in technologies affected your work
> and/or attitude towards 'live' performance?
> Laurie 212: They've improved my typing somewhat.
>
> <div align="right">Laurie Anderson[1]</div>

The 'new' digital media, including Internet art, computer interactivity
and telematic communications, have a ragingly ambivalent
relationship to the central values of live art; the performative, the
embodied and the document. The effects of new media have often been
overstated, although practising artists including Laurie Anderson do
tend to have a more realistic view of the particular tools offered by
digital and computer-based media. This essay therefore takes recent
new media artistic practice as the starting point for exploring
interestingly ambiguous relationships between 'performance' and a
range of novel technologies.

The Opposite of Persona?

> Our machines are disturbingly lively, and we ourselves frighteningly inert.
>
> <div align="right">Donna Haraway[2]</div>

The Russian artist Alexei Shulgin is standing on a stage, making an
immaculately deadpan performance of his work *386DX*.[3] The artwork
is essentially a piece of software that makes computer-generated voices
sing cover versions of songs such as *California Dreaming*. Shulgin's

performance adds a 'live' projection of the software code, and, of course, his live persona on stage, with a computer keyboard slung where an electric guitar should be. He can simply start and stop the tunes, but is he also changing the code live? The audience whoop and cheer as the bearded, bespectacled and bejumpered pop idol makes knowingly ironic jokes with computer code. Shulgin, of course, does not need to be on stage as a persona, and the audience can also simply go to his website to hear the songs, buy the CD and see documentation of the live events. A solo computer has also been known to perform the works – sitting on the streets of Moscow as a lone electronic 'busker'. As the clunky voices warble away, the artist is cleverly acknowledging the essentially *ersatz* nature of technology, with its cheap imitations of the real things – digital copies, artificial almost-intelligence, toy pets, fake violence, and of course the risible 'virtual sex'.[4]

The persona of the wild individual performance artist, who might do all sorts of titillating, dangerous or socially embarrassing things, is a persona that is deliberately rejected by many contemporary new media artists in favour of pseudonyms, distance and embodiment through evolving software. Shulgin, for example, was primarily known for his very minimal online art such as *Form Art*.[5] Here, there is a marked divergence between those artists with a background in performance or video, and those who may come from programming, hacking or other non-art backgrounds. As Rosalind Krauss pointed out in 'Video: The Aesthetics of Narcissism' in 1978, this may be rooted in the medium itself:

> Unlike the other visual arts, video is capable of recording and transmitting at the same time – producing instant feedback. The body is therefore as it were centered between two machines that are like the opening and closing of a parenthesis. The first of these is a camera; the second is the monitor, which reflects the performer's image with the immediacy of a mirror.[6]

This might be very literally applied to Dan Graham's mirror-based *Present Continuous Past(s)*;[7] however, as Ken Feingold has more recently described, the new media can also offer similar pleasures: 'Interactivity is, in many ways, about affirmation of the human action by a non-human object, a narcissistic "it sees me"'.[8] As an alternative to this approach, as

early as 1995 curator Louise Dompierre was already asking 'Can we leave aside the "miracles" of popular culture, including those of cinema and computer games, to engage with works not having the notion of "spectacularity" as central?'[9] Thus, for every Stelarc using the body as technology-enhanced spectacle, there are many net artists who welcome the disembodied anonymity of the Internet, and revel in the home-made potential of being able to make their art in their bedrooms.

Again in divergence from the individual artistic persona, there is also an inherent tendency in new media art to collaborate, if only because of the sheer range of technical and artistic skills needed to produce finished work; artistic partnerships including Diller Scofidio, JoDi, Thompson and Craighead, Nina Pope and Karen Guthrie evidence the enduring success of this approach. There is also a strong political history of collective ethics coming from net activism, which has a contemporary artistic embodiment in groups including Critical Art Ensemble, KIT, RTI, Mongrel and irational. The particular characteristics of certain new media including blogs, wikis or videoconferencing have sometimes enabled these groups to collaborate more easily across geographical separation, but their working structures also draw from older formats: from political activism, production co-ops or media lab approaches. ('Blogs' is an abbreviated word for weblogs – online logs often in journal form, which can involve images from mobile phones, texts, etc., added by one author or several. 'Wikis' are any online documents that not only allow any user to add content, but also allow that context to be edited by any user.) Certain artists have also found themselves using working methods from older forms of performing art, rather than the 'heroic individual' of performance art:

> Even when I am working on a project alone I still feel it is a collaboration because I am always aware that tools that I use are already encoded with the 'personality' of its programmer/designer. Creation is always a fluid dialog. The mode of cooperative conception that works for us is one derived from the performing arts: there is a director, actors, composers, and so on.[10]

In considering the role of 'persona' in new media art, therefore, the range of personae chosen by artists is as wide as the range of the media themselves, from god-like technology shock and awe, to complete

self-effacement beneath streams of code, in an escape from the analogue, which is a particular characteristic of digital media.

Embodied?

> they are nothing but signals, electromagnetic waves... and these machines are eminently portable, mobile – a matter of immense human pain in Detroit and Singapore. People are nowhere near so fluid, being both material and opaque.
>
> Donna Haraway[11]

Strongly related to the idea of presence or persona is the subject of the body. This is obviously crucial to the history of performance art, but is also brought up within a large body of 1990s theory around new media. Theorists including Alluquere Rosanne Stone articulately explored the gendered embodiment of virtual space,[12] and artists such as Lynn Hershmann Leeson equally articulate the issues of voyeurism, sexuality and intimacy. Hershmann Leeson's work has its roots firmly in pre-digital performance, with artworks including a durational piece in the Dante Hotel, a skid-row venue inhabited by those in transition, including her assumed persona as a mystery woman.[13] In moving on to new media, the artist was able to utilize eye-tracking cameras and interactive videodisc to make *A Room of One's Own*, a small black box featuring a woman's bedroom, into which the viewer could peer. The audience would, however, be challenged by reactive video clips about their own voyeurism. Crouching, peeping and reacting, the audience were made very aware of the body politics both of the artwork and of their own physical position, by using the particular qualities of computer-controlled interactive technology.

Karin Sander's work *1:10* is a set of one-tenth scale human figures created via a body scanner, and computer rapid-prototyping model-making machines. These odd plastic figures, which bear the names of their original human models, have an eerie miniature presence, but also raise another question of embodiment – where is 'the hand of the artist'? Are they merely mechanical reproductions? Although the figures are actual objects, in the popular press they raise many of the same questions raised by conceptual and postmodern art – where are the craft

1 Gerd Hatje 1:10, 1997,
3D bodyscan of the living
person, FDM (fused
deposition modelling),
rapid prototyping,
ABS (acryl-butadien-
nityl-styrol), airbrush,
measurements: 1:10,
circa 16 cm.
Photo © Studio Karin
Sander 1997

2 Persons 1:10, 1996/97,
3D bodyscan of the living
person, FDM (fused
deposition modelling),
rapid prototyping,
ABS (acryl-butadien-
nityl-styrol), airbrush,
measurements: 1:10,
circa 16 cm.
Photo © Studio Karin
Sander 1996/97

skills? Is it art? Those artists who move away from actual objects are
even more prone to this repeated questioning: Jenny Holzer is one of the
few mainstream or conceptual artists to have worked with virtual reality,
and her *World II*[14] from 1993 deals with embodied knowledge – featuring
stories from war-torn areas of the world. The viewer uses a headset and
glove to 'move' through a basic three-dimensional computer graphic
landscape, and enter crude breeze-block huts. The movements trigger
voices to speak phrases, at first puzzling and then harrowingly narrative.
These 'immersive' technologies give the sensory impression of moving
through space, but artists are obviously also interested in the potential
for deep emotional or mental 'immersion' in, or engagement with, an
artwork, which can transcend the crude nature of the technology. Virtual
reality makes obvious the issues of a Cartesian mind/body split (as
obvious as the occurrence of virtual motion sickness when the body is
not is motion). Where, exactly, does the body lie in virtual space? There
does not necessarily need to be high technology in order to discuss the
body in virtual space: Alluquere Rosanne Stone, in 'Will the Real Body
Please Stand up...', starts with examples from phone sex, before moving
through the now famous examples of online gender-swapping, assumed
avatars and the adolescent male's desire to escape from an
uncontrollable body into cyberspace. Definitions of this space tend to
greatly excite media theorists, although still perhaps the most succinct
description is John Perry Barlow's analogy of when inserting your cash
card into a bank machine, 'cyberspace is where your money is'.[15]

Artists very rarely get access to virtual reality technologies, but those who work across media and performance are nevertheless very used to grappling with space, time and embodiment. Monica Ross's *transcription* (2001–) manages also to touch upon craft skills, in a literal way. The process of the artwork is focused on a copy of the essay *The Work of Art in the Age of Mechanical Reproduction* by Walter Benjamin. In a variety of physical locations, Ross sat and painstakingly wrote by hand the words of the printed text, layering it with tracing paper, and sending live video of the process onto the Internet, using web streaming technologies. The artist describes it as 'inscribed into the net by hand in a series of live works made at intervals since 2001. Performing reproduction as both a physical and technical ritual in real time...'[16] Here, the new media are being used not merely as a document of performance, but as an integral tool, process, medium and means of distribution of the artwork. Louise Dompierre has described certain new media artwork as 'No longer serving only to represent, art here becomes actuality as it is more or less performed in the space'.[17]

Although new media may be live, may be site specific and may have a certain amount of disembodied 'presence' or 'aura',[18] they are most definitely not, as Shulgin highlights, embodied. Therefore, those artforms which have live humans alongside technology must wrestle with the problem or either having the technology take over as sheer spectacle, or having the bodies take over as being far more live and compelling than technology's pale and jerky imitations. The awkward adolescent relationship with embodiment may be reflected here in the adolescent nature of the development of some new media. Many theatrical and dance-based performance traditions have struggled unsuccessfully with what Matt Fuller has called 'the awful naffness of technology',[19] and those that survive often do so on large doses of wit, relevant content and improvisation. Marlon Barrios Solano's *Spiff/ Unstablelandscape V* (2004), for example, includes a section with clips of squabbling couples from the film *Who's Afraid of Virginia Woolf*, triggered by accelerometers on the hands of the dancers. As sudden emotional hand movements trigger emotional movements on screen, the piece manages to balance meaning and tools with the power of

bodily movement. The wicked sense of humour about gender and sexuality also help to satirize the inherently mechanistic nature of the hardware. Technology is absolutely not the same as the body, but those involved in dance are perhaps used to this ambivalence, have lived for many years with the fact that documented dance is not the same as live dance, and watching dance is certainly not the same as dancing with a hot, improvising body.

Where are you? Live and Located

> it seems that Benjamin's concept of the aura, which was obliterated by cinema and TV as well, is reconnected within locative media…

Naomi Spellman[20]

When the telephone was first invented, it was proposed that a possible use of this medium would be the live transmission of opera into people's homes. Since then, it has been one of the particular characteristics of telematic and broadcast media that a 'performance' in one place can have an audience in another place, and that people on mobile phones will always want to know 'where are you?' Newer technologies such as GPS (Global Positioning Systems) mean that your machines will track you and tell you (or others) exactly where you are, and when.

The Surveillance Camera Players cleverly utilize other people's technologies to provide the means of production and distribution, as well as making comments on the obvious command and control potential of surveillance. The Players plan their location and context, and work within the limitations of the silent, slowly refreshing, fuzzy images; miming and holding up written signs in an odd echo of early silent movies. Costumes and props help to get across their messages, and those viewing the surveillance camera form their audience, along with the puzzled passers-by in public places. Using technologies intended for factual documentation for fictional 'playing' raises

3 Surveillance Camera Players

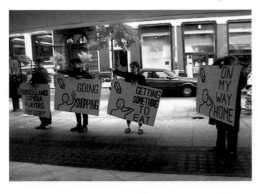

another aspect of new media – it is extremely good at lying about time and location (there are still some who question whether the American space programme really did land men on the moon). The artist Susan Collins has described how the users of her telematic art projects such as *In Conversation*[21] often spend some time establishing the basics of where and when, and she has also wryly observed that even women in live bedroom-cam sex sites spend a good deal of their time waving in response to messages querying whether they really are live. Rachel Reupke's artwork *Pico Mirador* also delves into the strange dislocated world of web-cams. The cameras of the national park of *Pico Mirador* have the usual 24 hours of bad weather, scenic views and wandering tourists, but also slowly perform Hitchcockian aspects. Reupke's site builds on her previous video artwork where disturbing activity happens gradually in the corners of picturesque landscapes. This use of landscape and physical space relates in some ways to the important characteristic that Lev Manovich[22] has identified – 'in many computer games... narrative and time itself are equated with movement through space (i.e., going to new rooms or levels)'. This computer-game/ landscape/narrative matrix has been used in conjunction with GPS and palm-sized devices by the group Blast Theory, who have a history in performance. Their artwork *Uncle Roy All Around You* involves users navigating around a city in order to find (or not) a real venue where interactions with live people may be facilitated.

Many column inches have been expended on the field of 'telerobotics' – the ability not only to see but to act at a distance. Robots can be sent into inaccessible or dangerous places, and impressive diagrams exist of future surgeons remotely operating on soldiers in combat situations, bolstering the fantasy desire that technology will provide escape from the body. Less impressive, however, is the clunky level of current technology, and the need for 'predictive simulation' to cover gaps in actual transmission.[23] Ken Goldberg's *The Telegarden*[24] (1995–99) enables the user, via a web page, to make a robot arm root around in a small patch of earth and plants. The essentially *ersatz* nature of the remote experience again seeks to highlight the frailty of our belief in the reliability of remote experience.

To sum up the examples so far, the questions peculiar to new media and performance concern all of the journalistic W's. *Who/what* is performing (the persona, the software, the body?) *When/where* (live, later, at a distance, site specific, face to face?) With Alexei Shulgin's *386DX* for example, there are choices to either witness a live performance of computer voices or to download it later. With his software *WIMP*[25] there is also the option to download a piece of software that basically messes around with the 'Windows' on your PC, and lets you 'perform' your own variations at your leisure. Who/what is performing here? Or, to take Monica Ross's *transcript*: is the slow duration of the live writing important? Is the live web stream the same experience as the archived video stream? Is the site where she is writing a specific site?

These characteristics specific to the range of new media have been usefully summarized by curator Steve Dietz as interactivity, connectivity and computability,[26] and the challenges that they pose to curators in particular are further explored in 'Curating New Media Art: Models and Challenges'.[27] The factors of 'connectivity' (telematics, location or time) have been touched upon in the examples of artwork already mentioned, but when it comes to computability and interactivity, this raises not only the 'W' questions of who, what, when and where, but the more difficult question of *how* the performance is happening.

Computability (generative)

Sollfrank has the work done for her, as she propagates on her front page: 'A smart artist makes the machine do the work!'

from the Female Extension website[28]

As Dietz points out, computers can use a logarithmic code to elaborate, evolve or develop a set of actions which can work upon each other. In the sciences, this code can be used to model or predict complex systems. In the arts, this code can be used, well, in whatever way the artist desires.

In 1997 the German artist Cornelia Sollfrank instigated *Female Extension* (later developing into the *net.art generator* in 1999), a computer programme which randomly collected material from the

4 Sneha Solanki, *The Lovers*, installation view at 'x-bit'. curated by Lindsay Duncanson. North Tyneside, 2001. Courtesy of the artist

5 Sneha Solanki, *The Lovers*, screen view. Courtesy of the artist

Internet and recombined it automatically to make 289 entries submitted by 'female virtual net artists' to an Internet art competition. In later versions, several other programmers contributed different versions of similar software, further confusing hapless curators with questions of authorship. Sneha Solanki's *The Lovers* (2001--) is an installation of two low-end computers, connected by a cable, and lit with a dim red light. In real time, the computers are sending each other the text of Robert Burns's 'My Love is Like a Red, Red Rose'. The artist has, however, inserted a virus-like code so that gradually over time the text becomes corrupted at each transmission ('Til| ('theℜθαp melt p>_un').
Here, the artist has the original concept, but sends the computer off on a generative thread that may be more or less unpredictable. The computer may be the performer, and the artist the playwright with only partial directorial control over the text.

In mapping complex systems, the aim of the artist is, however, often very different from that of the scientist. Lisa Jevbratt's *1:1* (1999–) is a consciously quixotic attempt to map the entire heaving and flowing vastness of the Internet. Each tiny coloured pixel links to one URL (the numerical code which marks the address of each web page) ... or at least used to link before the page died, moved on or disappeared. This is a time-based medium where each historical map is marked with last year's date, but seems as old as parchment. The viewer is therefore not in control of a medium where control is seen to be vital (although doomed to be a losing battle).

This embracing of evolving cybernetic systems, chance and software has early echoes in the 'systems' work of Fluxus and other conceptual art groups, who used a range of tactics from fledgling computers to paper-based data systems, object-based games, or performance 'happenings' to interact with their publics. Yoko Ono's *Imagine Peace Map Room* (2003), for example, could be said to be carrying on that tradition. However, the factor of generative computer code means that the artwork or 'puppet' is not simply a mechanical substitute for the human performer, but one which can animate or 'bring to life', as Andrew Quick points out.[29] Computability also makes reference to much earlier forms where creations might go on to evolve way beyond the control of their 'parents':

the puppet that takes over from the ventriloquist, the worker robot that gets ideas above its station, or Dr Frankenstein's creature.

Human–Computer Interaction (I see you're writing a letter!)

JABBERWOCK: Screw the weather. Let's talk about something really interesting. How's about flowers?

JUDGE: What about flowers? Isn't that a bit of a girlie subject?

JABBERWOCK: That's a little vague. Could you be more specific?

JUDGE: I don't like flowers so would rather talk about travel. Where do you like to go on holiday?

JABBERWOCK: No, I do not want to go on holiday.

A textual interaction between human judge and computer programme during the Loebner Prize competition.[30]

'Interaction' is a much-hyped but weakly understood characteristic of some new media. If we are discussing interaction between a computer and a human, then the nature of this interaction is severely limited by the fact that Artificial Intelligence, as defined by Alan Turing, has yet to arrive, despite announcements of its imminence since the 1960s. The Loebner Prize is a yearly competition where Turing's challenge is set by human judges who try to identify whether an invisible textual conversationalist is a human or a computer. As can be seen from the brief transcript, as soon as a few formulaic pleasantries have been exchanged, things quickly start to go suspiciously awry, and a computer programme could only be mistaken for a human conversationalist of the most deranged or boorish kind.[31] So far, no programme has passed the Turing test, and human–computer interaction remains fraught, frustrating and infuriating, as typically evidenced by that wee cartoon that pops up in some computer software to oh-so-helpfully inform you that you are writing a letter. Artists who have spent much time considering the tools offered by new media are often fascinated and amused by the obvious shortcomings. David Rokeby's *The Giver of Names*, for example, is a computer programme that can look as objects via a

video camera, before improvising a name for that object, based on human programming, learning curves and computer logic.

The results are sometimes apt, sometimes creative or innocently shocking, and run the gamut of our feelings about computers as god-like power or malleable slave.

To return to the simplest forms of human–computer interaction, there is also the bald fact that having a user choosing, pointing and clicking on a computer screen is undeniably a different user experience than looking at a painting (although not necessarily a better one). Much has been written on the relationship of this to the narrative form,[32] but the very basic difference is in the actions and responsibilities of the user. As seen in Lynn Hershman Leeson's *A Room of One's Own*, the viewer may become aware of their direct physical effect on the work through eye-tracking, which relates directly to the message of the artwork concerning voyeurism. However, even low-tech media can also be true to their materials by matching the message to the medium.

Harwood's *Rehearsal of Memory* is a conventional point-and-click interactive multimedia single-screen CD-ROM, but the point-and-click is very different to the pointless choices inherent in certain 'interactives'. The artwork was made in a high-security mental hospital, and the participants, including Harwood, pressed their bodies against a scanner to make images. On the screen, these bodies are 'sewn' together to make a map, and the scars and 'tattoos' on the bodies, when clicked, trigger stories of self-harm, harm and loss of love. Each click sounds like a slap, and the effect is very different to the aimless impatient clicking and meandering of some multimedia. The user is responsible for whether or not they wish to probe certain wounds, whether they wish to hear stories more harrowing, whether they wish to remain so close to disturbing, albeit mediated, bodies. Interaction between human and computer programme can therefore potentially offer a different kind of relationship where a certain intimacy, engagement and responsibility can be offered; but what cannot be offered, of course, is a full conversation between human and computer.

Human–Human Interaction (computer programmes as party hosts)

Successful pieces that feature 'interactivity for groups' are usually out-of-control. For me, a piece is successful if the behaviours and relationships that emerge from participation manage to surprise the artist/designer... in other words, the outcomes have not been pre-programmed.

Rafael Lozano-Hemmer[33]

Conversation is a highly elaborate skill involving exchange, evolution, creativity, interpretation, empathy and ambiguous language. Computer logic may just about be able to manage the first two factors, but beyond that it needs firm rules and predictable structures. It is little coincidence that computers have now beaten Grand Masters of chess, although they still founder in the Turing test. Games, it would seem, weave into both the history of computer programming as well as the history of art. Regina Cornwell has pointed out that Marcel Duchamp's interest in chess was a sustained time-based commitment, when compared to the 'fun' of computer games,[34] but nevertheless, many artists are giving serious thought to the subversive and engaging potential of games. Anne-Marie Schleiner, for example, has been involved in the locative political game *OUT* (2004)[35] around New York City, and on *Velvet-Strike* (2004), a shoot-em-up game with anti-war graffiti opportunities.[36] These games, however, often necessarily follow the interests of the individual competitor, whereas historically, games have also been formal ways to break the social ice between groups of people.

Toshio Iwai's game *Resonance of 4* (1994) is a very elegant means of getting strangers to interact and collaborate, which even works in that most icy of social venues – the white cube art gallery. Four computer mice on podia each control a grid projected on the floor. The intuitive interface soon reveals that each grid is a grid of notes that can be played like a different musical instrument. Clever programming means that it's easy to stay in some kind of collective harmony, but that for a true resonance of four people, the ability to cooperate through patterns and sounds greatly enhances the work. This generosity of spirit, where the artist is using computer programmes to act as a kind of subtle party host, enabling human–human interaction of a much more elaborate

kind than that possible between individual and machine,
is a rare but crucial happening.

Rafael Lozano-Hemmer came to appreciate the unpredictable but
rich nature of this kind of interaction through a series of individual
and group works. His work *Body Movies, Relational Architecture 6*
(2001–) used projected digital images, the shadows of people in public
squares and computer programmes which tracked the position of the
shadows. People both interacted with the programme by covering the
projected images of people with their own shadows, and also used the
sociable tools provided to interact with each other's shadows, in a
simply mediated way. Mock violence, flirting and cheerful obscenity
were obvious popular themes, as were quite elaborate mimes and
props – pouring water into the mouths of smaller shadows, making
combined body shapes, children towering over parents, or acting out
stories. If any one group became too dominant, violent or obscene,
there were also ways in which groups could block out their light by
standing together. As the works toured, national differences in
interaction became apparent. Liverpudlians, apparently, show a
marked tendency to take their clothes off when faced with silhouette
opportunities. The artist welcomes this kind of free-range true
participation, and has found that this particular role of the artist is a
very important and delicate one. 'Dependency on participation',
he has found, 'is a humbling affair'.

The particular skills needed to enable this kind of interactive,
participative or 'relational architecture' come from not only an
understanding of performance in Lozano-Hemmer's case, but also
from a history of conceptual and post-modern art. Nicolas Bourriaud
cites the artists Felix Gonzalez-Torres, Rirkrit Tiravanija and Philippe
Parreno in his theory of 'relational aesthetics', all of whom use use-low
tech methods of encouraging participation as a site of 'where the art
happens'. Ritsuko Taho's *Zeromorphosis: Swans and Pigeons* (1996),
to take another example, used the low-tech materials of grass-seed,
shredded money and duplicate notes to make an artwork which grows
grass through time, as each participant leaves their own contribution.
This work is wholly dependent upon participation, and demonstrates

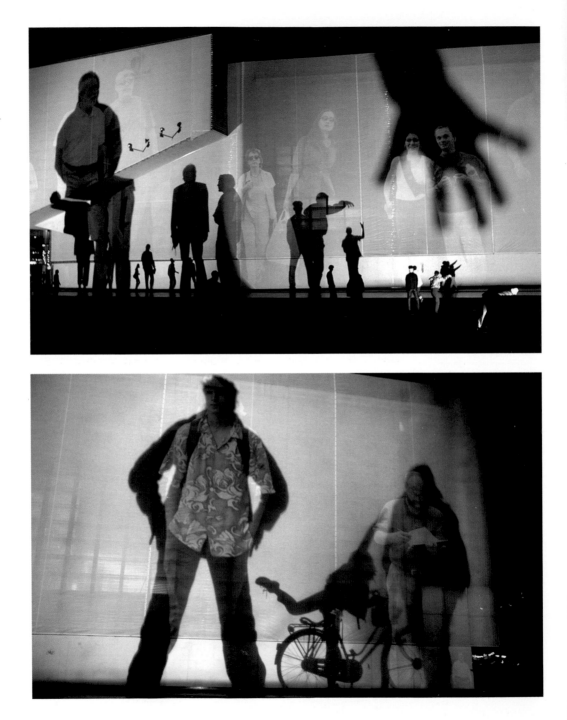

6 Rafael Lozano-Hemmer, *Body Movies, Relational Architecture 6*, V2, Rotterdam, Cultural Capital of Europe 2001, photo by Arie Kievit. Courtesy of the artist

7 Rafael Lozano-Hemmer, *Body Movies, Relational Architecture 6*, V2, Rotterdam, Cultural Capital of Europe 2001, photo by Jan Sprij. Courtesy of the artist

the history of Fluxus games and projects, including Yoko Ono's sets of instructions for participation. Bourriaud, however, is convinced that contemporary relational artwork differs significantly from these precedents ('How are these apparently elusive works to be decoded, be they process-related or behavioural by ceasing to take shelter behind sixties art history?')[37]

Outside the art world, the history of participative activist work has used 'any media necessary', including new media, to attract attention and real participation. The Spanish group La Fiambrera, for example, have scanned in development corporation logos to protest against city decline-and-gentrification cycles. These logos were digitally manipulated and made into small flags which were carefully placed into rubbish and dog faeces in order to protest against declining street cleaning. Handing out hard hats to the public alongside a dangerously neglected wall also made the events into 'performances' to stimulate live debate. The current form of 'flash mobs' (where, for instance, a group of people connected by mobile phones turn up at Liverpool Street station to dance simultaneously to different tunes on their cheap earphone radios)[38] is perhaps the child of the 'phone trees' of early eco-activism, to alert participants of local actions. In the world of activism, tools for group use are assumed to be important and necessary, whereas the world of visual art, being based on the individual artist, and the individual viewer having a personal epiphany, has found this group ethic particularly difficult to deal with. Thus when a group such as Mongrel makes software such as *Linker*, intended for free group use as a tool (merely a shell to enable future human–human interaction) then a conventional gallery faces the challenge of locating not only the art 'object', but the audience and the author.

There is always a need to question whether the art, the interaction or the performance is happening between computer and computer (as with *The Lovers*), between human and computer (*Rehearsal of Memory*), or between human and human (and maybe digital new media can help, if the artist is a good enough host, as with *Resonance of 4*). If the popular media are anything to go by, then the latter

option (mobile phones for example) would seem to be rather more in demand than the 'press the red button' struggles of the human–computer option.

In considering the early exhibition *Cybernetic Serendipity* (1968), Gloria Sutton points out that interaction is not only a basic logistical problem for the point of exhibition in conventional galleries, but also for questions of documentation.

> Computer generated films were shown as projected films during the evenings, but then represented in the exhibition and in the catalogue as black and white stills. Through this process, the exhibition transferred the experience of interacting with the machines into iconic images. Visitors were denied the usual spectacles or frustrations that accompany trying to use any type of electronic device in a public space, and the interaction remained confined to a surface glance.[39]

The question of how the performance or artwork is relating to the audience (whether this is called relational aesthetics, interaction, participation or merely reception) is therefore of enduring importance to the whole field.

Medium-independent behaviours – the end of the line

> Where does art end and housework begin?

Kodwo Eshun[40]

When people consider the media of websites, multimedia or digital video in relation to art, they often first think of museum websites, 'online galleries', virtual walk-throughs, archiving or documentation in general, rather than the media used as an art form.[41] This is often a problem for the exhibition and criticism of new media art. However, it is also often at the point of documentation that thinking on the nature of new media has to become most focused. The questions of who, what, when, where or how the performance or artwork might actually work becomes central. The Variable Media project works on questions of collecting and preserving artworks across a range of new and old media, and developed the useful phrase 'medium-independent behaviours'[42] for those characteristics which did not fit

neatly into medium categories: 'Among the important questions for interactive behaviour is whether traces of previous visitors should be erased or retained in future exhibitions of the work.'[43] In taking examples as various as Nam June Paik, Felix Gonzalez-Torres and Mark Napier, the Variable Media project has highlighted that any art involving interaction or particular relationships with audiences (and this might involve both performance and new media) faces similar challenges of preservation.

Thus, as can be seen from the examples given, new media often appears to be working in opposition to the inherent live-ness, persona or embodiment of traditional performance art, and yet also shares the issues of process, document and interaction. At the centre of these recurring issues is the continuing debate concerning the 'materiality' of the art object versus the disembodiment of the conceptual or the virtual. Lucy Lippard's seminal book concerning 'the dematerialization of the art object'[44] has informed many curators of 'the other' (live art, community art, architecture, dance) while current debates continues to question just how immaterial digital media really are.[45]

To end as this essay began, by basing the issues around actual artworks, there are certainly artists whose works critically span the range from computer as surrogate performer to programmer as instigator of human–human interaction. The artwork of Canadian Max Dean, for example, was informed by his performance work in the 1970s and video installation, but also includes *Be Me* (2002). This computer-enabled installation allows a viewer to animate the facial expressions of the artist's face in the projected video image. When the user speaks into a microphone, the projected image appears to speak those words, creating a crucial confusion of performance and identity. *The Table: Childhood* (1984–2001) is a robotic work where a simple white table displays a complex set of behaviours in relation to different people moving through the gallery. Because the table is capable of distinguishing between people, the resulting human–human interaction is as valued as the human–artwork scenarios.

Because artists are undoubtedly leading the development of both new performance and new media, and because these artists necessarily

use 'any media necessary', it seems likely that the field of new media performance will evolve in a hybrid way, cross-fertilized by the art practice itself. This approach holds some promise that 'the awful naffness of technology' can be overcome by a critical approach to interaction. There is also some promise that those responsible for documentation and archiving are starting to catch up with the challenges that this presents.

NOTES

1 Cited as being from *America Online* 10/31/94 'Live chat with Laurie Anderson', in Robert Delius Royar, *Quotations* (2000) http://people.morehead-st.edu/fs/r.royar/quotations.html.

2 Donna Haraway, *Simians, Cyborgs, and Women* (New York: Routledge, 1990), p. 152.

3 http://www.easylife.org/386dx/

4 See Beryl Graham, 'The Panic Button: In Which our Heroine Goes Back to the Future of Pornography', in Martin Lister (ed.), *The Photographic Image in Digital Culture* (London: Routledge, 1995), pp. 77–94.

5 http://www.c3.hu/collection/form/.

6 Rosalind Krauss, 'Video: The Aesthetics of Narcissism', in Gregory Battcock (ed.) *New Artist's Video* (New York: E. P. Dutton, 1978), p. 45.

7 Aaron Williamson, 'The unconscious performance', in Adrian George (ed.), *Art, Lies and Videotape: Exposing Performance* (Liverpool: Tate Publishing, 2003), pp. 54–63.

8 Ken Feingold, 'Ou: Interactivity as divination as vending machine', *Leonardo*, 28 (1995), p. 401.

9 Louise Dompierre, *Press Enter: Between Desire and Disbelief* (Montreal: The Power Plant, 1995), p. 17.

10 Rafael Lozano-Hemmer, quoted in Heimo Ranzenbacher, *Metaphors of Participation: Rafael Lozano-Hemmer interviewed by Heimo Ranzenbacher* (2001) http://www.aec.at/festival2001/texte/lozano_e.html.

11 Haraway, *Simians*, p. 153.

12 Alluquère Rosanne Stone, 'Will the Real Body Please Stand Up? Boundary Stories about Cyberspace', in Michael Benedikt (ed.), *Cyberspace: First Steps* (Cambridge, MA: The MIT Press, 1991), pp. 81–118.

13 Lynn Hershman Leeson, 'Romancing the Anti-body: Lust and Longing in (Cyber)space', in Lynn Hershman Leeson (ed.), *Clicking In: Hot Links to a Digital Culture* (Seattle: Bay Press, 1996), p. 330.

14 Kevin Teixeira, 'Jenny Holzer. Virtual Reality: An Emerging Medium', *Art and Design* no.39 (Art and Technology issue) (1995), pp. 9–15.

15 Alluquère Rosanne Stone, *The War of Desire and Technology* (Cambridge, MA: The MIT Press, 1995), p. 35.

16 http://www.justfornow.net/

17 Dompierre, *Press Enter*, p.17.

18 Josie Berry has explored the issue of net art and 'aura', in the Walter Benjamin sense, in her dissertation 'The Thematics of Site Specific Art on the Net' (unpublished PhD thesis, University of Manchester, 2001) http://www.metamute.com/mfiles/mcontent/josie_thesis.htm.

19 Tate, *British New Media* seminar, 3 April 2004, London: Tate Britain.

20 Naomi Spellman, 'Re: locative', *NEW-MEDIA-CURATING Discussion List* (26 April 2004), http://www.jiscmail.ac.uk/lists/new-media-curating.html.

21 http://www.inconversation.com/

22 Lev Manovich, 'The Aesthetics of Virtual Worlds: Report from Los Angeles', *Ctheory, Global Algorithm 1.3.* (1996), http://www.ctheory.com/e42.html.

23 Ken Goldberg and Roland Siegwart (eds), *Beyond Webcams: An Introduction to Online Robots* (Cambridge, MA: The MIT Press, 2002), p. 241

24 http://telegarden.aec.at/

25 With Victor Laskin, http://www.wimp.ru/.

26 Steve Dietz, 'Why Have There Been No Great Net Artists?', *Through the Looking Glass: Critical Texts* (1999), http://www.voyd.com/ttlg/textual/dietz.htm.

27 Sarah Cook and Beryl Graham, 'Curating New Media Art: Models and Challenges', *New Media Art: Practice and Context in the UK 1994–2004* (London: Arts Council of England, 2004), pp. 84–91.

28 From the *Female Extension* website http://www.obn.org/femext

29 Andrew Quick, 'The Artist as Director', in George (ed.), *Art, Lies and Videotape*, pp. 82–91.

30 http://www.loebner.net/Prizef/loebner-prize.html

31 This conversational metaphor is further explored in Beryl Graham, 'A Dialogue with an Idiot? Some Interactive Computer-based Art', in Finn Bostad, Craig Brandist, Lars Sigfred Evensen and Hege Charlotte Faber (eds), *Bakhtinian Perspectives on Language and Culture: Meaning in Language, Art and New Media* (London: Macmillan, 2004).

32 Including Martin Reiser and Andrea Zapp (eds), *New Screen Media: Cinema, Art, Narrative* (London: BFI, 2001).

33 Rafael Lozano-Hemmer, 'Too Interactive (Belated)', *New-Media-Curating Discussion List* (6 December 2001), http://www.jiscmail.ac.uk/lists/new-media-curating.html.

34 Regina Cornwell, 'Artists and Interactivity: Fun or Funambulist?', in Carol Brown and Beryl Graham (eds), *Serious Games* (London: Barbican Art Gallery/Tyne and Wear Museums, 1996), pp. 10-16; http://www.newmedia.sunderland.ac.uk/serious/rcessay.htm.

35 http://www.opensorcery.net/OUT/htm/project.htm

36 A collaboration with Brody Condon and Joan Leandre, http://www.opensorcery.net/velvet-strike.

37 Nicolas Bourriaud, *Relational Aesthetics* (Paris: Les Presses du Reel, 2002), p. 7.

38 http://www.mobile-clubbing.com

39 Gloria Sutton, 'Exhibiting New Media Art', *Rhizome Digest: November 5, 2004 and November 12, 2004*, available from: digest@rhizome.org.

40 Rob La Frenais, Rob Gillean Dickie and Paul Khera (eds) *Makrolab* (London: The Arts Catalyst and Zavod project, 2003), p. 7.

41 This problem is covered in more detail in Beryl Graham, 'Redefining Digital Art: Disrupting Borders', in Fiona Cameron and Sarah Kenderdine (eds), *Theorizing Digital Cultural Heritage: A Critical Discourse* (Cambridge, MA: The MIT Press, 2007).

42 Jon Ippolito, 'Accommodating the Unpredictable: The Variable Media Questionnaire', in Alain Depocas, Jon Ippolito and Caitlin Jones (eds), *Permanence Through Change: The Variable Media Approach* (New York: Guggenheim Museum, 2003), p. 48; http://www.variablemedia.net/e/preserving/html/var_pub_index.html

43 Ippolito, 'Accommodating the Unpredictable', p. 50.

44 Lucy Lippard (ed.), *Six Years: The Dematerialisation of the Art Object from 1966 to 1972* (Berkeley, CA: University of California Press, 1973).

45 Sarah Cook, 'Immateriality and its Discontents', in Christiane Paul (ed.), *Curating New Media* (Berkeley, CA: University of California Press, 2008).

Contributors

Jane Chin Davidson received her PhD on diasporic Chinese performance art from the University of Manchester in 2006. Her undergraduate thesis on contemporary art from China was published at Reed College in Portland, Oregon. Her research interests include the signification of the body in contemporary performance art in relation to conceptions of 'race', psychoanalytic theories of identification, and phenomenology.

August Jordan Davis is an art historian based in London. She is completing her doctoral research on the performative praxis of Martha Rosler with Professor Jonathan Harris at University of Liverpool. She is a regular contributor to *The Art Book* and has lectured at University of Northumbria at Newcastle, University of Liverpool, and currently at University of East London and the University College for the Creative Arts (Farnham, Surrey).

Anna Dezeuze is a Postdoctoral Research Fellow in the School of Arts, Histories and Cultures at the University of Manchester. Her research and teaching interests focus on 1960s North and South American art, in particular Minimalism, Fluxus, kinetic art and conceptual art, and the work of Brazilian artists Lygia Clark and Hélio Oiticica. She is currently preparing two edited books, *The 'Do-it-yourself Artwork': Spectator Participation in Contemporary Art*, with Jessica Morgan and Catherine Wood; and *Involuntary Sculpture: Process, Photography and the Ephemeral Object*, with Julia Kelly. Her own book, entitled *The 'Almost Nothing': Dematerialisation and the Politics of Precariousness*, will focus on the theme of precariousness in artistic practices from the 1960s to the 1990s.

Beryl Graham is Professor of New Media Art at the University of Sunderland. Her professional work over fifteen years has included curating the *Serious Games* exhibition of international interactive artwork, and co-editing the CRUMB website – a resource for curators of new media art. She has lectured internationally, including at Banff Centre for the Arts and the Slade School of Art, London. Her writing includes a book for Heinemann, chapters for Routledge, and articles in *Art Monthly*.

Amelia Jones is Pilkington Professor in the History of Art in the School of Arts, Histories and Cultures at the University of Manchester. She specializes in many different aspects of modern and contemporary art including feminism and art; performance, body and video art; and Dada. She has curated many exhibitions and is the author of *Postmodernism and the En-Gendering of Marcel Duchamp* (1994), and *Body Art/Performing the Subject* (1998), as well as the primary survey essay in the Phaidon book on *The Artist's Body* (2000). Her new book *Self-Image: Technology, Representation, and the Contemporary Subject* (2006) expands on her work on body art, exploring the experience and understanding of the self in relation to performances of the body via technologies of representation from analogue photography to the Internet.

Richard Layzell is an artist, performer and 'visionaire', and a Research Associate at ResCen, Middlesex University. His work in industry and the arts has been acknowledged internationally. His quest for new contexts has led to solo and collaborative projects with numerous institutions and organizations, both public and private. His interactive installation *Tap Ruffle and Shave* was seen by 100,000 people in four major UK cities. His work is included in the Gallery of Modern Art Glasgow, the Science Museum London, the London School of Hygiene and Tropical Medicine and Skills for People, Newcastle. He is the author of *The Artists Directory*, *Live Art in Schools* and *Enhanced Performance*.

Joshua Sofaer is an artist and writer, and Senior Research Fellow at ResCen, Middlesex University. Recent projects include *SFMOMA Scavengers* for the Museum of Modern Art in San Francisco. His solo performance *The Monologue Machine* premiered at 'Points d'Impact' at Piano Nobile in Geneva, Switzerland in spring 2005 before travelling to the ANTI Festival in Kuopio, Finland. He is co-editor of *Navigating the Unknown: The creative process in contemporary performing arts* (London: Middlesex University Press/ResCen Publications, 2006) and is currently writing *Performance and (his) Everyday Life* (Brussels: Whatt, 2007).

Robert Summers is completing his PhD in art history at UCLA, where he was a Cota Robles and UCLA Research Fellow. He is a regular contributor to *artUS* and *Xtra* art magazines, and has an essay entitled 'From A to Me and Back Again: Andy Warhol's Autobiographies', in *Pop Culture and Postwar American Taste* (2005).

Frazer Ward is Assistant Professor of Art at Smith College. He was educated at the University of Sydney, Australia and Cornell University. He has written extensively about contemporary art and the history of the art of the 1960s and 1970s and his work has appeared in journals including *Art Journal, Art] Text, Documents, Frieze, October* and *Parkett,* as well as in various anthologies. His current research interests include performance art of the 1960s and 1970s, the implications of new imaging technologies, and the status of art in contemporary public spheres.